Eroticism in Western Art

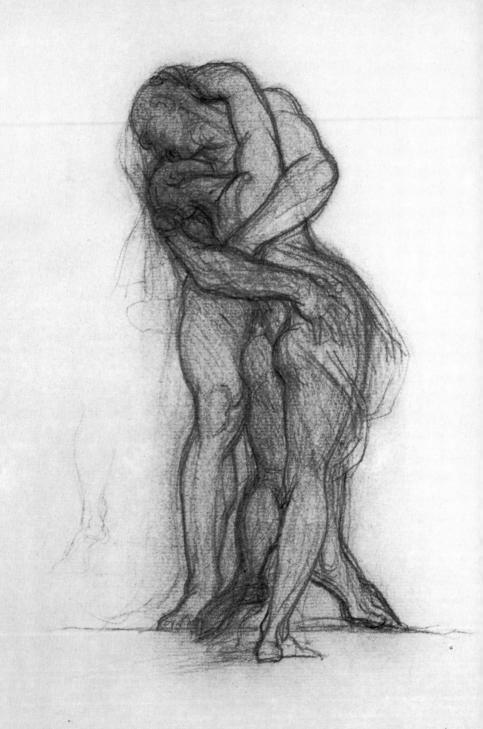

Eroticism in Western Art

Edward Lucie-Smith

Praeger Publishers

New York · Washington

This book is dedicated (without permission) to The Right Hon. the Earl of Longford, KG, PC whose public pronouncements stimulated me greatly while I was writing it

Frontispiece:

I JOHN HENRY FUSELI, The Kiss, c. 1816

BOOKS THAT MATTER Published in the United States of America in 1972 by Praeger Publishers, Inc.

111 Fourth Avenue, New York, N.Y. 10003

 $\ \ \bigcirc$ 1972 in London, England, by Thames and Hudson Ltd

All rights reserved

No part of this publication may be reproduced, stored in a retrieval system or transmitted in any form or by any means, electronic, mechanical, photocopying, recording or otherwise, without the prior permission of the Copyright owner

Library of Congress Catalog Card Number: 72-180729

Printed in Great Britain

Contents

Introduction	7
PART ONE: CONTEXTS	
CHAPTER ONE The erotic and the sacred	II
CHAPTER TWO The open secret	32
CHAPTER THREE The new paganism	47
CHAPTER FOUR Eroticism and realism	75
CHAPTER FIVE Cruel fantasies	107
CHAPTER SIX Love for sale	121
CHAPTER SEVEN The all-devouring female	139
CHAPTER EIGHT Erotic metamorphosis	155

PART TWO: SYMBOLS

Venus observed	17.
CHAPTER TEN Lust in action	183
CHAPTER ELEVEN Deviations	197
CHAPTER TWELVE Pleasurable pains	21
CHAPTER THIRTEEN Here comes a chopper	227
CHAPTER FOURTEEN Symbols and disguises	239
CHAPTER FIFTEEN Eroticism and modernism	26
Further reading	270
List of Illustrations	270
Index	28

Introduction

This book is intended to trace the history, and describe the functions, of erotic art in a single culture – that which has its origins in Western Europe. The reasons for confining my approach to the subject in this way are twofold. One is lack of space. It would take several volumes the size of this one to give even an outline account of the way in which erotic art has functioned in all the cultures known to us. The second reason is more weighty. We must admit that erotic art in the European tradition makes concrete what is very intimately part of ourselves. The Oriental and African erotica which it is now fashionable to study undoubtedly has a wit, a charm, a power and a beauty of its own. But it seems impossible for Europeans to experience its content in the same way as we experience that of European art, because it springs from a different and alien tradition. This has not prevented me from using examples from other cultures where they shed light on an aspect of my own theme.

It is also my intention to put as much emphasis upon the artistic value of the works illustrated and discussed as upon their eroticism. There is a tendency, among those who write about erotic art, to concentrate upon representations which illustrate some specific aspect of sexual activity, without laying much stress on the aesthetic quality of the representation. Undoubtedly, the bad or mediocre work of art offers the commentator certain advantages. It is seldom as complex or as subtle as a work of real quality, and what it has to say is said openly, even crudely. At the same time, the commentator is protected from the assumption that he is ignoring, or even insulting, aesthetic values in his search for erotic content. If, during the course of this book, I seem to pursue erotic symbolism in a masterpiece at the expense of its greatness, I hope to be forgiven. My assumption has always been that any work worth discussing for its erotic or sexual significance must also be worth talking about regarded simply as a painting or as a piece of sculpture.

Though I am not a psychoanalyst, this book makes use of certain of the simpler analytic concepts, and also of analytic terminology

where the latter cannot be avoided. One idea which I have borrowed from psychoanalysis is the concept of displacement. A work of art may be full of erotic feeling without depicting sexual activity in any narrow definition of that phrase.

There is one further point to be made: it concerns the structure of the book. It seems to me that, in the context of eroticism, works of art can be described and discussed in two principal ways. One is historical – that is, it attempts to place them in the context of the culture, the social situation, and the prevailing aesthetic beliefs of the epoch when they were produced. This is what I have attempted to do in the first half of the text.

The other method is quite different. In the second half of the text I have tried to group various works of art together according to what they seem to express – that is, according to subject-matter, and, still more, according to both conscious and unconscious symbolism. I am well aware that this kind of classification is open to many objections, most notably that there are many works of art of such psychological complexity that to organize them in this way is perhaps to direct the reader's attention too exclusively at only one aspect of what they have to communicate. I believe the risk to be worth taking, as my chosen method does in fact force many familiar works of art to give up information which has hitherto been largely overlooked.

This second method of categorization has a logic which I hope will be apparent, but it is worth outlining one or two of the ideas which both inform my choice of categories and help to bind them together into a structure. Erotic art is not merely hedonistic - the hedonistic element, indeed, may often take a very secondary place. The how and why of the pleasure given by erotic works of art is extensively discussed in Part Two. But erotic art also seems to serve as an act of exorcism. We recognize that this is an important aspect of the art produced by primitive peoples; we are less ready to recognize the same function in the art of our own culture. The illustrations to this book are a parade, not only of the things which have given men gratification, but of their deepest fears. The strong emotions of rage aroused by erotic works - these have often led to their destruction - often seem to be due to the fact that, for certain spectators at least, the catharsis is imperfect, and the eroticism of the work is seen as a real and personal threat.

PART ONE Contexts

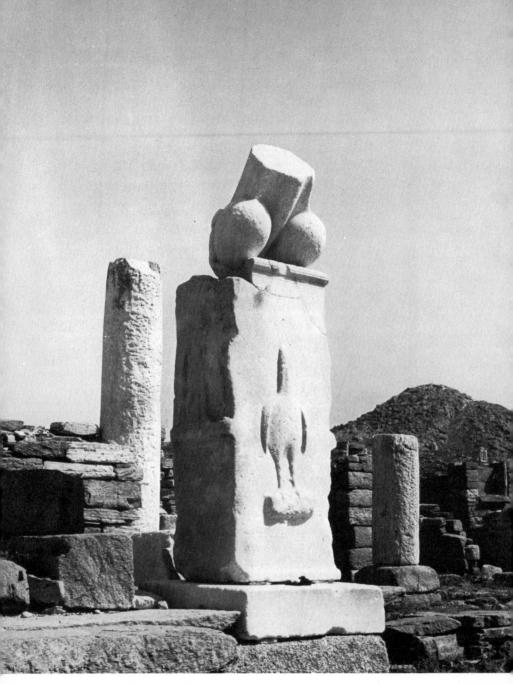

2 Phallic altar of Dionysus, Delos

The erotic and the sacred

At the dawn of art – at the time when man himself was only in the process of becoming recognizably human – the erotic and the sacred were inextricably fused with one another. In terms of its influence on European culture, palaeolithic art is both very young and very old. Its most important monuments have become available to us comparatively recently, with the discovery of the great caverns within which they had for so many centuries remained hidden. The cavepaintings of early man have added a whole new dimension to the artistic achievements of mankind. But there is also a sense in which they tell us nothing which we might not have guessed for ourselves.

Palaeolithic man was driven by his need to survive in an environment which he had barely begun to master. Survival was a matter of two barely separable things: food and fertility.

Since man was not yet an agriculturalist, but purely a hunter and food-gatherer, much of his food supply depended upon his brothers the animals. He looked to them – teeming herds of bison, mammoth, oxen and reindeer – to keep him alive. Small wonder that he drew these and other beasts with such intensity of observation. The telling details of appearance which distinguished each species were life and death to the hunter-artist. And his wish was, not merely to be successful in the hunt, but always to have beasts available for hunting. They multiply and increase upon the walls of his caves, and the sympathetic magic of these hidden representations controlled the fate of the herds that galloped outside.

Yet it was equally necessary that man himself should multiply, if the survival of the race was to be assured. So the palaeolithic artist also created things which were meant to exert a magical influence upon human fertility. The most famous of these are the so-called 'prehistoric Venuses' – statuettes like the Venus of Willendorf, relief carvings like the Venus of Laussel. All these representations have something in common. They are not naturalistic, in the way that the paintings of animals are naturalistic. Instead, they exaggerate certain sexual

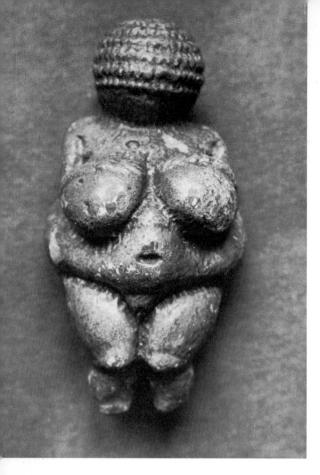

3 'Venus' of Willendorf. Late Aurignacian

4 La Polichinelle. Late Aurignacian

5 'Venus' of Laussel. Aurignacian

characteristics, such as the thighs (in particular) and the breasts, at the expense of other anatomical details. It has been said that the steatopygous character of these representations of women was in addition more directly related to the idea of physical survival, because the members of the tribe who carried the most fat would be the last to die at times of famine. We must remember, too, that fatness has been an admired quality in many cultures: in some parts of Africa, the obesity of a chief proclaims his power, prosperity and well-being. Fatness continued to exercise a specifically erotic attraction tens of thousands of years after the making of the Venus of Willendorf. The Queen of Punt, in the reliefs of Queen Hatshepsut's beautiful temple at Deir el Bahri, is a slightly more immediate ancestress of a long succession of ample beauties – among them the nudes of Rubens and

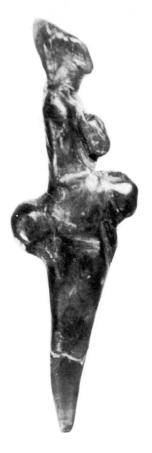

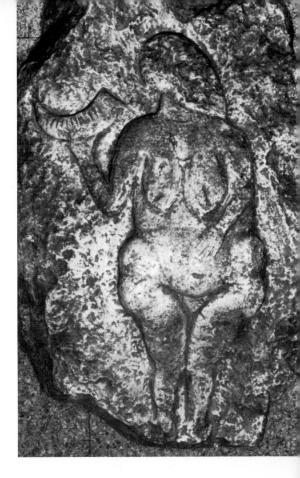

the principal figure in the *Bain turc* of Ingres – who, in creating her, was reflecting, whether consciously or unconsciously, a well-attested Middle Eastern preference.

Another type of palaeolithic female figurine, more elongated than the Venus of Willendorf, puts a yet more definite emphasis on basic sexuality. In figurines of this type, head and legs taper away to nothing, while breasts, hips and stomach are emphasized; the figure thus has a lozenge-like shape when seen from the front. In some examples of this type, the hips seem comparatively slender when the figure is seen frontally, but when it is looked at in profile, the stomach and buttocks are seen to have been given an exaggerated projection, as if to emphasize their sexual importance. The swollen, projecting stomach of the figure nicknamed 'La Polichinelle', and now in the

Museum at Saint-Germain-en-Laye, makes her a remote ancestress of the young bride in Jan van Eyck's *Arnolfini Wedding* – as late as the fifteenth century, women still felt the need to dress in a way which emphasized their fertility, or potential fertility.

These more elongated figurines, in their turn, can be related to specimens which seem to be actually androgynous. In extreme cases, the swollen hips can be interpreted as testicles, and the elongated neck as a phallus. Objects of this type continued to be produced in Neolithic times. In our own day, Picasso has revived the idea, with a female head whose features resemble the male genitals. Male representations dating from the prehistoric era are less impressive artistically than the 'Venus' figurines and reliefs. But they occur, nevertheless.

6 The 'Sorcerer', from the cave of Les Trois Frères, Ariège. Magdalenian

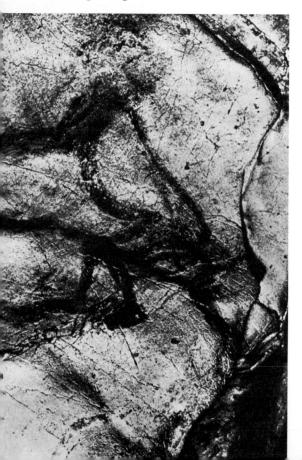

7 The Egyptian god Min. Fourth millennium BC

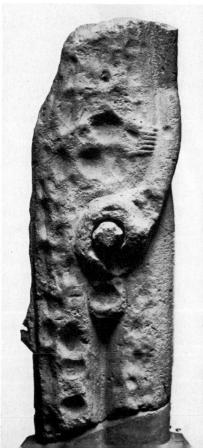

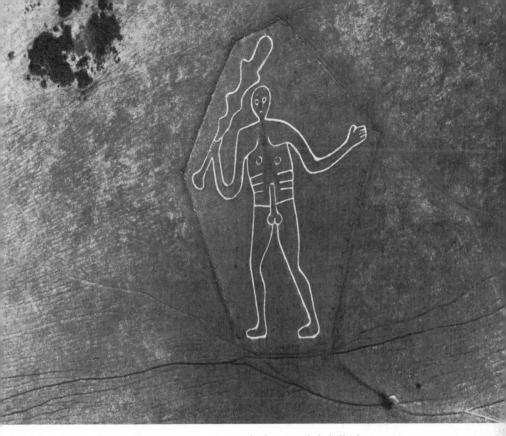

8 The Cerne Abbas Giant, cut into the turf of an English hillside in prehistoric times

Perhaps the commonest type is the so-called 'sorcerer' – the masked male whose most striking features are the animal head (or mask) with which he has been provided, and the evident potency of his member. We find in him the ancestor of numerous other ithyphallic representations in the art of prehistory, and indeed in that of the whole ancient world.

For example, there are the predynastic Egyptian ivory figurines of the early Naggadah period, and (perhaps not to be separated from these) all Ancient Egyptian representations of the god Min, who embodied the principle of fertility. The great turf-figure at Cerne Abbas in Dorset, which is probably the most impressive relic of Celtic art still to be seen in Britain, belongs to the same tradition.

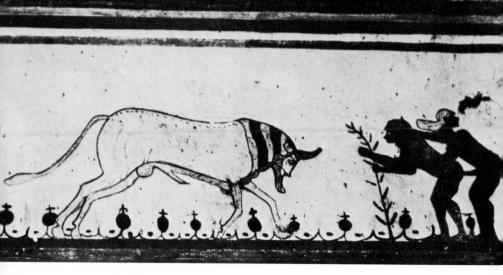

9 Wall-painting from Tomb of the Bull, Tarquinia

The art of the Greek and Roman world is especially rich in works with a strongly erotic content, and by examining a few specimens of these, we see how eroticism gradually became secularized. The god Priapus, for example, plays the same role in the Roman pantheon as was given to Min in the Egyptian, and he is therefore represented with an erect penis, above which he sometimes holds a drapery full of fruits in allusion to his function as the god of fertility. Yet, if we compare these elegant representations to those produced in predynastic Egypt, we are immediately aware that the earlier, rougher and more direct version of the theme has much greater vitality.

Priapus himself was often given the shape of a herm (a figure compressed into a free-standing pillar), by analogy with the ithyphallic pillars which were originally sacred to the Greek god Hermes. Herms were common in Greek and Roman art alike, and the Greek ones at least are powerful representations of masculine vitality. Nor did the Greeks forget the sacred function of their herms. Alcibiades was driven from Athens into exile for the crime of mutilating them.

The Greek-influenced civilization of the Etruscans carried religious respect for erotic activity to even further extremes than the Greeks themselves, and erotic representations are of frequent appearance in Etruscan tomb-painting.

11

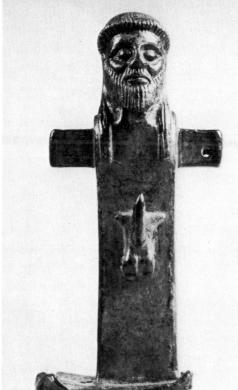

10 Greek herm, c. 500–475 BC

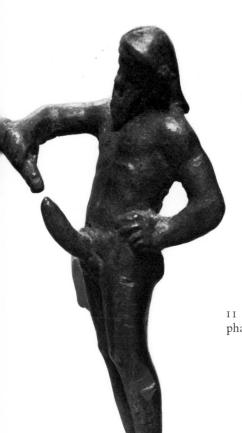

11 Priapus pouring oil on to his phallus. Graeco-Roman

So far as Greek artists were concerned, the richest source of erotic imagery was the cult of Dionysus. Dionysiac scenes, since Dionysus was the god of wine, are especially common upon cups and vases, and the lively tricks of the ithyphallic satyrs who attended upon the god offered endless amusement to the vase painters. We do not find these Dionysiac images upon pottery alone; they even appear upon coins – and the coin-type was the public statement which a Greek community made about itself. Wine-growing communities naturally favoured the god of wine and his unruly followers – a tetradrachm from Sicilian Naxos has Dionysus himself upon the obverse, while the reverse shows a muscular satyr grasping a drinking bowl. From

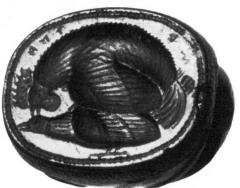

14 Coin: Satyr with drinking-bowl, c. 460 BC

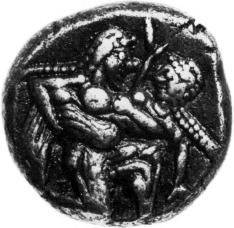

13 Coin: Satyr carrying off a nymph, c. 550 BC

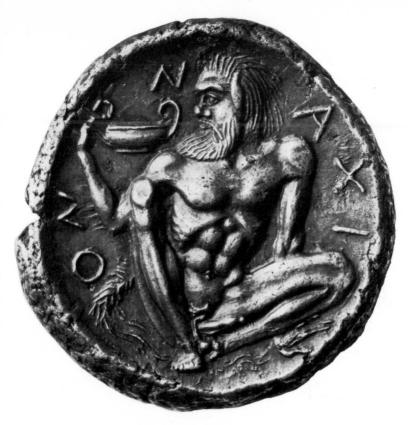

the other side of the Greek world comes the coinage of Thasos, an island rich in vines. In the mid-sixth century BC these coins show an obviously eager satyr carrying off a complaisant nymph; and it is only in the issues of some thirty or forty years later that the more visible signs of his ardour are moderated. Greek intaglios – the gems used as seals by private individuals – occasionally present images which are equally erotic in their implications. The British Museum has a fine Greek scaraboid of the fifth century BC, which shows a cock treading a hen, and an identical scene appears on an Etruscan gem of the same period.

Obviously linked to the Dionysiac scenes on vases are those where no religious allusion seems to be intended, and which show erotic scenes of the greatest frankness; for example, heterosexual or homosexual encounters often adorn the centre medallion or border of a cup. These subjects serve as a reminder of the fact that the Greeks of

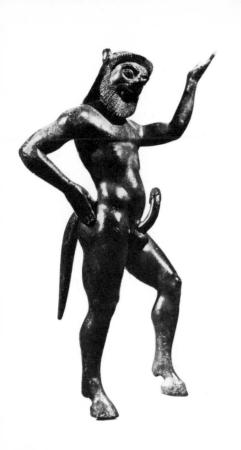

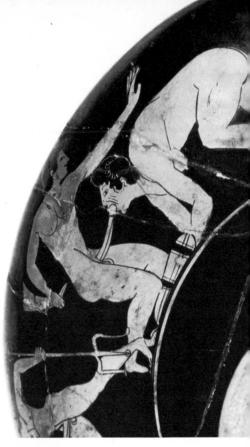

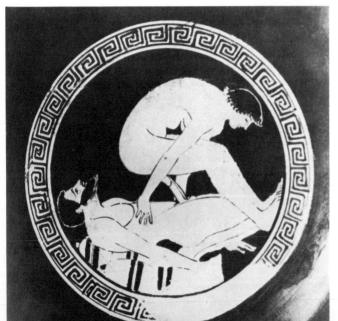

15 Satyr, 575-550 BC17 Cup: Erotic scenes.Fifth century BC

16 Cup: Courtesan and client. Fifth century B C

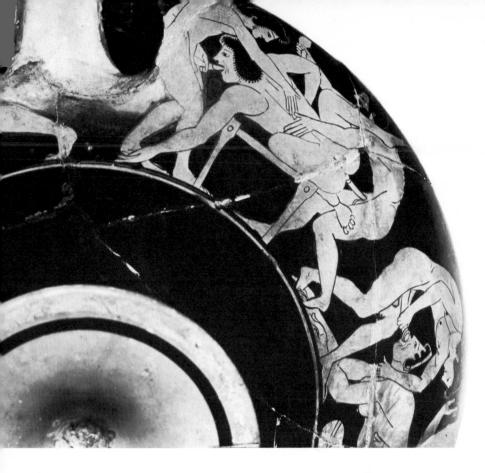

the archaic and early classical periods seem to have had little feeling of guilt about any form of sexual activity. The release of orgy was as much to be celebrated as the dignity of the gods. Not that divine dignity itself was immune from mockery, and sexual mockery above all, as the comedies of Aristophanes go to prove. The theatre provided another rich source of subject-matter for the vase painters – for an example from Greece itself, we may choose the amphora by the Leningrad Painter now in Boston, which shows the chorus of a satyr-play, complete with the strapped-on artificial phalluses required by their role. In southern Italy, a special form of comedy developed, which was dependent on a ribald parody of tragic subjects for its effects. The actors were dubbed *phylakes*, and scenes from the entertainments in which they appeared are often to be found on vases.

18 Vase: Comic actors with strapped-on phalluses in satyr dance, c. 499 BC

One, now in the museum at Lipari, shows a girl tumbler being lubriciously examined by the male actors in the piece.

This scene, indeed, is the first sign of something which develops progressively in later Greek art – a feeling of self-consciousness about erotic subject-matter. In the archaic and early classical periods, the female nude interested Greek artists much less than its male counterpart. In the fourth century BC, the balance shifted, and the Cnidian Aphrodite of Praxiteles, which soon became the most famous statue in the ancient world, stands at the beginning of a long series of representations of naked females. Praxiteles showed the goddess stepping from her bath, unmoved by those who might survey her. Variants soon began to be produced on this theme – one, which seems to date from the early third century BC, and which has been

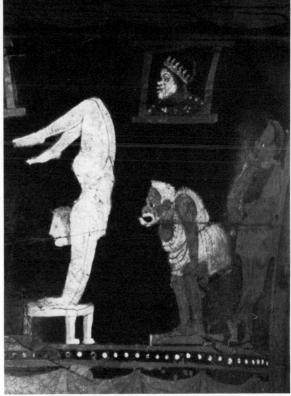

19 Vase: Dwarf staring at a female tumbler c. 350 BC

attributed to the sons of Praxiteles, is the type now known to us as the *Venus pudica*, or Medici Venus. There is a world of difference between the calm dignity of the Cnidian Aphrodite and the nervous gesture of modesty made by this only slightly younger sister.

During the Hellenistic period there seems to have been a progressive modification of artistic taste which matched the convulsions which the whole classical world was then undergoing. Sculptors, though less certain of the rules of their art, were by this time fully in command of all its technical subtleties, and they were eager to tackle the problems of composition posed by groups or pairs of figures. After the elaborate baroque phase of the Pergamon Altar, we reach the style of the second and first centuries BC, which has been dubbed by some specialists the period of the 'Hellenistic roccoo'. This is

20 Cup: Scenes of homosexual dalliance. Fifth century BC

especially rich in works whose subject-matter is playfully erotic. To this time belong the group of Eros and Psyche embracing; that of Aphrodite threatening Pan with her slipper (found in Delos, and

21 Satyr uncovering a sleeping hermaphrodite. Roman

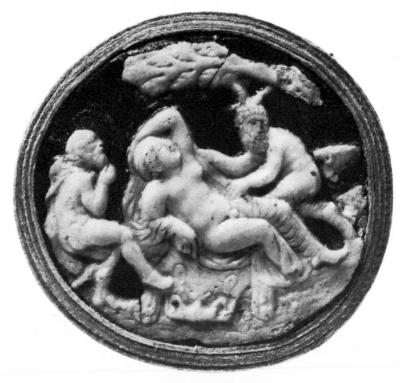

made for a Syrian merchant); and that of a hermaphrodite struggling with a satyr. The last-named is especially typical of the rather gamy taste of the time – more than fifty examples are known. One only has to make the shortest of steps from this to the outright pornography of the celebrated group from Herculaneum, which shows Pan having intercourse with a goat.

Equally characteristic of this late phase of Hellenistic art are the numerous small bronzes in the so-called Alexandrian style. The Alexandrian school seems to have specialized in grotesques – many of them misshapen dwarfs with outsize penises.

22 Sleeping satyr bestraddled by a winged female figure. Hellenistic

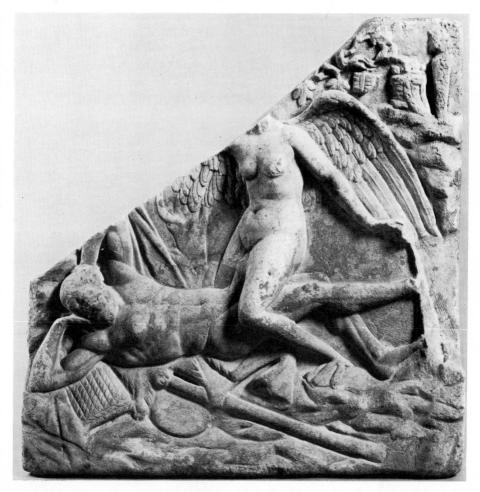

Yet, if the religious respect for sexuality was to take on some strange guises in the late Greek and Imperial Roman world, it was far from dying out. The superb frescoes in the Villa of the Mysteries at Pompeii supply a case in point. The Dionysiac rites were by this time celebrated in secret, as a more potent alternative to the tepid ceremonies of Roman official religion. There has been a good deal of controversy about the exact significance of some of the details to be found in the Pompeiian paintings, but their general import is plain enough – an initiation is taking place.

The scene runs in continuous narrative sequence, and there is an intermingling of gods, demigods and mortals. We pass from 'The Reading of the Ritual' and 'The Sacrifice' to the complex Dionysiac group which occupies the centre wall. In the midst is the god, reclining upon the lap of his consort, Ariadne. At the foot of her throne, a girl begins to unveil an object which stands in a winnowing basket. It is a huge phallus that is revealed, and above this sacred object in its container stands a winged genius with a whip, about to lash the girl-initiate who kneels trembling to receive the blow. What

23 Hermaphrodite struggling with a satyr. Graeco-Roman

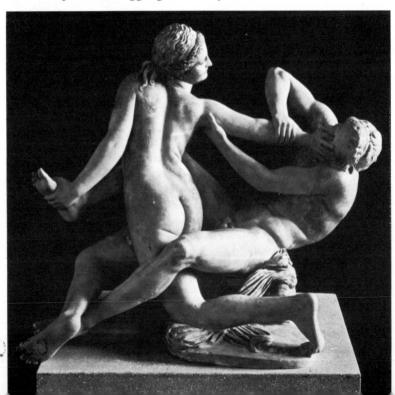

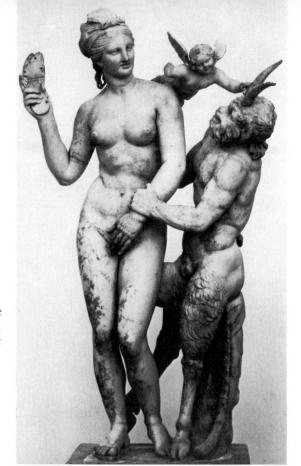

24 Aphrodite threatening Pan with her slipper. Hellenistic

here seems to be signified – as the veil, too, tells us – is a virgin's defloration. The neophyte encounters first the pain, and then the ecstasy of sexuality.

Another cult which has left some curious works of art behind it is the Phrygian one of Attis and the Great Mother. The Great Mother had been admitted to a place in the Roman national pantheon as early as the time of the Second Punic War, but aspects of her ritual troubled the Romans, and indeed continued to do so even after the goddess and her companion had been installed in a temple of their own on the Palatine at the beginning of the third century AD. The cult, like the cults from Syria made fashionable by the Severan dynasty, was a very direct form of nature worship, and orgiastic behaviour formed an essential part of the rite. In addition, there was

25, 45 the detail that the saviour-god Attis, who died and was resurrected again, met his end through self-castration, and his priests dedicated themselves to his service by the same act. Attis himself is sometimes represented as a small boy in Phrygian costume, with his clothes opened to show his sexual organs – a means of reminding the worshipper of the legend.

In addition, other statuettes exist which are less certainly intended for Attis himself. It seems more likely that they are intended to represent the *galli* – the priesthood of the cult. These are described in ancient texts as having the curled hair and wearing the effeminate garments which are to be seen in these sculptures. Here, too, the garment is arranged so as to show the sexual organs.

We can find a parallel for the softly swaying pose adopted by these epicene beings in the attitudes adopted by the *yakshis* and *apsaras* of classic Indian art, except that in this case all is femininity, rather than an imitation of femininity. While it is certainly true that the Greek,

25 Attis. Graeco-Roman

26 Hermaphrodite.Graeco-Roman

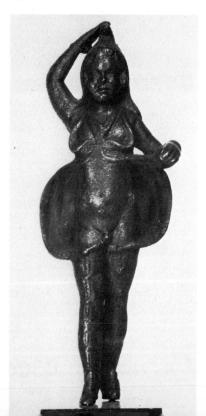

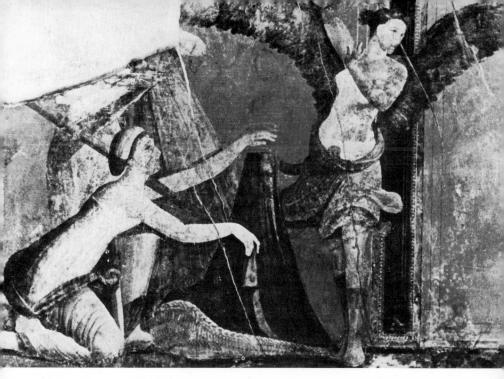

27 Girl initiate unveiling a symbolic phallus before a winged figure. Wall-painting, from the Villa of the Mysteries, Pompeii. Before AD 79

and more especially Hellenistic, tradition made an immense contribution to the development of Indian art, there are highly important differences. Indian art, and perhaps most especially Indian sculpture with a marked erotic content, shows characteristic elements which are hostile to classical conceptions.

We get a first glimpse of them in one of the earliest Indian sculptures known to us – the copper statuette of a dancer from Mohenjodaro, which dates from the second or third millennium BC. This displays not only a keen interest in the erotic possibilities of the female body but a feeling for that sculptural rhythm which will speak of those possibilities most effectively. If we look, for example, at the torso of a *yakshi* (nature spirit associated with fertility) from Sanchi, which dates from the first century BC, we are aware that this is less naturalistic in its details than the torso of a Greek Venus would be, but also more sensual. The swelling forms of the stone contradict

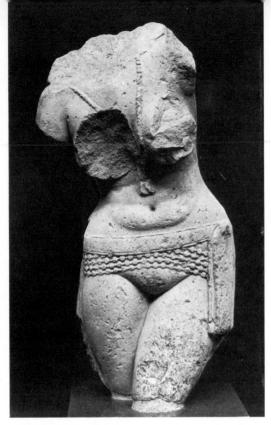

29 Façade of Kandarya-Mahadeva Temple, Khajuraho. Tenth to eleventh century AD

28 Yakshi torso. Indian. First century BC

its stoniness by suggesting softness and warmth; the tight belt, crisply carved, emphasizes the heavy fleshiness of the hips. In addition, the sculptor focuses attention on erotic detail in a way which is very un-Greek – notably on the dimple of the navel and on the pubic triangle.

The yakshi from Sanchi is among the first in a long succession of these representations of women, each of them more tempting, more deliberately seductive than the last. Often the female figures are joined, among the multitudinous carvings that adorn Indian temples, by their divine lovers. At Khajuraho (tenth–eleventh centuries AD) and at Konarak (thirteenth century) the figures grip and entwine in every imaginable erotic posture. The stone becomes a lexicon illustrating the whole art of love. The erotic candour of medieval Indian religious art makes a striking contrast with the repressive nature of the Christian art then being created in Europe – or so it may seem at first sight.

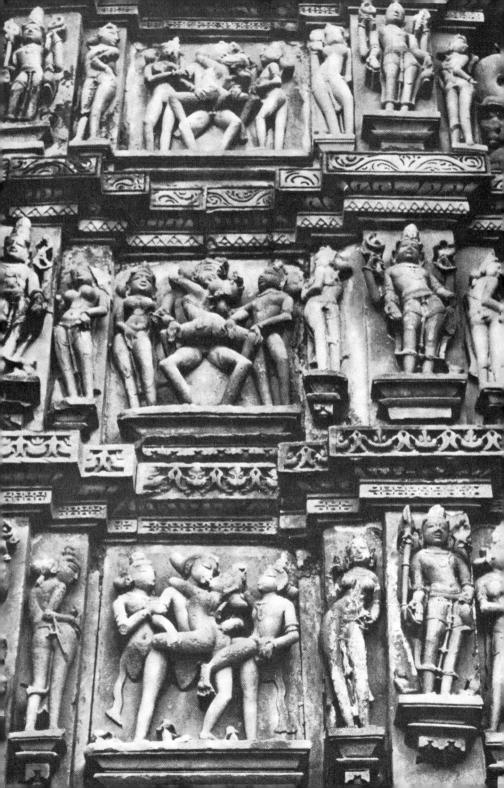

The open secret

In theory, with the triumph of Christianity, the orgiastic eroticism of the cults fashionable in third-century Rome was utterly defeated, consigned to the category of 'pagan abominations', and enthusiastically denounced by the Fathers of the Church. The most puritanical of all Near Eastern religions had swallowed up its rivals.

Yet in fact we can discover many examples of eroticism in medieval art. Sometimes these appear to be vestigial survivals of the old pagan cults, as, for example, with the Shelah-na-Gig, a woman depicted with great emphasis on the vulva, which is found in Irish churches. The function of such carvings was evidently apotropaic – they warded off ill-luck in the same fashion as the 'lucky' phalluses found at Pompeii.

30 Shelah-na-Gig. Irish fertility figure. Between eleventh and fourteenth centuries

More generally, however, erotic representations appear in medieval art as a kind of *obbligato* to solemn and sacred themes. Thus, we discover them in the margins of breviaries, and in the minor elements of ecclesiastical architecture and church furnishing – on bosses, corbels and on the capitals of columns, and also on misericords, the woodcarvings which adorn choir-stalls.

These last present us with an especially interesting repertoire of imagery. Sometimes proverbial phrases are illustrated. In Bristol Cathedral there is a misericord which is an illustration of the expression 'to lead apes in Hell', which meant 'to suffer from sexual frustration'. The carving shows a naked woman with a group of lustful apes. A devil welcomes her into Hell-mouth. In the church of Saint-Martin, at Champeaux (Seine-et-Marne), there is an illustration of the French proverb *Petite pluie abat grand vent* (Little rain beats a big wind). The sculpture on the misericord is a visual pun – a peasant urinates into a wicker winnowing-fan or *van* (*vent* and *van* are pronounced identically). Coarse rustic sports are also shown, as, for instance, in the misericord at Ely which depicts the peasant game of arsy-versy, or (the French is more graphic) *pet-en-gueule*, where a couple arrange themselves in a ball-shape, and roll over and over.

31

31 The game of *pet-en-gueule*, carved on a misericord at Ely Cathedral, c. 1340

But it would be a mistake to suppose that these coarsely humorous, even scatological, scenes are the only examples of eroticism to be discovered in medieval art. Christian fear of sex, and contempt for the body, are frequently expressed in a way that graphically expresses the attractions of what was feared and despised. Sometimes the artist's reaction was almost wholly sadistic. This is true, for example, of the fresco of The Last Judgment by Giotto in the Arena Chapel at Padua. Prominent in the composition is a group of four naked sinners, each suspended by the part through which he or she has offended - one hangs by the tongue, another by the hair, and two more, a male and a female, are suspended by the sexual organs. Elsewhere, a devil castrates yet another sinner with a pair of pincers. It may here be said, in parenthesis, that medieval artists were never very squeamish about sadistic representations, even those with a strongly sexual element. The Bibliothèque de l'Arsenal in Paris has a lavishly illuminated volume containing Boccaccio's De casibus virorum illustrium, in the French translation by Laurent de Premierfait. Many of the scenes are violent and bloody. Most terrible of all is the one which shows the unfortunate King William III of Sicily being blinded and castrated by his enemies.

Not all erotic representations by medieval artists are as savage as Giotto's fresco, however, even when the subject is the punishment of sinners. The *Très Riches Heures* of the Duke of Berry contains a representation of *Purgatory* by Jean Colombe which is a great deal less harsh. True, the right foreground shows a female nude, bound, being attacked by two wild animals, one of which is a crocodile; but in the middle distance we see two more naked females, who are being rescued from their torments by compassionate angels.

And sometimes there seems to be little or no implied condemnation of what is shown to us. This is the case, for example, with representations of the Golden Age (a theme later to be exploited by Renaissance and post-Renaissance artists for its erotic possibilities). A fifteenth-century manuscript in the Bodleian shows a scantily clad couple embracing intimately, while other figures look on. An almost similar mood is conveyed by the scene *The Garden of Nature* which serves to illustrate a text called *Les Echecs amoureux*. Nature guards the gate of a garden containing three goddesses, one of whom, a scantily draped Venus, looks at herself in a mirror while she herself is observed by two male spectators, who look over the wall.

32

33

34

35

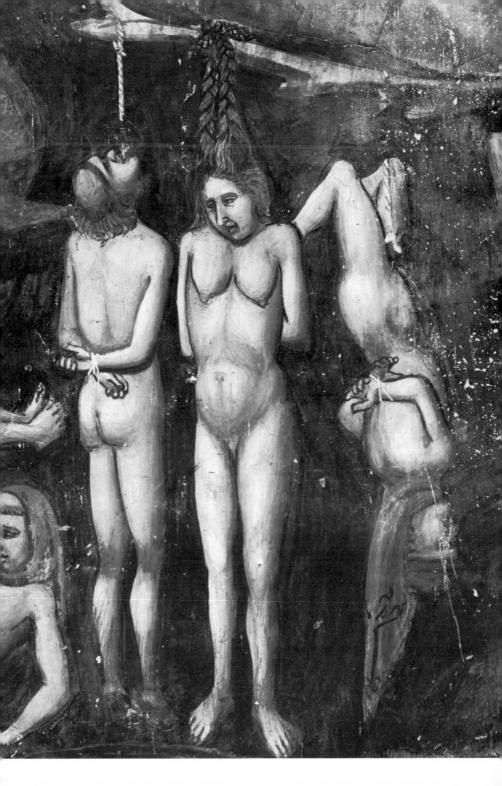

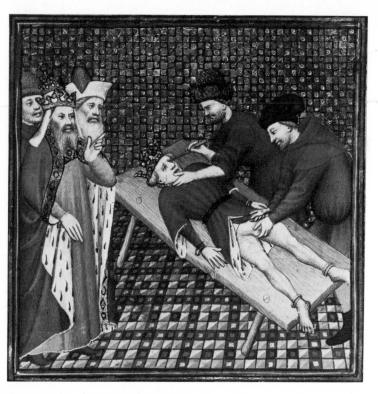

33 Torture of King William III of Sicily, from De casibus virorum illustrium of Boccacio

These are early instances of the voyeurism which is one of the most important themes in European erotic art. But there is a more striking example still – the scene showing Bathsheba bathing, and observed by King David, which regularly appears in fifteenth-century books of hours. It is interesting to note that, in these illuminations, the figure of Bathsheba conforms to a type which can be traced far back in prehistory – a type with spindly limbs, narrow shoulders, broad hips and a swelling belly. The miniature in the Hours of Marguerite de Coëtivy at Chantilly exaggerates the type to the point of caricature.

When the texts before them did not offer a direct opportunity for erotic illustration, medieval artists were quite capable of creating the occasion. The *Bible moralisé* written and illustrated for Charles V of

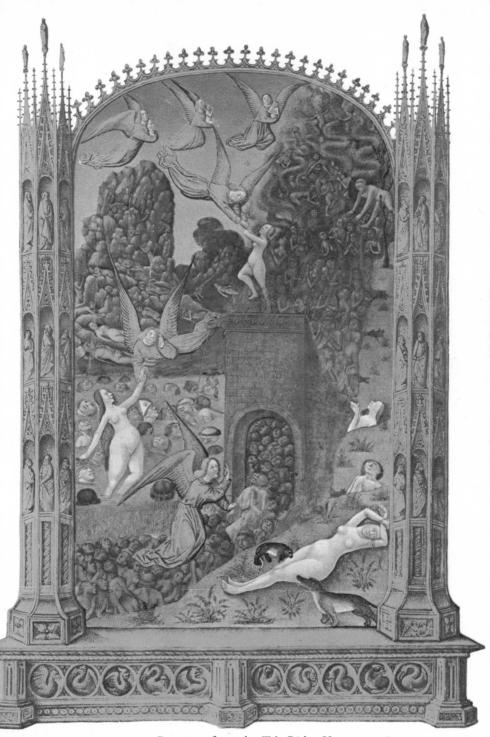

34 JEAN COLOMBE, Purgatory, from the Très Riches Heures, c. 1485

35 The Golden Age, from a fifteenth-century manuscript

France offers a case in point. One picture shows a naked couple engaged in the sexual act, and being urged on by a devil who has a second head where his sexual organs ought to be. The whole is designed as a warning against drunkenness, 'which leads to all other vices'. It would be difficult to find a better instance of the ambiguity of medieval attitudes towards erotic representations.

Very occasionally, however, where a secular text is concerned, the motive for showing something which we now look upon as erotic was a direct and simple curiosity, a naïve appetite for marvels. A *Livre des merveilles* of the early fifteenth century, in the Bibliothèque Nationale in Paris, contains a number of texts, among them the narration of Marco Polo, and the fictitious but equally popular *Mandeville's Travels*. Mandeville has many wonders to relate; he

mant dunic se fut purtie de lacte 2019 de dit et gille lor repré De sa fosser state il faint en son suure il sessa la forest on diverte connerse e train.

37 The Land of the Hermaphrodites, from a Livre des merveilles. Early fifteenth century

speaks, among other things, of the Land of the Hermaphrodites, and the artist has done his best to imagine what these creatures can be like.

The incidence of erotic representations undoubtedly rises during the last phase of the Middle Ages. And just as the medieval spirit was breathing its last, a great artist arose in whose work we find embodied the characteristics of many of the works discussed in this chapter. This artist was Hieronymus Bosch. Bosch looks both forward and back: we find in him elements which seem to be allusions to the old cults of fertility, which had flourished before Christianity began; and, at the same time, he seems to foreshadow the extravagances of twentieth-century Surrealism.

39-41

From the standpoint of our current inquiry, the most interesting of Bosch's works is the great triptych *The Garden of Earthly Delights*, which probably dates from the opening years of the sixteenth century, though some authorities put it as early as 1485. The work is extremely complex, and has provoked a number of opposing interpretations, especially so far as its central panel is concerned. It seems fairly clear

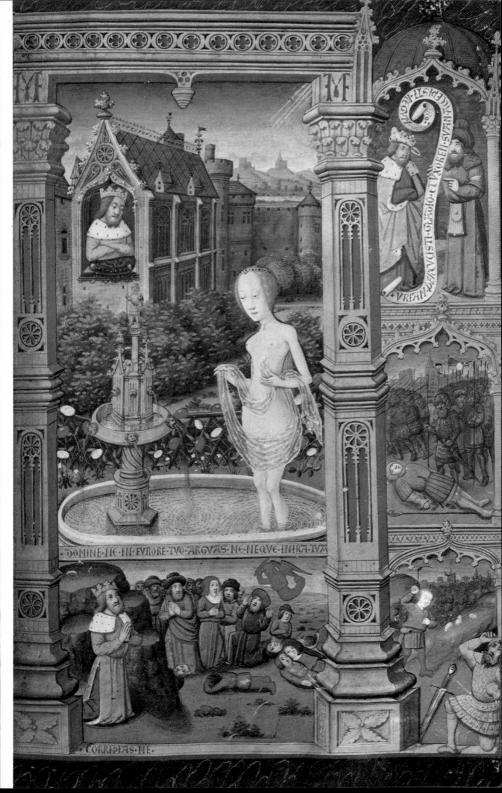

that the main subject of the left-hand panel is the Creation of Eve, though it does not follow the usual iconographic tradition, in which God brings Eve forth from Adam's rib. The right-hand panel shows the damned in hell, with particular emphasis, as so often, upon the punishment for lust.

The central and most important scene has been read in diametrically opposite ways: as a warning against the sins of the flesh, and as an image of full harmony between the human soul and nature. The fifteenth-century material already illustrated offers some support for both these points of view; but both are drastically over-simplified. As Charles de Tolnay suggests, Bosch is trying to show both 'the sweetness and beauty of mankind's collective dream of an earthly paradise that would bring fulfilment to its deepest unconscious wishes', and, at the same time, the vanity and fragility of these wishes.

The central panel is meant to be read from its lowest level upwards. In the foreground are groups and couples, embracing, eating fruit (symbolic of lust); a few curious details, sometimes close in mood to the more *risqué* scenes on misericords, indicate that all is not innocent: a naked man seems to be plucking flowers from his partner's anus.

On the next level, there is a cavalcade of real and fantastic animals, urged on by naked riders, circling the Fountain of Youth. Passion is here more obviously evident. The riders spur their steeds forward, but it is their own animal natures which are now in control. Finally, we come to the Pool of Lust, out of which there rises the Fountain of Adultery. Through an opening at the base of the fountain we see a couple who have completely surrendered to their desires: the male reaches for his partner with an unequivocal gesture.

Though he treats his subject-matter with so much frankness, Bosch remains a medieval artist – indeed, we may even say that his particular kind of openness is characteristically medieval, rather than otherwise. It is significant that his female nudes conform absolutely to medieval type, not only in their physical proportions, but in the attitudes towards the body that they express. The body is shown naked, but essentially that nakedness is miserable rather than glorious; this is true even though, as the proportions tell us, its sexual possibilities are very much in the forefront of the artist's mind. If we compare Bosch's Eve, for instance, to the Venus in Botticelli's *The Birth of Venus*, we are aware that the goddess has a calm certainty, a trust in her own body, that Bosch's figure entirely lacks.

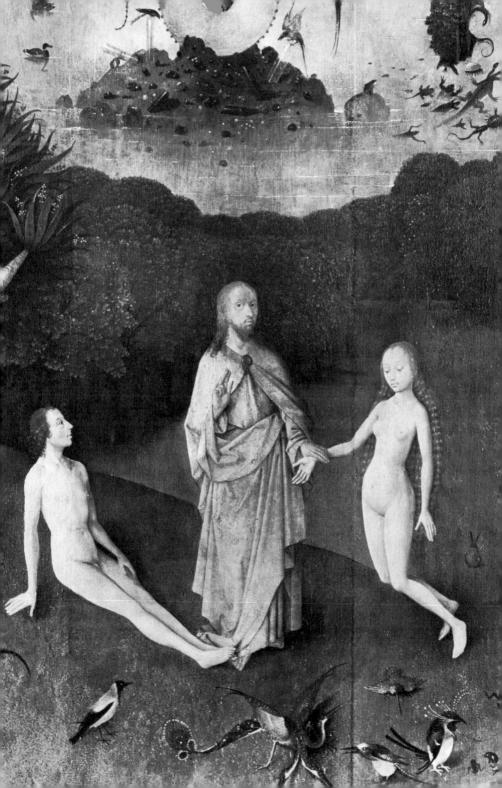

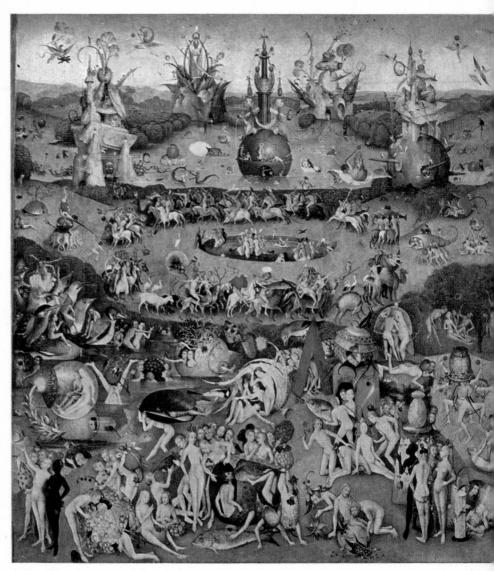

40 HIERONYMUS BOSCH, The Garden of Earthly Delights, c. 1500. Central panel

41 HIERONYMUS BOSCH, The Garden of Earthly Delights, c. 1500. Detail of central panel

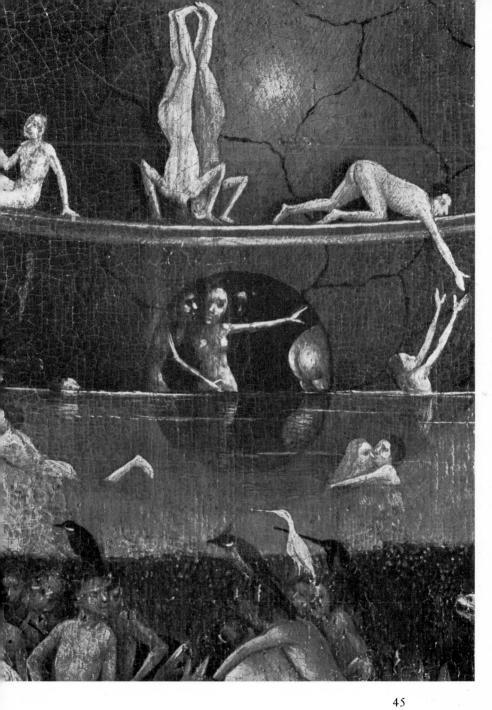

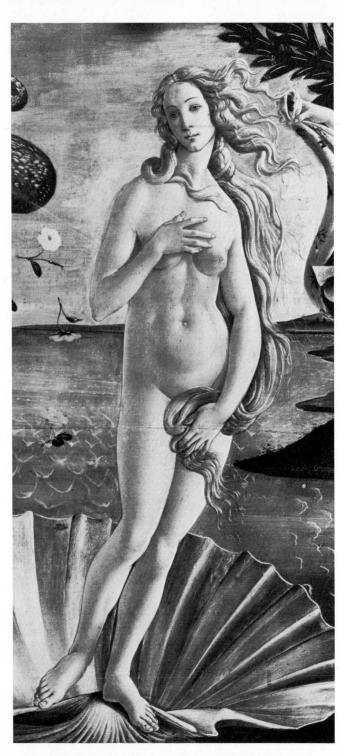

42 SANDRO BOTTICELLI, The Birth of Venus (detail), c. 1478

The new paganism

The Renaissance is often thought of as representing a return to pagan hedonism, after the Christian asceticism of preceding centuries. This is a notion which needs to be taken with a pinch of salt. The Birth of Venus, by Botticelli, is indeed the embodiment of ideas very different from those of Bosch; and a distinction must certainly be drawn between neo-Platonic philosophy, which supplies the programme for this mythological composition, and the more strictly medieval ideas about the cosmos and man's place in it which we find elaborated in The Garden of Earthly Delights. And yet although Venus is nude and, for all the modesty of her gesture, quite evidently unashamed of her nudity - Botticelli's picture is by far the less sensual of the two. If an erotic element is present, it is deliberately refined and etherealized. It comes as no surprise to discover that a very similar nude is the personification of Truth, in Botticelli's allegorical composition Calumny. Botticelli simultaneously accepts the nude as a subject and spiritualizes it.

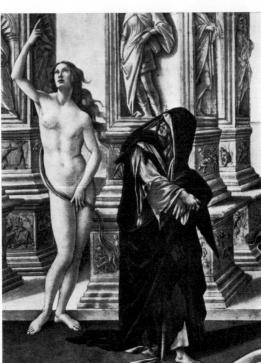

43 SANDRO BOTTICELLI, Calumny (detail), 1494–95

...

40

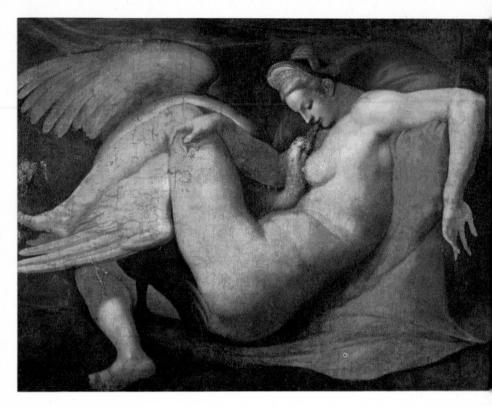

Of course, though Botticelli makes use of classical subject-matter, his forms are very far from being classical. His Venus gliding towards the shore upon her shell has any number of classical prototypes, but her body is essentially an arbitrary construct, a very personal reinterpretation of a standard late-medieval type. The real effort towards achieving a truly classical style in painting comes a little later in the history of Italian art – it is associated with the generation of Raphael, Leonardo and Michelangelo. In sculpture, however, we meet it sooner: in the work of Donatello. Two of Donatello's best-known works, both of them based upon antique prototypes, do in fact enable us to distinguish between the kind of classicism which is purely intellectual and programmatic, and the kind which is truly a matter of the overall style in which the work has been conceived. One of these is the *Attis-Amor*, and the other the *David*, both in the Bargello in Florence.

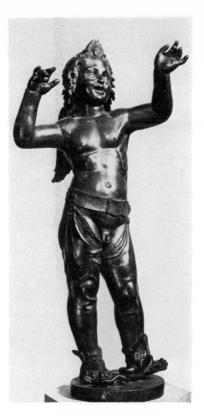

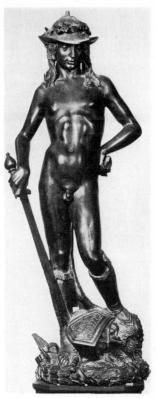

44 After MICHELANGELO, Leda and the Swan

45 DONATELLO, Attis-Amor

46 DONATELLO, David, c. 1430

The Attis-Amor has a complexity of reference which has not as yet been fully disentangled. The figure wears the open breeches of Attis, which both reveal and call attention to the genitals. In addition, it is equipped with a pair of wings, like Eros, and tramples a serpent underfoot, like the infant Hercules. The style brilliantly assimilates that of the Roman bronzes which the figure imitates, but it also has a preciosity which reminds us that this is indeed an imitation. We are aware, because of this quality, of the way in which it defies not only the stylistic but the moral assumptions of its own time, and this aggression constitutes its eroticism.

The David is rather different. Here the source is Hellenistic and Roman representations of Hermes, and the body has a combination of solidity and suppleness unknown since the fall of paganism. And despite such accessories as the hat and the sword (which often act to particularize a figure, and thus to accentuate any erotic quality it may

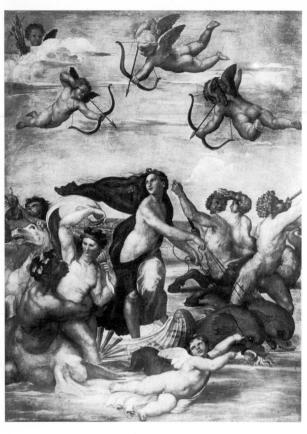

47 RAPHAEL, Triumph of Galatea, c. 1511

48 SODOMA, Marriage of Alexander, 1512

possess), this bronze has a self-containment which restrains any directly sexual response.

Raphael's *Triumph of Galatea* invites, I believe, the same reaction. Here the subject is overtly pagan, and the composition, moreover, is full of action and energy, both of which, again, are things which might lead us to expect that the impact of the work would be erotic. But this is not the case. The feeling is that all the elements – rhythm, colour, content, literary association – are here so fused that it is impossible to dissociate them. It all makes one *general* impression of harmony. I emphasize the word 'general' because, as I hope to demonstrate, particularity, and especially unexpected and therefore surprising compositional emphasis, is one of the most constant, and most easily spotted, contributory factors in the truly erotic work of art.

It is possible to illustrate the point immediately by citing another fresco in the Farnesina: Sodoma's Marriage of Alexander. Sodoma was a gifted provincial artist, drawn temporarily into Raphael's circle in Rome. But even though Raphael's was one of the easiest of all styles to absorb, Sodoma was sufficiently formed as a painter before he arrived in Rome to preserve certain quirks of his own. Compared to Raphael, he has a naïve love of illusion, and an equally naïve love of detail. Thus the two things which seem un-Raphaelesque about the fresco are the rather exaggerated emphasis on perspective, and the Cupid who draws the veil away from Roxana's breast. One cannot imagine that Raphael himself, had he undertaken the composition, would have found the latter conceit necessary to his purpose, and it gives the scene a specifically erotic character which one cannot find in the compositions which Raphael himself designed.

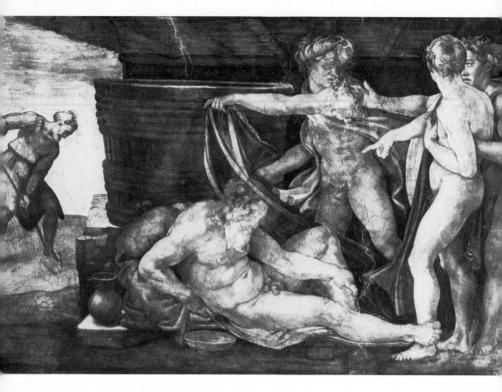

Of the great trio of High Renaissance masters, Raphael is, in the latter part of his career, the most consistently and steadily classical. Michelangelo, on the other hand, has something ambiguous and disturbing in his nature which readily breaks forth into erotic allusion. Thus, he will take a theme, such as *The Drunkenness of Noah* on the Sistine ceiling, which embodies the tension between fear and curiosity which sex often inspires (in his drunkenness, Noah exposes his genitals, a forbidden sight), and will treat it in a grandly generalized way which almost makes us forget the true content of the scene. Or he will take a far less loaded idea, such as the commonplace conjunction of Venus and Cupid, and will give it a powerful and even rather perverse eroticism.

Michelangelo's *Venus and Cupid* is, unfortunately, known to us only through copies, but even so it retains much of its power. In it, we already perceive the way in which things would develop during the second half of the sixteenth century, so far as European art was

49 MICHELANGELO, The Drunkenness of Noah, 1508–10

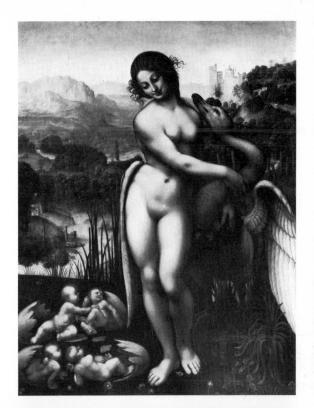

50 After LEONARDO, Leda and the Swan

51 SCHOOL OF MICHELANGELO, Venus and Cupid

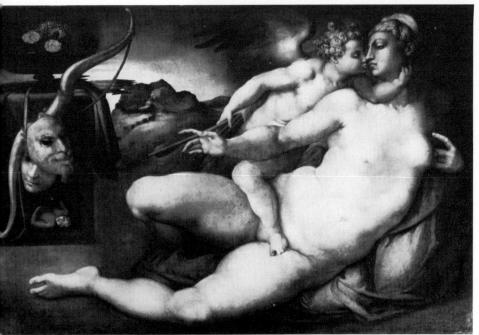

concerned. The relationship between the two figures is very far from being either filial or maternal, as perhaps we might expect. We see this at once, from the expressions of the two figures, and from the way in which they kiss. Two details help to complete the impression of avid sensuality: the position of Cupid's foot upon Venus' upper thigh, and the way in which her hand caresses the shaft of one of his arrows. The arrow is one of the commonest phallic symbols in all art – like the emblem of the fish, it has served as such since palaeolithic times.

44 50 Equally erotic was Michelangelo's *Leda* (again, like Leonardo's painting of the same subject, known to us only through copies). Both artists were influenced, Michelangelo perhaps more directly than Leonardo, by classical versions of the subject – a typical specimen is the Graeco-Roman relief in the British Museum which, some centuries later, was to inspire a famous sonnet by W.B. Yeats. But, where the relief is cool, descriptive, impersonal, the two sixteenth-

52 RAPHAEL, The Three Graces, c. 1500

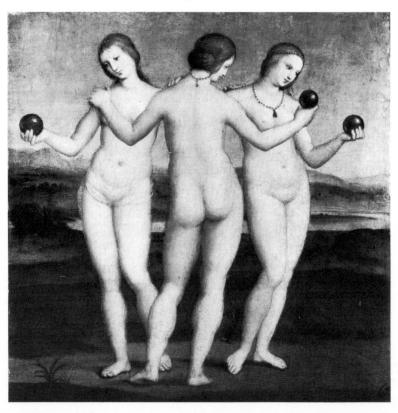

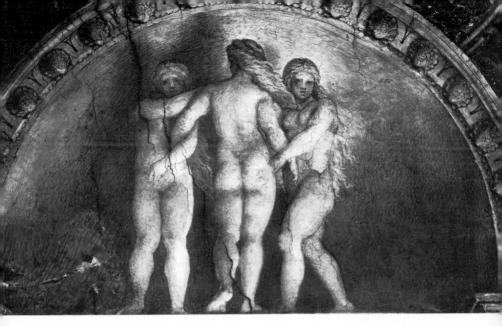

53 ANTONIO CORREGGIO, The Three Graces, c. 1518

century *Ledas* are, by contrast, feverish, and filled with a personal sensuality. The principal figure is in each case shown with violently contorted limbs, expressive (I feel) of a state of erotic unrest in the artist himself. In works such as these are to be found the beginnings of the great outburst of erotic energy which overturned High Renaissance ideals, and led to the triumph of Mannerism.

There is one other leading figure in Italian art of the early sixteenth century who deserves discussion – if only because his work makes a violent contrast with the grand classicism which intermittently prevailed in Rome and Florence. This is Correggio, who worked in Parma. Correggio's work has a delicate sensuality which seems astonishing for its period, and for the stylistic context in which we find it. If we compare, for instance, Raphael's little painting of *The Three Graces*, now at Chantilly, with Correggio's handling of the theme (admittedly somewhat later in date) in one of the lunettes of the Camera di San Paolo in Parma, the differences are striking. Both compositions are closely based upon a small Hellenistic group, but the alterations which Correggio makes in his source are all of them designed to call our attention to the attractions of these three goddesses considered simply as women.

Correggio is the author of a series of well-known mythological compositions – the Jupiter and Antiope in the Louvre; the Education of Cupid in the National Gallery, London; and the Ganymede and Io in Vienna. These prefigure the stylistic notions of the Baroque, and even of the Rococo, in a striking way. No composition by Boucher is more delicately sensual, more expressive of the idea of sexual surrender, than Correggio's Io; and this, painted about 1530, shows us that the attitude towards the body has changed in an astonishing way in the space of less than a hundred years. The nymph shown here is a very different kind of creature from the Bathsheba whom we see in the Hours of Marguerite de Coëtivy. Her body is not a cause for shame, but a delicately responsive instrument of pleasure.

On the other hand, perhaps it is misleading to invite a comparison between the work of an Italian and a northern artist. In the art of France, Germany and the Low Countries, the high classical phase of Italian Renaissance art was certainly influential, but its lessons were never fully absorbed. There was an almost immediate transition from the late medieval style to Mannerism. In one sense, this transition can

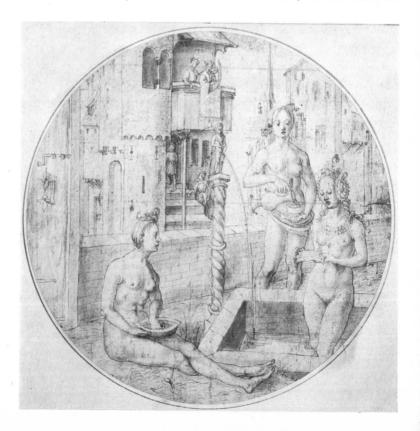

38

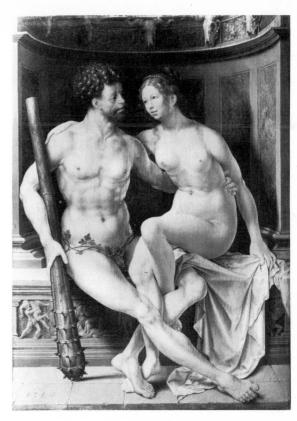

54 SCHOOL OF ANTWERP, Bathsheba Being Spied on by David, c. 1520

55 MABUSE, Hercules and Deianeira, 1517

be thought of as representing simply a further secularization of art, which had in any case, in the course of the fifteenth century, become increasingly secular. It is not a large step from the Bathsheba of the Hours of Marguerite de Coëtivy to the Antwerp Mannerist presentation of the same subject, dating from about 1520, which is illustrated here, though one would generally be classified as medieval and the other as Renaissance.

Even where the differences of style and spirit are more marked, the art of Northern Europe retains a characteristic awkwardness in its approach to erotic material, and this awkwardness often enforces the erotic force of a mythological image by giving it the particularity that I have already spoken of. A case in point is the beautiful *Hercules and Deianeira* by Mabuse. The lack of idealism in the physical types, and the slight clumsiness of pose and gesture, make the embrace itself more real. German and Swiss artists, especially, seem to have been

shrewd enough to exploit this element of awkwardness quite consciously, as appears from the allegorical drawing by Hans Baldung Grien illustrated here; its symbolism has been disputed, but one can hardly argue about the part played by the hobbling gait of the main figure in creating its piquant effect.

This drawing, like the Mabuse, looks forward to Mannerism without being Mannerist in the full sense of the term. True Mannerism had its roots in Italy – more specifically in Florence and Rome, which were also the centres of High Renaissance classicism – and gradually conquered the rest of Europe. Bronzino's Venus, Cupid, Folly and Time may serve us here as a fully developed example of a Mannerist composition. It has very visible links with the Michelangelo Venus and Cupid – but there are also significant differences. Cupid, here, is no longer a child, but an adolescent, and the kiss which he presses upon Venus' lips is an openly lascivious one. The bodies of the incestuous lovers are arranged so as to emphasize their erotic potentialities – Cupid kneels in a somewhat constricted position, so that his buttocks jut provocatively backwards; one of Venus' breasts is caught in the crook of his elbow, and he squeezes the nipple of the other between his first and second fingers.

The new style made an immediate appeal. One of the first countries outside Italy to feel its full impact was France, which, under François I, now looked towards Italy for guidance in all artistic matters. It was Italians – Rosso, Primaticcio, Niccolò dell'Abbate – who were the apostles of the new style. Working for the French court, they created a new, secular, hedonistic court style which drove out the last remnants of medieval art. Their school – the School of Fontainebleau as it is called, after the great palace which they decorated for the king – opted for allegorical and mythological subject-matter, as supplying the most suitable background for the life of a prince as different from his predecessors as François believed himself to be. The subjects favoured at Fontainebleau amounted to a declaration, on the part of the king and his courtiers, that emphasis was henceforth to be laid on the things of this world, rather than on those of the next.

Rosso was a Florentine, and, though little of his work at Fontainebleau remains in its original condition, there is enough evidence of various kinds to show the effect which his talent in particular had upon French and eventually upon European art. The print of *Pluto*, engraved by Caraglio after Rosso, is a case in point. Contrary to the

56

usual tradition, the god is presented as slim and youthful. The gesture with which he hides his face invites us to concentrate our attention on the body which is displayed before us, to the point of distracting us from the announced subject-matter of the representation. We have here, in fact, a relatively simple instance of the primacy of the nude in Mannerist art, and of the way in which the undraped body becomes the principal instrument of statement.

The tapestry of *Danaë*, woven after one of the decorations which Rosso designed for Fontainebleau, gives us an insight into what the Fontainebleau artists wanted to achieve. The central figure, a female nude, provocatively posed, represents the erotic ideal of the age, with her long limbs, small head, pert breasts and gently swelling stomach. Her immediate derivation is from the female nudes of Michelangelo, notably the *Dawn* in the Medici Chapel, but she is less massive, more candidly the predestined instrument of erotic pleasure. Her proportions, and the distribution of emphases, actually link her to medieval representations of the nude.

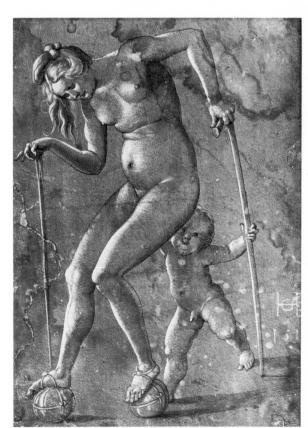

56 HANS BALDUNG GRIEN, Allegory, 1514–15

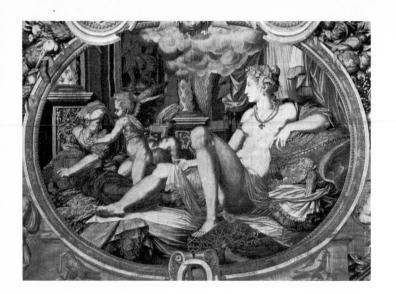

57 Tapestry after decorations by ROSSO, *Danaë*

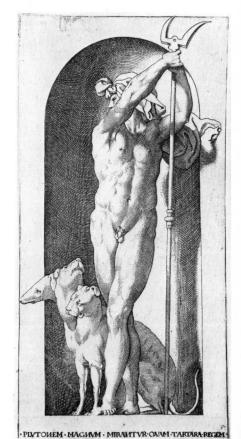

58 CARAGLIO, engraving after ROSSO, *Pluto*

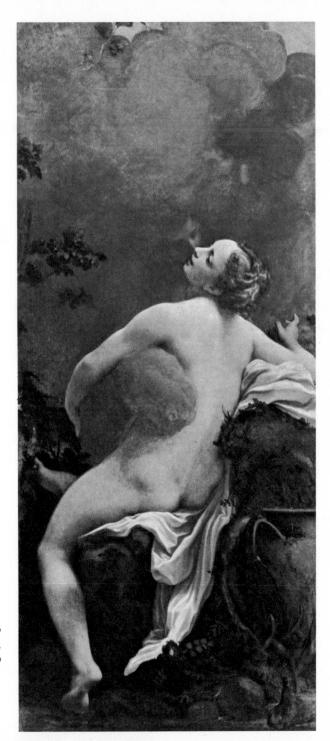

59 ANTONIO CORREGGIO, *Io*, c. 1530

60 MASTER OF FLORA, The Birth of Cupid, c. 1540-60

When artists who were French by birth took up the types favoured by the Italian Mannerists employed at Fontainebleau, they exaggerated the proportions still further – we can see an extreme case in the work of the so-called Master of Flora. From his work, we can gauge the way in which deliberate distortion simultaneously heightens and distances erotic responses. We experience the erotic stimulus, but nevertheless it remains safely controllable. The same can be said of

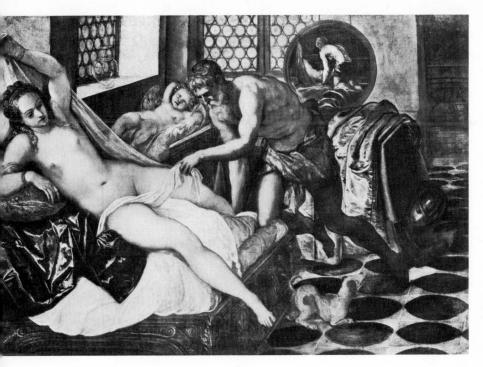

62 TINTORETTO, Vulcan Surprises Venus and Mars, c. 1551

three-dimensional works which have been subjected to the same process of distortion – witness the celebrated *Diana of Anet*.

Towards the end of the sixteenth century, artists all over Europe were engaged in creating erotic dream-worlds for their patrons. Though a single convention ruled, the stylistic boundaries were not wholly constricting. There was room within them for Tintoretto's *Vulcan Surprises Venus and Mars*, with its curious spatial organization and its rich bloom of Venetian colour; there was also room for the work of Bartholomäus Spranger, a Fleming who was court painter to the Emperor Rudolph II in Prague. Spranger's mythological paintings are among the most amusingly perverse products of international Mannerism. In his *Vulcan and Maia*, erotic feeling is skilfully created through a deliberate use of contrasts: the difference in age between the lovers, for example, and the way in which Maia is posed, held back by her partner, yet struggling in his grip so that her hips seem to swell towards us out of the picture-plane.

62

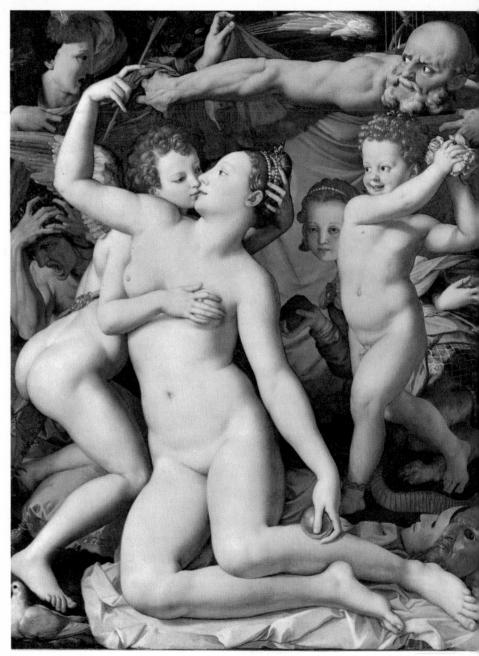

63 AGNOLO BRONZINO, Venus, Cupid, Folly and Time, 1545

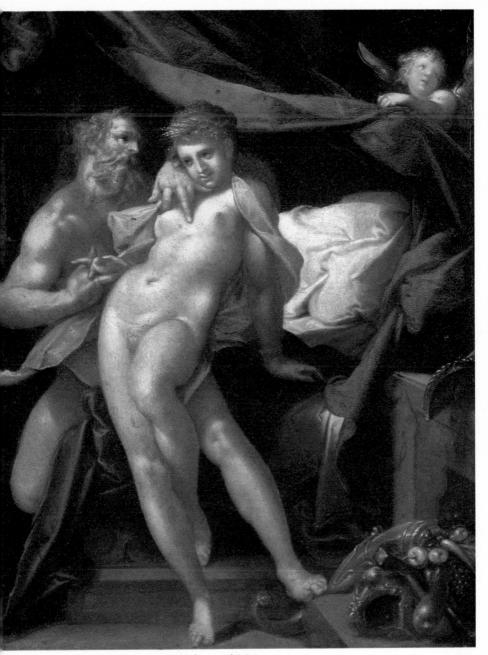

64 BARTHOLOMÄUS SPRANGER, Vulcan and Maia

Mannerist artists such as Spranger delighted in showing off their powers of composition, and their erotic ingenuity as well, by creating complicated groupings of nude figures. The male or female body here becomes a term in an elaborate pictorial grammar. Among the subjects which gave an excuse for this kind of virtuoso compositional exercise, the commonest were probably *Parnassus* and *Olympus* – Frans Floris's version is typical of late Mannerist taste. A rarer subject, but one which provided yet more specific erotic opportunities, was *The Golden Age* (otherwise, and more moralistically, dubbed *The Corruption of Men Before the Deluge*). Tackling this theme, Cornelis Cornelisz van Haarlem, another late northern Mannerist, took the opportunity to provide what is really a milder version of Bosch's *The Garden of Earthly Delights*. The composition is spiced with some

66

65

40

65 CORNELIS CORNELISZ VAN HAARLEM, The Corruption of Men Before the Deluge, c. 1596

surprisingly lascivious details of gesture and pose.

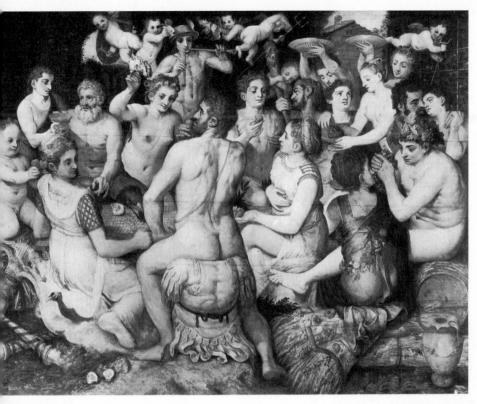

66 FRANS FLORIS, The Gods of Olympus

The erotic court art of Europe, as it existed during the sixteenth century, prompts a comparison with the court art of a contemporary but very different culture: the miniature paintings which were produced at various Indian courts from the end of the sixteenth until well into the nineteenth century. There are in fact many parallels with European Mannerism – the feeling for an exquisite closed world is much the same, and so is the technique of arousing erotic feeling through the use of sudden, unexpected emphases in the composition. The native Indian painters were in fact influenced by European art, through the medium of engravings.

Yet there are striking differences as well. For one thing, in Indian miniature painting we are immediately struck by the continuity between mythology and realistic (or at least genre) material; often it

67, 69–70

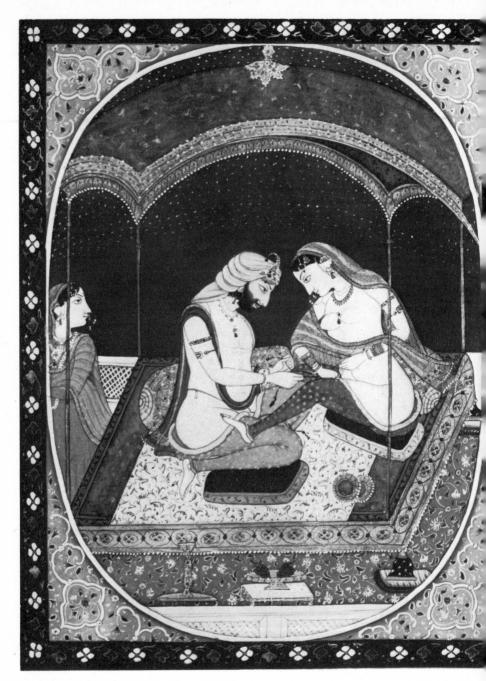

67 KANGRA SCHOOL, Erotic Scene, c. 1830

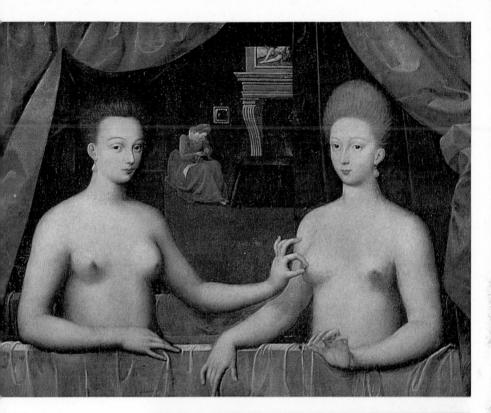

68 SECOND SCHOOL OF FONTAINEBLEAU, Gabrielle d'Estrées and the Duchesse de Villars, c. 1594

69 Lovers, from a series illustrating the Kama Shastra. Late eighteenth century

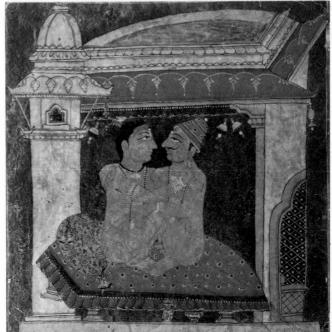

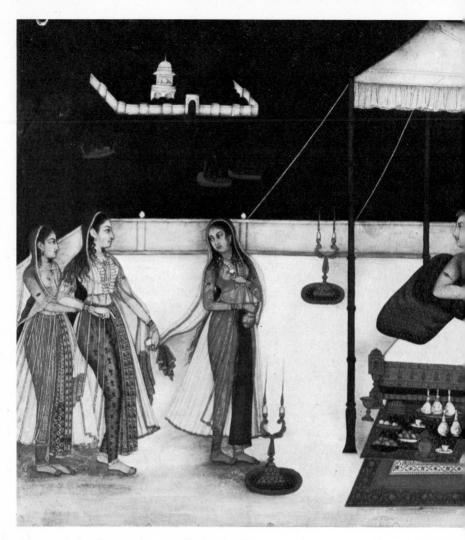

is hard to make any distinction between the two. But, however we classify it, a large part of the subject-matter of these Indian paintings is erotic. The scenes treated include those meant to illustrate the nature of the various ragas – the modes of Indian music. The subject chosen to match a particular mode will often be amorous; for example, a lady waiting for her lover. The story of Krishna is also a frequent choice for illustration, and here, too, there is a wide choice of erotic episodes. From miniatures such as these, we pass without a perceptible

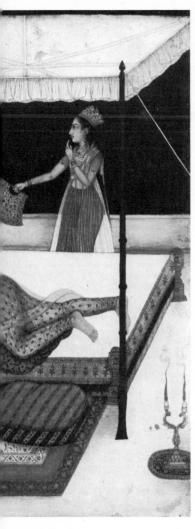

71 SCHOOL OF FONTAINEBLEAU, Lady at her Toilet, mid-sixteenth century

72 After LEONARDO, Nude Gioconda

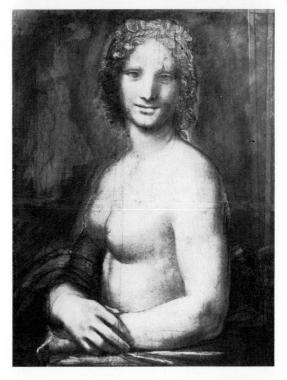

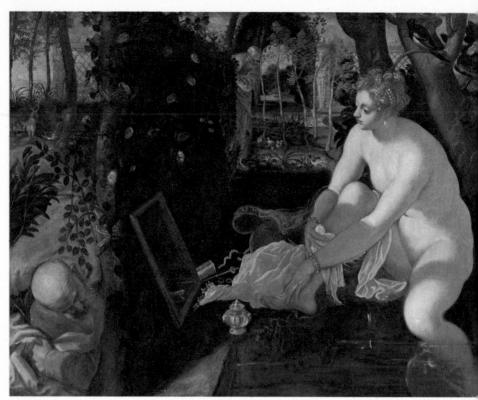

break in style to erotic genre scenes, some of the most beautiful of
which show a lady being led to a prince at night. And from these,
again, it is an easy progression to paintings which show lovers
caressing one another, like the delicious Sikh miniature illustrated,
or in the act of love.

The innocent sophistication of Indian princely art was difficult to achieve in Europe, thanks to the difference in the European religious and moral tradition. However, we do find some tentative approaches being made to it. For example, the artists of the School of Fontaine-bleau produced a number of half-length portraits of court beauties, based on the type of the *Nude Gioconda* which originated in Leonardo's studio. Two of the most charming – both by unknown painters – are the *Lady at her Toilet* in Dijon, and the double portrait of *Gabrielle d'Estrées and the Duchesse de Villars*. The two ladies are shown sharing

d'Estrées and the Duchesse de Villars. The two ladies are shown sharing a bath – with a bold gesture, one reaches out to squeeze the nipple of the other.

72

71

73 TINTORETTO, Susannah and the Elders, c. 1555

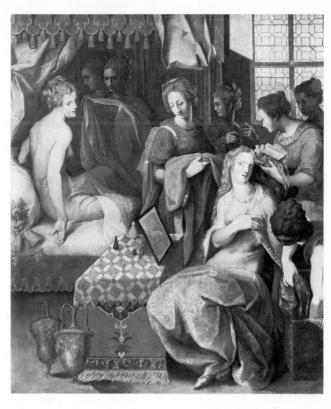

74 TOUSSAINT DUBREUIL, Lady Rising

More elaborate, and less successful as a work of art, is the *Lady Rising*, by Toussaint Dubreuil, one of the leading artists of the Second School of Fontainebleau, which flourished a whole generation later than Rosso and Primaticcio. Though the scene is apparently intended to be realistic genre, the painter is so much the prisoner of Mannerist pictorial conventions that little feeling of reality remains. The lady herself – seen twice over, first getting out of bed, and then at her morning toilet – is simply a more domesticated version of Rosso's Danaë.

In general, the artists of the sixteenth century in Europe were not yet ready to deal with eroticism through a confrontation with every-day reality. Indeed, as we shall see, this was something that continued to be difficult for European artists until comparatively recent times. The Renaissance strategy was to build up an erotic typology – a range of subject-matter through which erotic feelings could be expressed, and at the same time distanced. Some of these subjects

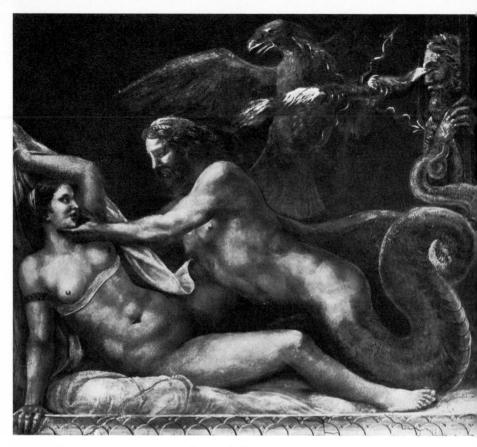

75 GIULIO ROMANO, Jove and Olympia, 1525–35

were drawn from the Bible, and from the lives of the saints: Lot and
His Daughters and Susannah and the Elders are typical examples. More
characteristic still of this typology are the 'pagan' subjects borrowed
from the Graeco-Roman world. So long as everything remained
safely in the realm of myth, sexual candour and harsh strength were
not excluded, as can be seen from some of the decorations which
Raphael's one-time chief assistant, Giulio Romano, painted for the
Palazzo del Tè in Mantua – the best-known instance of this is the
scene in the Sala di Psiche where Jove, disguised as a dragon, prepares
to ravish Olympia.

Eroticism and realism

Baldung Grien.

As the sixteenth century drew to an end, realism and the need for realism became important issues in the visual arts. Despite Mannerism's general tendency towards the allegorical and the fantastic, certain realistic tendencies did survive in the art of Northern Europe. This was especially true of the leading masters of the German Renaissance: Dürer's drawing of the *Women's Bath* is an often-cited example. The composition is not only realistic but positively voyeuristic; it is as if the artist had been peering at his subject-matter through a crack in the wall of the bath house. The drawing and the print make a fascinating and instructive comparison with *Le Bain turc*, by Ingres.

, ,

We may also include here, as it treats a similar kind of scene, one of the surviving fragments of the *Imperial Bath* fresco by Altdorfer. This shows an unclothed couple embracing, and is a bolder variant of the embrace theme which occurs quite frequently in the German and Swiss art of this period. Often, however, the artist is careful to take up a moral stance, usually by showing us a young woman who is being embraced by an old man, and who is exploiting her suitor's ardour in order to rob him of his money. There are a number of half-length two-figure compositions of this sort by Lucas Cranach; and an especially piquant version occurs in an engraving by Hans

185

Subsequently, too, a long series of moralistic-erotic works of this sort were produced, not necessarily by German artists. An amusing example is the School of Fontainebleau picture showing *Woman Between the Two Ages of Man*, which is now at Rennes.

80 78

Looked at from one point of view, all these attempts at realism were part of the heritage which northern artists in particular received from the Middle Ages. Thus, Pieter Bruegel the Elder, in his genre scenes, continues to make use of themes which were employed by the Limbourgs in the calendar pages of the *Très Riches Heures* of the Duke

of Berry. Bruegel's Seasons have the same function as the Limbourgs'

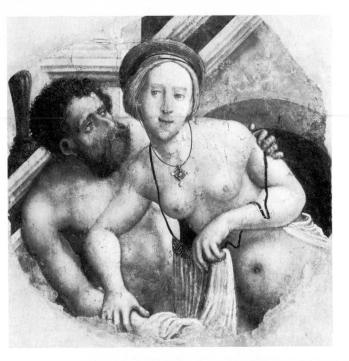

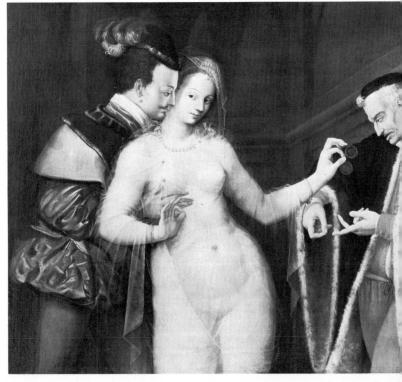

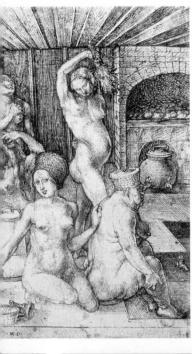

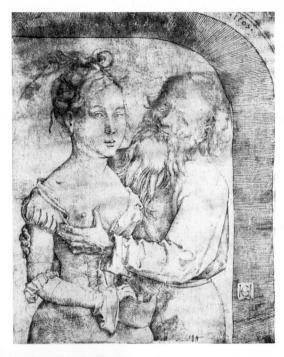

76 ALBRECHT ALTDORFER, *Imperial Bath* (detail)

77 ALBRECHT DÜRER, Women's Bath, 1496

78 HANS BALDUNG GRIEN, Old Man and Young Woman, 1507

79 SCHOOL OF FONTAINEBLEAU, Woman Between the Two Ages of Man

80 LUCAS CRANACH THE ELDER, *Ill-Matched Couple*, c. 1595

Months: they supply the aristocratic patron with a glimpse of a world very different from his own.

The realistic impulse which seized hold of Italian art during the last decade of the sixteenth century, and then spread elsewhere – to Flanders and to Spain, for example – was something rather different. It was a genuinely revolutionary attempt to overthrow some of the basic assumptions of Mannerism. Art now tried to define life as it really was, rather than present a remote dream-world. We see this impulse at work in the painting of artists otherwise as different as Caravaggio, Rembrandt, and the young Velázquez. Not that artists immediately lost their sense of humour. Early Baroque art has a distinctly sardonic side, especially in Italy. Some of the works illustrated in this book cannot be fully understood unless we know that they have an important element of parody: Caravaggio's St John the Baptist pokes fun impartially at Michelangelo's nudes in the

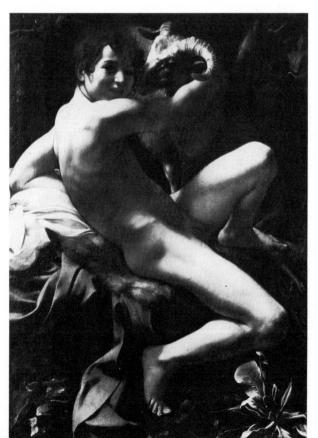

81 CARAVAGGIO St John the Bapti c. 1595

Sistine, at accepted morality and at established religion; Lanfranco's Young Boy on a Bed cocks a snook at the great Venetians. But artists were nevertheless not prepared to renounce everything which the sixteenth century had achieved. The new Baroque style was also motivated by a desire to reconsider the classical grammar of types and forms which the Renaissance had borrowed from the Graeco-Roman world: artists such as Annibale Carracci and his brother Agostino wanted to see if this grammar could be more correctly and logically used than it had been by Raphael's successors.

Finally, and this is the quality which we most commonly associate with Baroque painting and sculpture, there was a new kind of sensuality in art, more direct and more opulent than that of the Mannerists. It was as if men had begun to trust their senses more. The result was a blurring of the strict division between body and spirit which Mannerism had often been at pains to establish. Baroque artists gradually discovered a unified pictorial language, valid for sacred and secular scenes alike. In this respect they learned a great deal from the Venetian painters of the sixteenth century, and a great deal more from Correggio, perhaps the most sensual of all the great masters of the High Renaissance.

The result of these tendencies is that erotic feeling is diffused and generalized through nearly all the characteristic products of the Baroque. Sometimes it remained upon this level of generalization. Annibale Carracci's imagery on the ceiling of the Farnese Gallery, for example, is rich in nudes, but these nudes have the grand impersonality already achieved by Raphael in the *Galatea*. But other leading painters produce work which is more directly and specifically sensual. A case in point is Rubens.

Rubens, of all the painters who ever lived, is perhaps the one who best understands the use of erotic feeling as a component of great art. It is not simply that, being very prolific, he exploited the full resources of the mythological vocabulary, so that erotic typology can be very fully illustrated from his work. It is also that his technique appeals so powerfully to the senses. Sir Joshua Reynolds has left us an excellent description of the effect made by his paintings:

'The productions of Rubens', says Reynolds, in his *Journey to Flanders and Holland*, '... seem to flow with a freedom and prodigality, as if they cost him nothing; and to the general animation of the composition there is always a correspondent spirit in the execution

212

59

47

83, 251

82 DOMENICO FETI, Hero and Leander

of the work. The striking brilliancy of his colours, and their lively opposition to each other, the flowing liberty and freedom of his outline, all contribute to awaken and keep alive the attention of the spectator; awaken in him, in some measure, correspondent sensations, and make him feel a degree of the enthusiasm with which the painter was carried away. To this we may add complete uniformity in all parts of the work, so that the whole seems to be conducted, and grow out of one mind; everything is of a piece and fits its place.'

This verdict can be tested on painting after painting, and the important thing is that it applies as aptly to the *Small Last Judgment* in Munich as it does to an openly erotic painting such as the portrait of *Hélène Fourment in a Fur Robe*. In religious and secular paintings alike, sexual feeling is emphasized and thrown into relief by the rich sensuality of Rubens's technique.

The same can be said of much of the painting produced during the seventeenth century in Italy. When we look, for instance, at Domenico Feti's *Hero and Leander*, the central and most important group in which is a kind of secular *pietà*, with the body of the drowned hero borne by naked sea-nymphs, it is difficult to know whether we are reacting simply to their nakedness, or to the painterly quality of the brushstrokes of which they are composed.

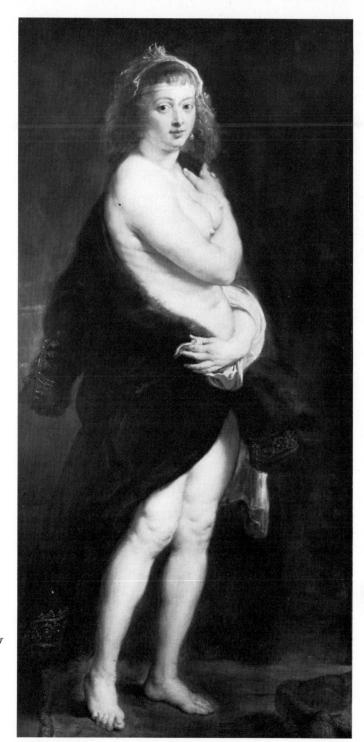

83 PETER PAUL RUBENS, Hélène Fourment in a Für Robe, c. 1631

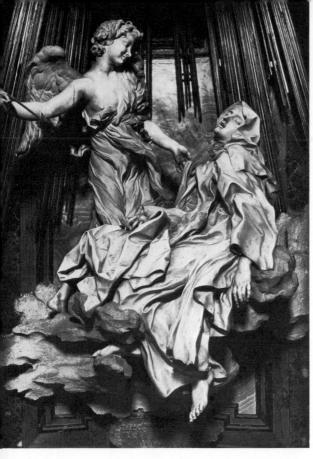

84 GIANLORENZO BERNINI, The Ecstasy of St Teresa, 1645–52

The association of sacred and profane iconography in this work is highly characteristic of Baroque art. Depicting Tancred Succoured by Erminia, the Lucchese artist Pietro Ricchi uses a formula which more commonly serves for St Sebastian Tended by Holy Women, or for The Good Samaritan. A yet more striking ambiguity occurs in Bernini's The Ecstasy of St Teresa, where the saint in ecstasy is also a woman in orgasm, and the arrow with which the angel is about to strike her is not merely an emblem of divine love but also a symbolic phallus.

Nor was ecstasy tinged with eroticism reserved for saints. We can compare St Teresa's pose and expression in Bernini's sculpture with that of Cleopatra, in the strange and beautiful *Death of Cleopatra* by the Florentine painter Sebastiano Mazzoni. Here, too, the protagonist seems to be in the throes of sexual climax, and the asp that strikes at her breast is as candidly phallic as the angel's arrow.

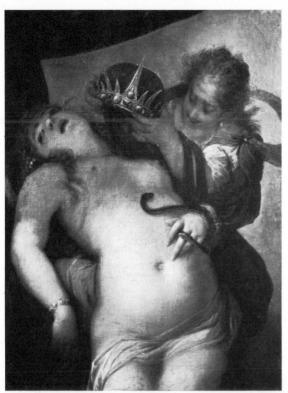

85 SEBASTIANO MAZZONI, Death of Cleopatra

86 PIETRO RICCHI, Tancred Succoured by Erminia

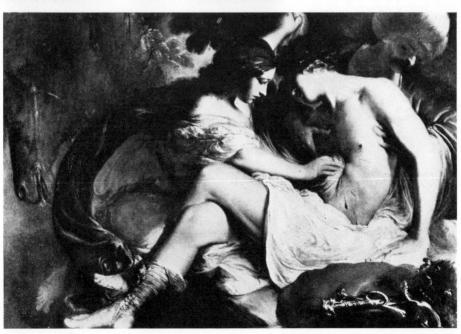

Mazzoni's painting can also serve as an illustration of a further tendency in Baroque art – the frequency with which it expresses sado-masochistic fantasies. This is, in fact, something very characteristic of European art as a whole. If we allow our definition of eroticism to be affected – as clearly we should – not merely by what is shown in a particular painting, but by the whole atmosphere that it conveys, then we must in honesty admit that some of the most highly erotic works by Baroque masters show either martyrdoms or incidents from the Passion. The disturbing Murillo of a rarely chosen subject, *Christ After the Flagellation*, is a case in point.

87

88

Only rarely, however, does Baroque painting seem to break through into what we, in the twentieth century, would recognize as an absolutely specific world of feeling. The outstanding exception to the rule is undoubtedly Caravaggio. His homosexual predilections find overt expression at the beginning of his career, in the series of fancy portraits of boys which culminates in the epicene *Bacchus* in the Uffizi. Even when Caravaggio's disclosures about himself are less

87 BARTOLOMÉ ESTEBAN MURILLO, Christ after the Flagellation, 1650–70

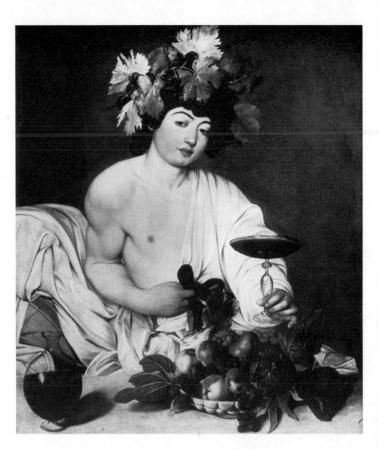

88 CARAVAGGIO, Bacchus, 1593–94

direct, his imagery continues to betray him. In the first version of St Matthew and the Angel, formerly in Berlin and now destroyed, it is not certain whether the ragamuffin angel is instructing the saint or attempting to seduce him. The picture, originally commissioned for San Luigi de'Francesi in Rome, was rejected by the priests of that church on the grounds (to quote a contemporary source) that 'it was not proper, nor like a saint, sitting there with his legs crossed, and his feet rudely exposed to the public'.

If we look first at these Caravaggios, and then at a standard Baroque version of a theme from Ovid's *Metamorphoses* – for example, Francesco Albani's *Salmacis and Hermaphroditus* – which seems the more genuinely erotic? The answer, surely, cannot be in doubt. Eroticism is not merely a question of imagery, but something which the artist himself brings to his subject-matter, and which he embodies

89

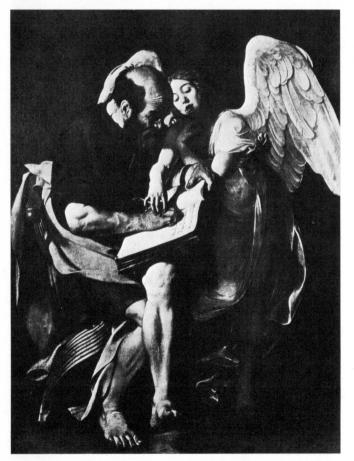

89 FRANCESCO ALBANI, Salmacis and Hermaphroditus, c. 1628

> 91 PETER PAUL RUBENS, Ganymede, c. 1636

> > 92 CARAVAGGIO, Amore Vincitore, 1598–99

90 CARAVAGGIO, St Matthew and the Angel, 1597–98

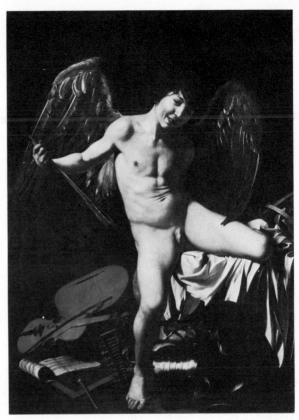

through the relationship created between the various figures, and through the very details of form. A painting showing an angel embracing an elderly apostle can be chaste or unchaste, very much in accordance with the way in which the painter chooses to inflect the scene.

This view is immensely reinforced by making comparisons between works where the question of sexual temperament is obviously crucial. The joyously heterosexual Rubens, asked to paint a *Ganymede*, makes Jove's minion into a plump youth who is as much like a woman as possible. Caravaggio's *Amore Vincitore* – a very convincing Roman urchin decked out in very unconvincing property wings – tells a different story. His level look simultaneously proffers an invitation and utters a warning.

91

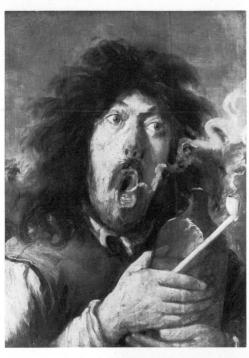

95 JAN STEEN, *The Trollop*, c. 1660–65

93 ADRIAEN BROUWER, The Smoker, c. 1628

94 NICOLAES MAES, Lovers with a Woman Listening

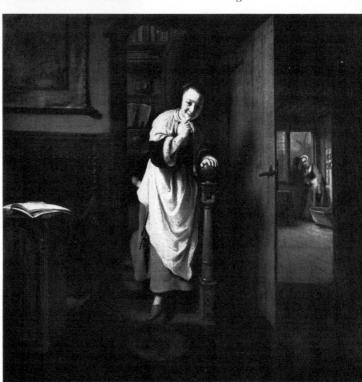

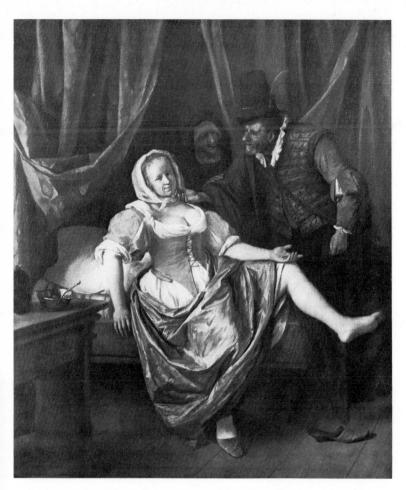

One reason why these compositional inflections become so important in seventeenth-century art is because of the changed attitude towards the enjoyment of the body. Essentially, this is what Reynolds meant about Rubens, and we can find this change of attitude reflected not only in the exuberance of the Baroque, but also in the genre painting which flourished in Protestant Holland, then at the very peak of her economic power.

The paintings which Dutch artists produced during the seventeenth century for a prosperous bourgeois clientèle are, at first sight, very different from the religious paintings and mythological compositions typical of Catholic Italy and, to a lesser extent, of Catholic Flanders.

Yet at some deeper level, these contrasting approaches to art have something in common. They represent a far more candid acknowledgment than had previously been possible of the body's capacity to give pleasure.

An artist who serves as a bridge between the apparently very different impulses of Dutch and Flemish art is Adriaen Brouwer, nominally Flemish, but very close in subject-matter and in attitude to his Dutch contemporaries. The difference is, perhaps, that Brouwer, especially towards the end of his brief career, tries to involve the spectator in a more intimate way than a Dutch painter would. We feel this when we look at the well-known picture in the Louvre of a boor smoking and drinking. In the seventeenth century, tobacco enjoyed something of the reputation which marijuana enjoys today, and there is a whole group of pictures by various artists devoted to the subject of the 'pipe drunkards'. Brouwer's is perhaps the most vivid presentation of this theme; the picture is a powerful image of oral gratification. It is an easy step, from the psychological point of view, from a work such as this to the opulent still-lifes of the period.

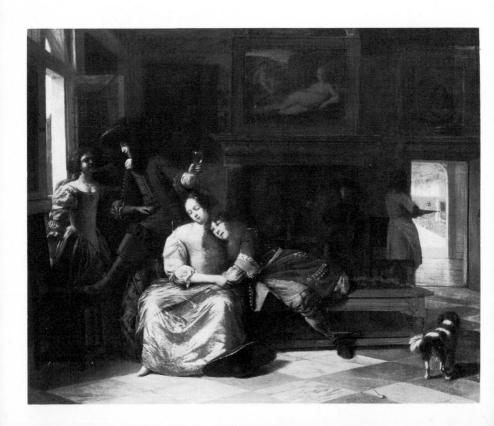

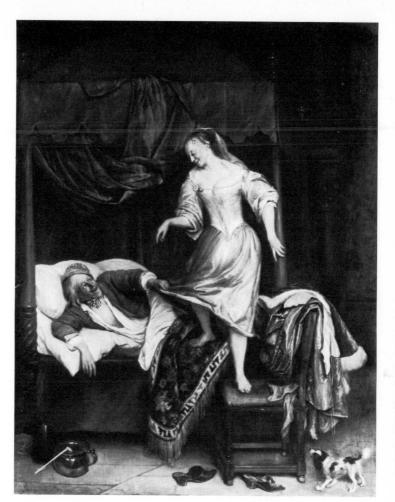

97 JAN STEEN, Bedroom Scene

In the circumstances of the time it is not surprising to discover among Dutch artists a copious production of realistic erotic works. There is frequent mention of brothel scenes in inventories. Unfortunately, thanks to the prudishness of subsequent ages, pictures of this type have survived in smaller numbers than those showing more innocent scenes. Jan Steen, on the remaining evidence, seems to have had a particular liking for libertine subject-matter – one can point to his *Bedroom Scene*, in the Bredius Museum, which shows a man pulling his maidservant into bed with him, to the slyly satirical *The Shepherd's Admonition*, where a priest converses with a whore through the open

window of a tavern-cum-brothel, and also to *The Trollop* in Saint-Omer, which gives a deadpan version of a favourite moralizing subject – the prostitute, her client, and her attendant bawd. Nicholas
Maes's *Lovers with a Woman Listening* scarcely qualifies as erotic, but does tackle a subject in which French eighteenth-century artists were
to find libertine possibilities, and the Pieter de Hoogh *An Interior with Gay Company*, which was recently on the London art market, gives at least a hint of what some of the vanished brothel pictures may have been like.

There is a striking resemblance between the range of subjectmatter to be found in Dutch genre pictures of this sort, and that used in the erotic or semi-erotic prints produced by masters of the *ukioye* school in Japan. This is not a coincidence: the Dutch painters of genre and the Japanese printmakers catered for a very similar public, a newly enriched bourgeoisie with an insatiable appetite for the pleasures and astonishments of 'real life'. It may seem at first that the Japanese were much readier to overstep the bounds which the Dutch masters set for themselves. Utamaro's elegantly outrageous compositions appear to reflect the manners of a society far less deeply

98 UTAMARO, Two Lesbians, c. 1788

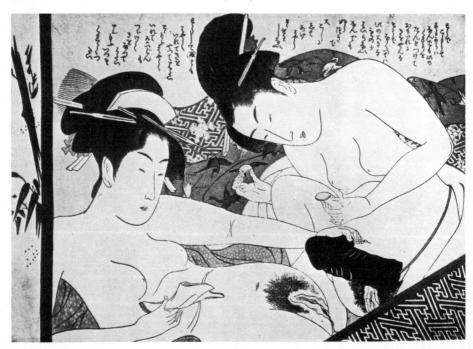

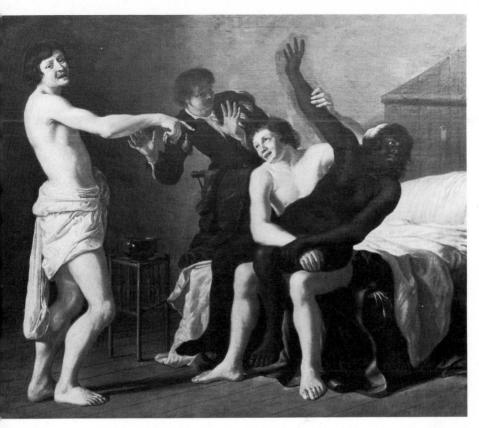

99 CHRISTIAEN VAN COWENBURGH, The Rape of the Negress, 1632

imbued with the puritan ethic than that of Holland a hundred years earlier. But it would be unsafe to assume that puritanism always triumphed so easily among the rumbustious Dutchmen of the time.

Extremely candid works have occasionally survived. The Rape of the Negress, by the minor painter Christiaen van Cowenburgh, is a case in point. Here a young man is violating a screaming Negress, while his two companions look on. Yet it must be admitted that there is, even in this, a nod to the religious tradition, such as we find in Baroque pictures of secular subjects in Italy at the same period. The gestures made by the rapist's companions are a clear case of the devil quoting scripture to serve his own purpose – the figure in the background would be just as much at home in a Raising of Lazarus.

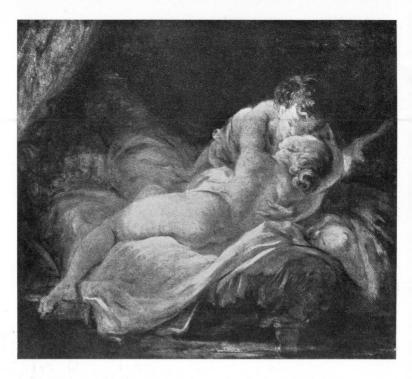

The French of the eighteenth century, who took over and continued to develop the possibilities of erotic genre, were cleverer than the Dutch at producing work which, if unvarnished enough in some cases, still possesses an irresistible wit and charm.

French erotic genre is in fact a blend of two traditions, the Flemish and the Dutch. On the one hand there is the kinetic energy and physical exuberance inherited from Rubens – we find this exemplified, for instance, in Fragonard's *The Happy Lovers*, a dashing piece of brushwork which is extremely unspecific as to setting, since the painter is clearly more interested in conveying feelings than facts. On the other hand, there is a Dutch feeling for the where and when of erotic situations and encounters, such as we see in Watteau's justly celebrated *A Lady at her Toilet* – a work with a complex and paradoxical parentage, as the artist's sources seem to have included the female nudes of Rubens, one or other of a series of Classical Greek gems which employ a similar motif of a girl putting on or taking off a filmy garment, and a painting by Jan Steen where the girl is clothed but busy pulling on her stockings.

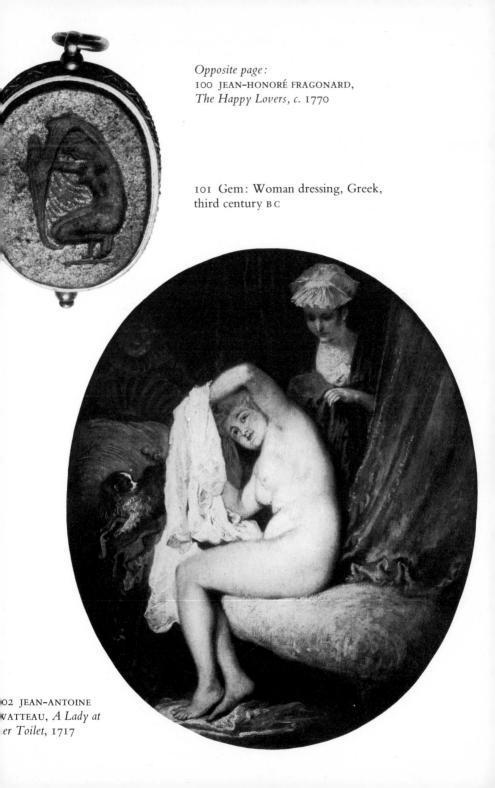

Like everything Watteau did, A Lady at her Toilet is exceptional. We get a better notion of the formulae commonly employed by eighteenth-century French artists by looking at the work of a minor painter like P. A. Baudouin, who was François Boucher's son-in-law, and who specialized in elegantly erotic genre scenes. His Morning and Evening achieved great popularity thanks to the engravings that were made after them. Morning exemplifies the degree of moral ambiguity present in many of Baudouin's compositions. A young girl lies asleep on her bed, her shift drawn up so as to expose her crotch. A young man dressed as an abbé enters the room. With him is a boy whom he tries to shield from this candid display of the female anatomy. There is a kind of prurience here; innocence is stressed and yet violated. The French public of the time found the mixture extremely acceptable.

No one was more skilful at serving it up than Jean-Baptiste Greuze, whom the critics of his own day – though Diderot, the shrewdest of them, had his reservations – tended to see as a moral storyteller par excellence. The many versions of The Broken Pitcher lay a morbid stress on the idea of the departure of innocence. The protagonist seems in fact to be too young to have lost this quality unless it has been forcibly taken from her – the 'rape' theme, which I shall discuss later (p. 192), thus plays an important part in Greuze's work. A more elaborate erotic composition, The Two Sisters, is more candid: two girls, just passing from childhood to womanhood, mark the signs of the change in their bedroom mirror.

103 JEAN-BAPTISTE GREUZE, The Two Sisters

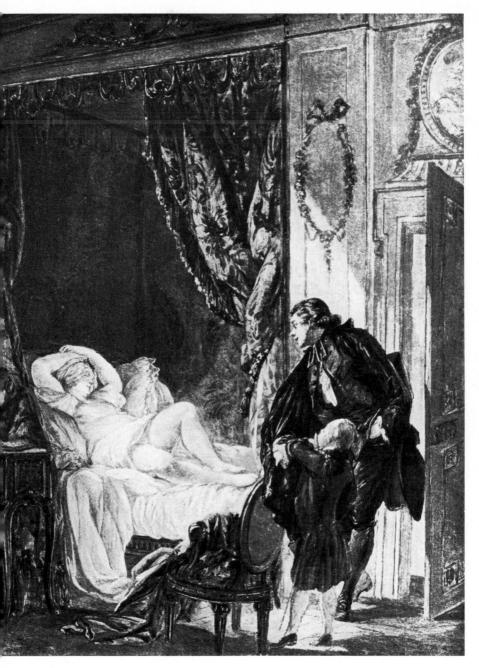

104 pierre antoine baudouin, Morning

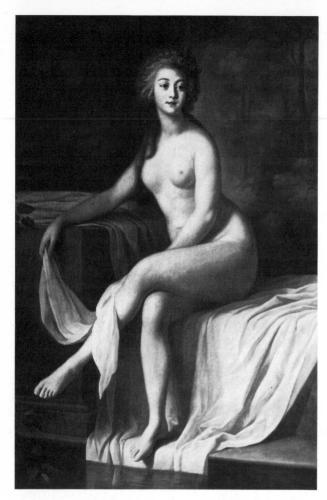

105 ANTOINE VESTIER, Mademoiselle Rosalie Duthé, ?1772–80

Boucher, usually thought of in his own day as a thoroughly immoral artist, one who traded heavily on his power to arouse erotic feeling, tends to be far less specific in his symbolism than Greuze. To some extent, he reverts to the Mannerist tradition, especially in his mythological paintings, where his female nudes conform to a generalized type, which, like all types, has much less power to arouse the erotic imagination than something absolutely specific. We can see the difference if we compare one of these mythological nudes with a representation in which Boucher is not generalizing quite so much – for example, the nude portrait of Mademoiselle O'Murphy,

one of the mistresses of the insatiable Louis XV. Of course, it is plain that the two girls are sisters, or, rather, that Mademoiselle O'Murphy approaches closely to the painter's ideal of what a desirable young woman should look like. But she still, in this picture, retains sufficient traces of individual identity to make one wonder what it would be like to go to bed with *her*. The same is true of another delightful portrayal of a royal mistress: Antoine Vestier's nude portrait of Mademoiselle Rosalie Duthé, a dancer who was for a while protected by the Comte d'Artois, younger brother of Louis XVI.

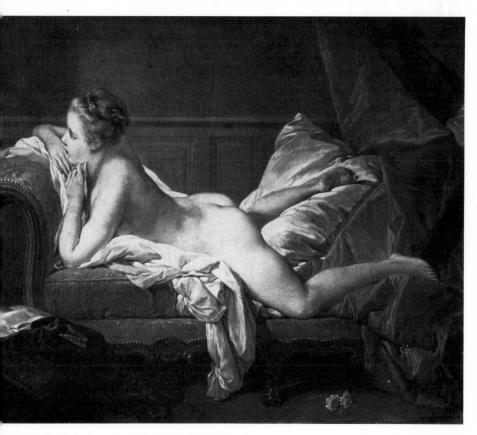

106 François Boucher, Mademoiselle O'Murphy, 1751

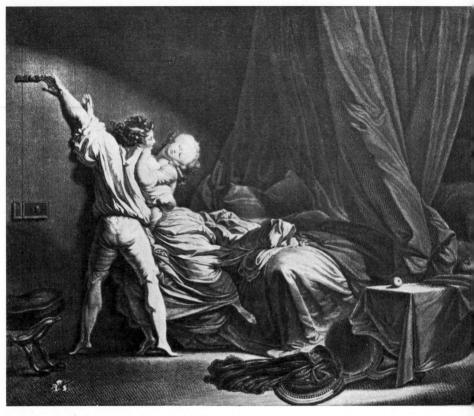

107 JEAN-HONORÉ FRAGONARD, The Bolt. Engraved by M. Blot, 1784

A third major figure of the French eighteenth century, perhaps more genuinely gifted than either Boucher or Greuze, was Jean-Honoré Fragonard. Fragonard is franker in his eroticism than either of his rivals, more libertine in temperament, more ingenious in devising titillating incidents and suggestive symbolisms. *The Swing*, which is the best known of his erotic works, was not wholly Fragonard's own creation – the client gave fairly strict instructions as to what was required: his mistress was to be shown seated on a swing pushed by a bishop, with himself lying on the ground, in a position enabling him to look up the girl's skirts (it must be remembered that this was an era when drawers had not yet been invented). Ironically enough, *The Swing* has now become one of those museum classics

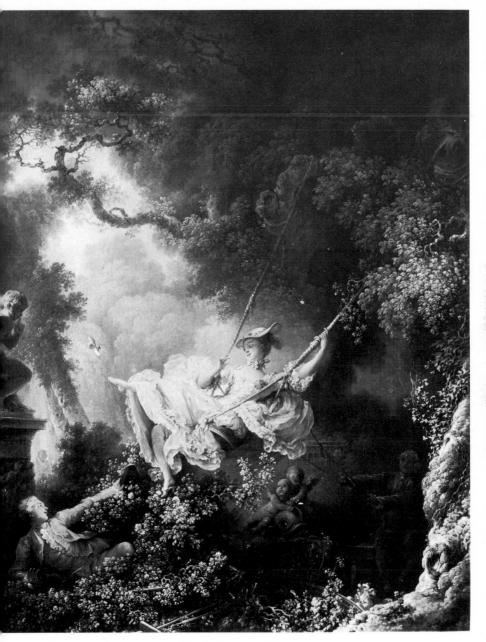

108 Jean-Honoré Fragonard, The Swing, c. 1766

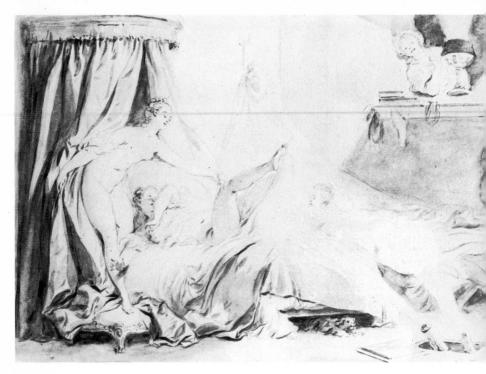

109 JEAN-HONORÉ FRAGONARD, Waterworks, before 1777

which nobody is disposed to think ill of. Hundreds, if not thousands, of schoolchildren must come to look at it every year, with the full approval of teachers and parents. This, in a way, is a tribute to Fragonard's skill as an artist; to the way in which he has managed to assimilate this apparently intractable brief, and to produce, without straying from it, something which is all gaiety, charm and lightness.

The more outspoken of his bedroom scenes retain a greater power of arousal. *The Bolt* is both ingenious and ingenuous: the lover bolts the bedroom door, in preparation for the fray, while his girl tries to restrain him. The bolt itself is certainly specific enough as a male/female symbol. Symbolism also plays an important role in *Fireworks* and *Waterworks*, two compositions based on the notion of traditional practical jokes which also have symbolic erotic content. The girls startled by the fireworks forget their modesty, and display them-

107

110

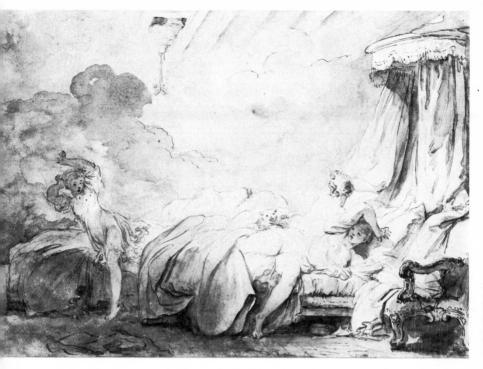

110 JEAN-HONORÉ FRAGONARD, Fireworks, before 1777

selves in provocative postures; the fireworks are metaphors for the explosions of orgasm.

Similar devices are sometimes employed by Fragonard's contemporary Thomas Rowlandson in England, though Rowlandson also draws upon the censoriously moralistic tradition of Hogarth – and he responds, too, to the need felt by many English artists to establish the social context of any given activity. Thus a drawing like *The Old Client* is *about* eroticism, rather than strictly speaking erotic – it reports on the activities to be witnessed in a high-class brothel, without trying to arouse a feeling of identification. Exactly the same thing might be said about the tavern-scene in Hogarth's *The Rake's Progress*; the young prostitute taking down her stocking in the left foreground is merely one term in an equation whose sum total is social, financial and moral ruin.

112

In the English art of the eighteenth century, real commitment to erotic feeling is to be discovered, not in Rowlandson's drawings—though some of these do indeed express a candid appetite for sex, a kind of gluttony which corresponds to the gluttonous habits in eating which prevailed at the time—but in the caricatures of James Gillray. In Gillray, sex and punishment go together; to represent sexual activity is to punish it. *Ci-devant Occupations*, a caricature in which Madame Tallien and Josephine Beauharnais (soon to become the Empress Josephine) are represented dancing naked before Barras, the Directoire statesman and reputed lover of both of them, while Napoleon peers at the scene from behind a curtain, is a case in point; though by Gillray's standards it is a comparatively mild one.

112 THOMAS ROWLANDSON, The Old Client

113 WILLIAM HOGARTH, The Rake's Progress (detail), 1732-33

III JAMES GILLRAY, Ci-devant Occupations, 1805

ci devant Occupations or Madame Talian and the Emprels Josephine denoing Naked before Barrefs in the Winter of The Emprels Josephine denoing Naked before Barrefs in the Winter of The State of State and State of State of State and State of State and State of State and State of State of State of State and State of St

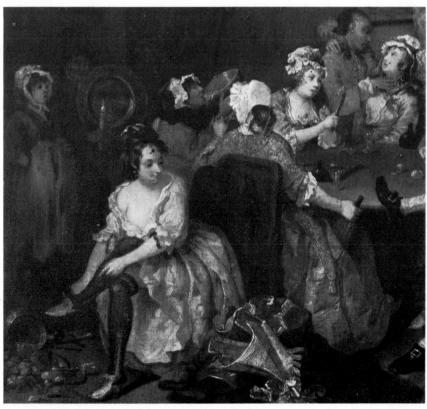

114 JAMES GILLRAY, Lubber's Hole – Alias the Crack'd Jordan, 1791

Caricaturists, as opposed to 'fine artists', were not bound by the conventions of realism. They could distort observed reality as much as they liked, for the sake of the message they wanted to convey. Occasionally, Gillray's work seems to anticipate the wild metamorphoses of twentieth-century Surrealism. A case in point is a lampoon on the naval Duke of Clarence, a younger son of George III who in due course was to reign as William IV. The Duke had taken an actress named Mrs Jordan as his mistress, and the drawing is a satire on this liaison. Entitled *Lubber's Hole – Alias the Crack'd Jordan*, it has many layers of visual/verbal punning, alluding not only to the slang meanings of the words 'crack' and 'hole', but also to the fact that 'jordan' was then used as another word for chamber-pot.

Gillray's satiric world has something excessive and obsessive about it. In its nightmarish quality it occasionally seems to anticipate the Romantics, and it is somehow not surprising to learn that the artist eventually went mad. Yet, though *Lubber's Hole* may in many respects seem to belong to a very different erotic and artistic world from that of the genre scenes of Fragonard and Baudouin, it does at least have one thing in common with the work produced by these Frenchmen. Artists in the eighteenth century were able to employ a particularly rich and flexible symbolic language; and Gillray, like his French contemporaries, could rely on encountering an audience which would read his symbolism without difficulty.

106

Cruel fantasies

There is more disagreement about the definition of the word 'Romanticism' than there is about any other term commonly used by art historians. Even in their own day, the Romantics found great difficulty in defining the movement in which they found themselves caught up. For the German critic August Wilhelm Schlegel, for instance, Romanticism was 'the particular spirit of modern art, in contrast to ancient or classical art'. For his brother Friedrich, it was the literary work, or work of art, which 'depicts emotional matter in an imaginative form'. At any rate, everyone who was touched by the Romantic spirit had no doubt that a profound crisis was taking place.

The Romantic insistence that art should conform to the image presented to the artist by his own unbridled imagination had a profound effect upon erotic imagery in particular. The writings of the Marquis de Sade suggested, to those who knew them, that the artist has the right to shed his inhibitions, and to express feelings and desires formerly thought to be either too shameful or too dangerous

to be directly acknowledged.

Yet there was a complication here, which is part of a larger difficulty – the matter of the relationship between Romanticism properly so called, and Neoclassicism. Superficially, it seems to be a case of two rival movements – Neoclassicism standing for order, logic, restraint and even a certain puritanism; while Romanticism stood, as I have said, for the free expression of individual passions, regardless of the consequences, and equally regardless of conventional notions of morality. Yet, at a deeper level, the rivals are linked: Neoclassicism is one of the many manifestations of the Romantic spirit, with its high ideals, its nostalgia for the past, and its hopes for the future.

Neoclassical puritanism was largely superficial. In France, for example, the leading Neoclassicists involved themselves in the political revolt against the *ancien régime*, and one aspect of that regime which particularly troubled a new and rebellious generation was its lax morality. When Diderot attacked Boucher as indecent, the attack

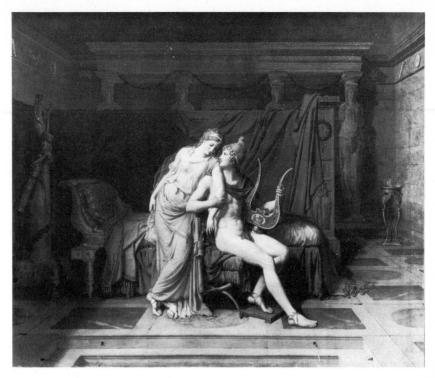

115 JACQUES-LOUIS DAVID, Loves of Paris and Helen, 1788

was politically motivated. Yet, as we have seen, even the 'new' art which Diderot supported – that of Greuze – was not without a strong undercurrent of eroticism. Gradually, however, the taste for Roman virtue grew; indeed, even before the Revolution, it was not without a measure of official support, and Jacques-Louis David, afterwards to be a member of the Convention, and an organizer of Revolutionary pageants, at the start of his career received the patronage of the Crown.

The differences between his work and those of the libertine *peintres galants* are, nevertheless, manifest – especially so, perhaps, when he tackles what might be considered erotic subject-matter. His *Loves of Paris and Helen*, for example, was painted before the outbreak of the Revolution – it dates from 1788, and the patron was the Comte d'Artois. Despite the nudity of Paris, the contrast with the work of Boucher and his followers could scarcely be more manifest. As the

108

representation of a fatal passion, the picture is exceedingly restrained. Things which emphasize its restraint are the coolness of the surfaces and the firm, unyielding quality of the outline. Though the two figures are intertwined, they yet remain separate entities.

But the Neoclassical idiom could nevertheless be interpreted in a number of different ways. If we turn from David's work to that of the Italian sculptor Antonio Canova, who is generally regarded as one of the most typical representatives of the movement, we see how ready the erotic fires were to break out again. Canova's group of *Cupid and Psyche Embracing* is full of sensuality. It is the direct ancestor of Rodin's *The Kiss*. The torsion of the two bodies, the abandonment of Psyche's pose, the position of Cupid's hand, all tell an erotic story. Nor is the feeling it conveys unique in Canova's work. The striking thing about his *Venus Italica* in the Pitti, for example, is the way in which Canova has chosen to stress sexual vulnerability. The piece conveys this feeling even more strongly than the Medici Venus which it was meant to rival.

116

117

117 ANTONIO CANOVA, Venus Italica, 1812

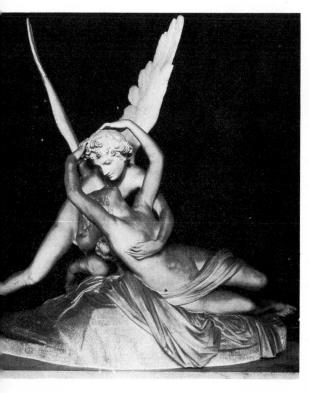

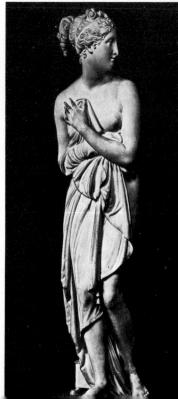

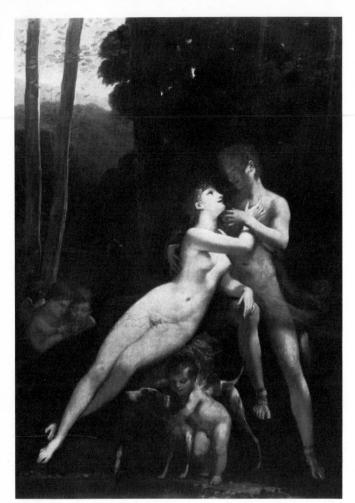

118 PIERRE-PAUL PRUD'HON, Venus and Adonis, 1810

119 JOHN HENRY FUSELI, A Sleeping Woman and the Furies, 1821

Pierre-Paul Prud'hon is another artist who demonstrates the degree of latitude which Neoclassical conventions allowed. His *Venus and Adonis* (sometimes said to represent the Empress Marie-Louise and her lover, Count Neipperg) owes a good deal to Correggio. The forms remain within the Neoclassical vocabulary; in this case it is the atmosphere which bathes them which seems to imbue them with sensual feeling.

The most striking examples of Neoclassical forms being used to express sexual themes are to be found not in the work of Canova, nor

118

in that of Prud'hon, but in that of the Anglo-Swiss painter and draughtsman, John Henry Fuseli, and of his Swedish contemporary, Johan Tobias Sergel. In Fuseli, we encounter a phenomenon which existed parallel to Neoclassicism properly so called, the *Sturm und Drang* or Storm and Stress movement which, especially in Germany, was the forerunner of full-blown Romanticism. Among the *Stürmer und Dränger* we already meet that insistence on the expression of individual feeling which was to characterize Romanticism as a whole. Fuseli, and those who thought like him, were captivated by the idea of the exceptional man, to whom all things were permitted, and who would transform his own experiences and emotions into art through the power of his imagination.

In the expression of personal fantasies and urges, Fuseli gradually frees himself from the 'set' subjects which artists had employed in the past. A painting like *A Sleeping Woman and the Furies*, and still more so a drawing like *The Fireplace*, represent a fuller release of subconscious erotic fantasy than the visual arts had so far been able to achieve.

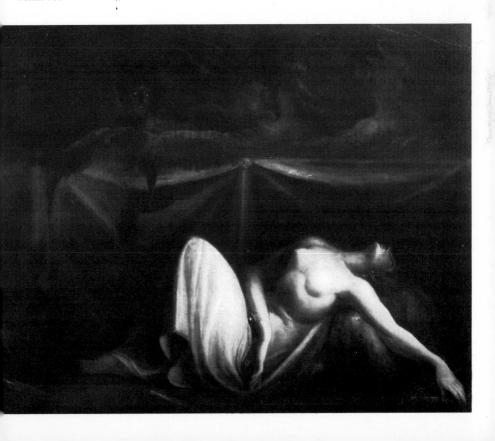

120 JOHN HENRY FUSELI, *The Fireplace*, 1798

One particularly striking thing about Fuseli's work is its obsession with both female dominance and female submission. *The Fireplace* is preoccupied with the former. These towering females, their coiffures fetishistically elaborated, recur throughout Fuseli's work. In this case the sexual parts of the tall central figure are exposed – an exposure which is emphasized by the elaborateness of the rest of the costume, while her tiny attendants serve to draw attention to her commanding height.

A Sleeping Woman and the Furies, though less candidly, gives us the other side of the coin. Here the female figure is posed, not only so as to emphasize her erotic attractions, but so as to suggest the idea

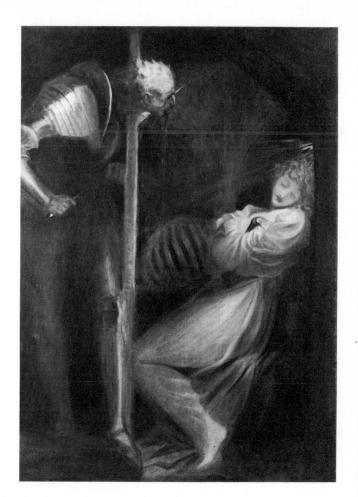

121 JOHN HENRY FUSELI, Wolfram Looking at his Wife, whom he has Imprisoned with the Corpse of her Lover, 1812-20

that she has been violated. The implicit sadism can be further elucidated by examining other compositions by the same artist, for example, the horrific Wolfram Looking at his Wife, whom he has Imprisoned with the Corpse of her Lover.

Sergel's work is more playful, and draws upon the two traditions which, in a larger sense, contributed to the formation of the Neoclassical style. Graeco-Roman art - in this case, specifically the erotic wall-paintings at Pompeii - and Mannerism (whose impact on Fuseli is even more evident than its impact on Sergel) are the source-material

for a whole series of drawings which, in their rather strained and feverish energy, go well beyond the sujets galants of the eighteenth

121

century. But in Sergel's work the sadistic element is almost entirely absent. The emphasis on violence and terror which we discover in Fuseli links him firmly to artists with little real interest in classical forms, such as Goya.

Goya, indeed, differs from Fuseli in the fact that the sadistic element is sometimes justified by the events of his time. The terrifying scenes which he depicts in *The Disasters of War* are well attested by contemporary descriptions of the Peninsular campaign. Yet, if we look through the whole body of Goya's work, we soon discover that the sadism is there even without the pretext of documentary realism.

It appears, too, in the work of the leading French Romantics, Géricault and Delacroix. Géricault matches Goya in his appetite for dismembered corpses and scenes of torture and execution. Where Goya paints missionaries being devoured by cannibal American Indians, Géricault paints still-lifes composed of the limbs of dismembered corpses. And when Géricault chooses instead to tackle a subject drawn from traditional mythology, such as his little sculpture A Nymph Being Raped by a Satyr, we are at once impressed by the violence of the assault – a quality more evident still in some of the preparatory drawings which the artist made for the work.

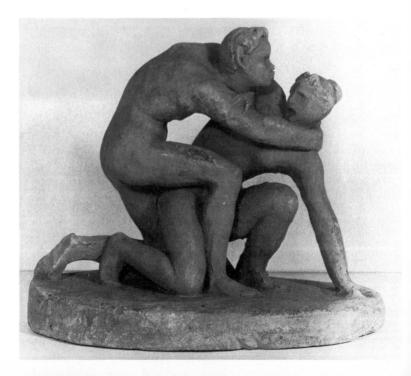

240 228

122

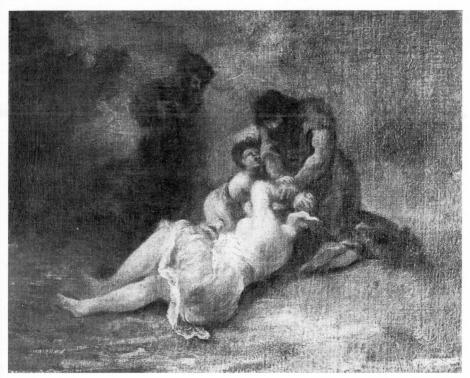

123 FRANCISCO DE GOYA, Woman Attacked by Bandits c. 1808–14

124 JOHANN TOBIAS SERGEL, Venus and Anchises Embracing

125 EUGÈNE DELACROIX, Mazeppa, c. 1824

Baudelaire, who greatly admired Delacroix, was fascinated by what he described as the 'visible Molochist character' of the latter's art. 'Everything in his work', said Baudelaire, 'is desolation; everything bears witness to the eternal and incorrigible barbarity of mankind. Towns set afire and smoking, victims with their throats cut, violated women, the very children thrown beneath the hooves of horses or about to be stabbed by distracted mothers; this whole œuvre, I say, seems a terrible hymn composed in honour of fate and irremediable pain.' And indeed Delacroix's most famous compositions are full of sadistic details - the woman dragged along by a Turkish horseman in the Massacre at Chios, the beautiful slave being stabbed to death in the foreground of the Death of Sardanapalus. When Byron's Mazeppa was published in 1819 it became a favourite subject with French Romantic painters - Delacroix made a striking watercolour of the theme, and seems to have planned a large composition. One can understand why it attracted him.

116

126

127 JEAN-AUGUSTE-DOMINIQUI INGRES, study for *Ruggiero Freeing Angelica*

But at this period the whole of French art is pervaded by this new and feverish brand of erotic fantasy. We find it in Ingres (considered in his own time anti-Romantic) as much as in his rival Delacroix. Harem scenes particularly attracted Ingres, not only for their exoticism, and for the opportunities they gave to present the female nude in a convincing setting, but because they enabled him to show women as playthings, victims of male caprice. The pose of the *Odalisque with a Slave* suggests the possibility of complete sexual abandonment, and it is interesting to note the family resemblance between this nude and the female nudes of certain Mannerists, such as Bronzino.

145

Ingres seems to have felt a particularly intense response to the notion of the bound or captive female. The female nude bound to a rock in his *Ruggiero Freeing Angelica*, otherwise a rather chilly work, has a striking intensity; and the sketch for this figure is more intense still. The torsion of the pose, the way in which the head is thrown back, half in supplication, half in surrender, the sidelong glance of the eyes – all of these testify to the degree of arousal which the artist felt.

217 127

The sadistic obsessions of the Romantics were to persist throughout the nineteenth century in European art. Those who inherited them in particular were the Symbolists and Decadents. As Mario Praz has demonstrated in his celebrated study of the period, *The Romantic Agony*, the literature of the time abounds in erotic imagery of exactly the kind I have been discussing here. It was as if the emphasis which the Romantics put on the individual's right to be himself, and to express what he was, had unleashed erotic forces which till then had been content to disguise themselves.

Where the subject-matter of painting and sculpture is concerned, the nineteenth century witnessed important changes. Puritanism drove out the light-hearted galanterie of Boucher and Fragonard (but this had, in any case, been in retreat long before the new century began). At the same time, it became increasingly less possible to use religious or even mythological subject-matter; or, at any rate, less possible to use it with conviction. Few paintings are more essentially hollow than Ingres's technically splendid Martyrdom of St Symphorian. The Romantic painters summoned modern literature to fill the gap – understandably enough, since literature was the 'ruling art' of the whole Romantic movement. Illustrations to literary works occupy an important place in all schools of nineteenth-century painting. The feelings which an artist of the seventeenth century would have embodied in a martyrdom were now canalized by the effort to make visible what was described in books. The public of the time, as puritanical and as excitable as the artists themselves, found these embodiments acceptable to its conscience, while the depiction of erotic reality, as Manet and some of his successors were to discover, remained intolerable. In general, however, eroticism was tacitly accepted as one of the purposes of the visual arts; one of the ways in which the artist communicated with the spectator. The debate was about which erotic convention to use.

140, 141

128 Adolphe Bouguereau, Nymphs and a Satyr, 1873

Love for sale

If we look at the work of the successful academic painters of the middle and late nineteenth century (now returning to favour with collectors and art-historians), we see how instinctively they responded to the needs of the contemporary public that supported them, and how ingenious were some of the formulae which they discovered for combining titillation with respectability.

The artist most generally thought of as typical of this nineteenth-century prurience is Bouguereau. But, from the erotic point of view, Bouguereau is by no means the most interesting of the painters who are now generally lumped together as academic or Salon artists. What we see in him is a continuation of the Baroque tradition, but without either the frankness or the appetite of a painter such as Rubens. His *Nymphs and a Satyr*, now in the Clark Institute, offers a typical specimen of his style, in which the handling of forms de-energizes what is being shown. The coyness of the nudes is striking, but it is hard to tell exactly how the effect is produced, since it resides, most of all, in small details of gesture and expression. In Bouguereau, as in Greuze, there is often a disturbing combination of knowingness and innocence.

Other popular academic artists turned to history in their quest for subject-matter which would satisfy both the public's unadmitted desire for erotic stimulation and its need to see immorality condemned. The wickedness of the Roman Empire is a favourite theme, tellingly portrayed for example in Couture's famous *The Romans of the Decadence*, which allows us vicarious participation in an orgy without soliciting our approval of it. The pagan world became so popular as a subject for painters that it was even possible to depict it without adding this note of condemnation. Alma-Tadema's *A Favourite Custom* is a good example: eroticism is very much present, but the contemporary spectator would not have felt threatened by it, as the scene the artist presented for his contemplation was so obviously removed, 'long ago and far away'. The cool, dry technique which Alma-Tadema used helped to reinforce this impression.

128

130

129 SIR LAWRENCE ALMA-TADEMA, A Favourite Custom, 1909

130 THOMAS COUTURE, The Romans of the Decadence, 1847

There are academic works, however, which give us a view of the darker aspects of nineteenth-century sexuality. One theme, inherited from the Romantics, and vigorously exploited by various artists throughout the century, is that of the captive woman, entirely at the mercy of the male, to be used as he shall decide. It is surprising, at first sight, how often the theme of slavery recurs in works which enjoyed an enormous contemporary response. In England, Hiram Powers's sculpture *The Greek Slave* scored a runaway success at the Great Exhibition of 1851; and Edwin Long's *The Babylonian Slave Market* fetched a record price for a contemporary work of art. In

132

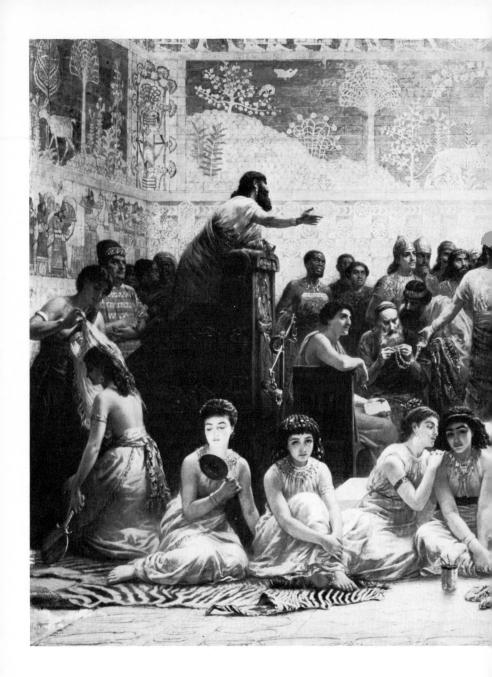

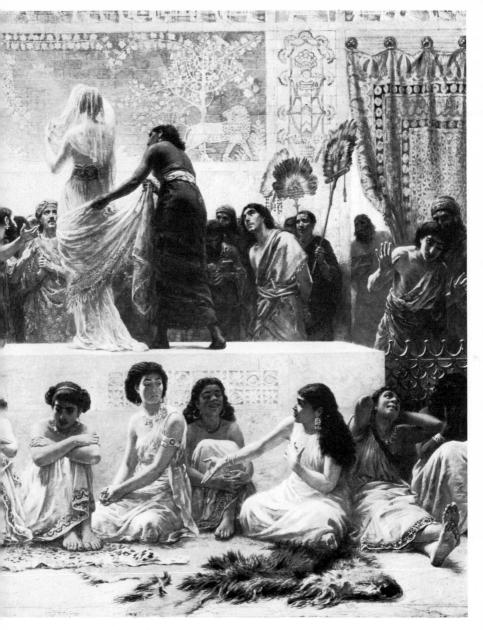

131 EDWIN LONG, The Babylonian Slave Market, 1875

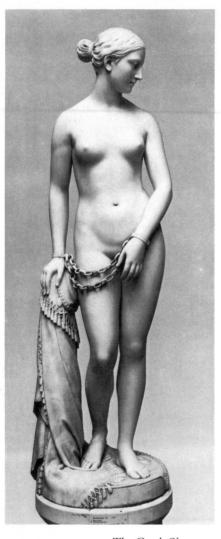

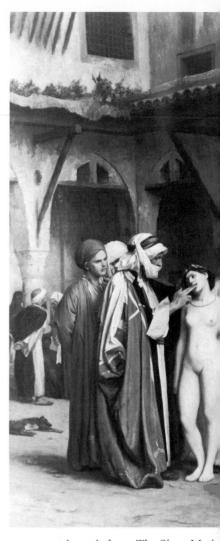

133 JEAN LÉON GÉRÔME, The Slave Marke

France, the Salon painter Gérôme made something of a speciality of this theme. *The Slave Market*, illustrated here, is a characteristic example of his work, and shows how conveniently the fashionable orientalism of the day could be combined with the taste for violated innocence and female subjection. Female slavery, indeed, was a

134 MAX SLEVOGT, The Victor (Prizes of War), 1912

subject which retained its fascination for artists and public alike until the opening years of the present century. It is curious to find it translated into the stylistic terms of German Impressionism in a painting entitled *The Victor (Prizes of War)* by Max Slevogt, which dates from 1912.

The nineteenth century has also left us more realistic records than these of its erotic life. The brothels and cabarets which formed so important a part of the urban scene fascinated artists, and more especially French ones. The literary realism of Maupassant, Zola, Flaubert and the Goncourt brothers (many of whom enjoyed close friendships with the best contemporary artists) found its echo in the work of Degas, Guys, Forain and Toulouse-Lautrec. Their depictions of low life often have a singular candour and fascination, and often go a long way towards explaining the tendencies of academic art, particularly through what they tell us about the consequences of economic dependency, so far as women were concerned. The prostitute was enslaved, not by chains and through the exercise of physical force, but by the need to find the money to live. From the sexual point of view – the woman's total submission to the man – the consequences were the same.

Toulouse-Lautrec is usually thought of as the master of brothel scenes, especially as it is known that he spent many weeks at a time

in residence at these places. His versions of what was to be seen there are, however, rivalled by those made by Degas, in a series of small monotypes which the dealer Ambroise Vollard used, many years later, as illustrations for an edition of Maupassant's classic brothel story La Maison Tellier. In The Client, Degas shows the moment of choice: a newly arrived customer, in the dress of a prosperous Parisian bourgeois, inspects the merchandise which is displayed before him. The Madam's Birthday shows us a 'family' occasion in the brothel: the girls, still in their working dress or undress, crowd around the formidably respectable proprietress of the establishment. These monotypes are masterpieces of exact and sardonic observation. They are the direct descendants of the brothel pieces produced by seventeenth-century Dutch genre painters, but they are endowed with far

136

135

95,96

135 EDGAR DEGAS, The Madam's Birthday, c. 1879

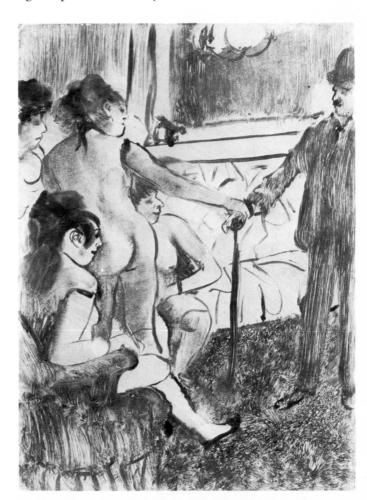

136 EDGAR DEGAS, The Client, c. 1879

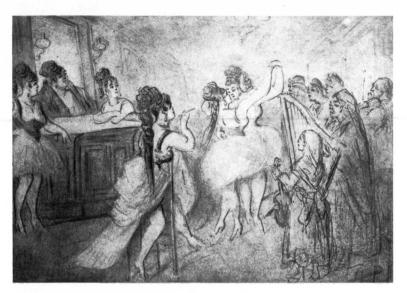

137 CONSTANTIN GUYS, Girls Dancing in a Cabaret

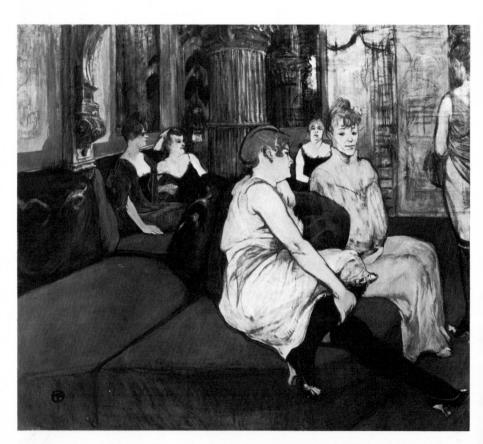

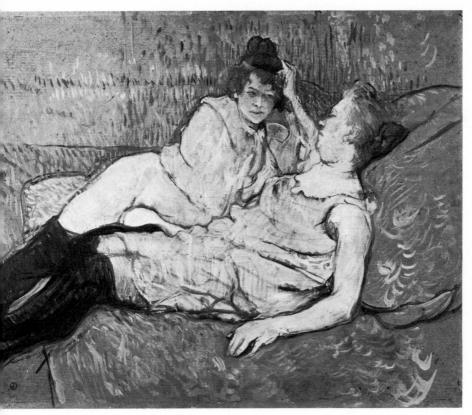

139 HENRI DE TOULOUSE-LAUTREC, The Sofa, c. 1893

greater sophistication. There is also a new element – the Romantic misogyny which Degas shared with Baudelaire.

Lautrec tackles much the same subject-matter as Degas. With his fascination for what went on behind the scenes, and behind the façade, he tends to choose a moment of repose. He is also interested in the personal relationships between the girls. The lesbianism frequent among professional prostitutes seems to have tickled his taste for what was grotesque, unnatural, and at the same time humanly touching and pathetic, and perhaps he associated the sexual deviations of these women with his own deviation – thanks to his dwarfish stature and crippled legs – from the expected physical norm. At any rate, female homosexuality in the brothels became part of his chosen repertoire of subjects, as a number of prints and paintings go to prove.

We also find hints of the same fascination in some of the drawings of Constantin Guys. Guys cannot claim the same degree of artistic distinction as Degas and Lautrec. Placed beside their work, his unambitious drawings seem naïve and even crude. But he did have great powers of observation, and an appetite for reality, for life in all its aspects. His Girls Dancing in a Cabaret are grisettes, rather than professional prostitutes, but the scene leaves little doubt that they are available. And Guys's work in this vein, just as much as that of Degas and Lautrec, makes one wonder whether the nineteenth century's reputation for sexual hypocrisy was altogether deserved. It is true that these were not works for presentation to the Salon public - good middle-class citizens, accompanied by their wives and daughters, but perhaps (as Degas's The Client reminds us) with a visit to a statelicensed house of ill-repute firmly in mind. But the list of such paintings and drawings is long enough, and the artists who produced them are distinguished enough, for us to claim that the detachment and compassion to be found in these works are in an important sense as representative of the age as the prurience of the academicians. And indeed we should expect it to be so from a study of the literature of the time. Forain's numerous paintings, drawings and etchings showing the young dancers and their protectors in the wings of the Opéra, or scenes in the private supper-rooms provided by fashionable restaurants for the convenience of their patrons, are like illustrations to an unwritten novel. In France at least, nineteenth-century hypocrisy was matched by extremes of honesty.

141-43

137

Why, then, was there such an uproar about two pictures in particular, Manet's Le Déjeuner sur l'herbe and Olympia? True, these pictures come earlier in the development both of French painting and of French attitudes towards morality than Lautrec's The Salon. And Manet, by showing the Déjeuner at the Salon des Refusés of 1863, and Olympia at the Salon of 1865, offered a direct challenge both to his fellow-exhibitors and to public opinion. All the same, why should the Emperor Napoleon III himself (in private life no paragon of sexual morality) be moved to declare that the first of these two masterpieces is indecent?

Le Déjeuner sur l'herbe has impeccable sources. Manet borrowed the composition from an engraving by Marcantonio Raimondi after Raphael. His crime was to put the two male figures into contemporary costume – Bohemian costume at that – while leaving their com-

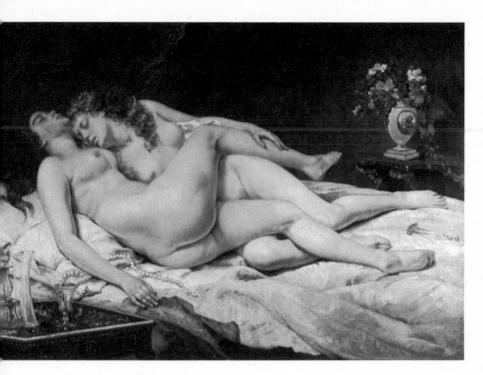

140 GUSTAVE COURBET, Sleep, 1866

panion nude. This suggested, not merely a compositional, but an actual social relationship between individuals – and that was the thing which shocked contemporary opinion so deeply.

In fact, nineteenth-century bourgeois opinion found distinctions of this kind quite as important as the more commonly accepted difference between the naked and the nude – the nude in art being, as Lord Clark has suggested, a figure which shows no self-consciousness about being unclothed. The female figure in *Le Déjeuner sur l'herbe* has an air of serenity and self-containment which ought to bring her safely within the boundaries set for the nude – from that point of view, she should have affronted bourgeois prudery no more than Bouguereau's nymphs, and certainly no more than a painting such as Courbet's *Woman with a Parrot* (true, there were complaints about the vulgarity of Courbet's types, and their lack of idealism). But, given the fact that the painting did suggest a social relationship, this classic serenity added to Manet's supposed offence. How dare

the model – and the artist who painted her – take it all so calmly? The woman in *Déjeuner* has no feeling of inferiority, despite her sex and despite her lack of clothes. She meets her companions on equal terms.

We can elaborate the argument by turning next to another work by Manet, the *Olympia*. There is no need to stress how traditional the painting is. The female nude, with an attendant or attendants, is one of the staple themes of European art, from the sixteenth century onwards. *Olympia* is closely related to Titian's *Venus of Urbino*, and also has a relationship to Ingres's *Odalisque with a Slave*. Yet, when we compare the Manet with the Ingres, what a world of psychological difference there is between the two paintings!

The odalisque is, as I have already noted, totally submissive. She awaits the man who will possess her, and every line of the pose tells us that she will not resist him, whoever he is. Her body is not her own.

141 ÉDOUARD MANET, Le Déjeuner sur l'herbe, 1863

142

178

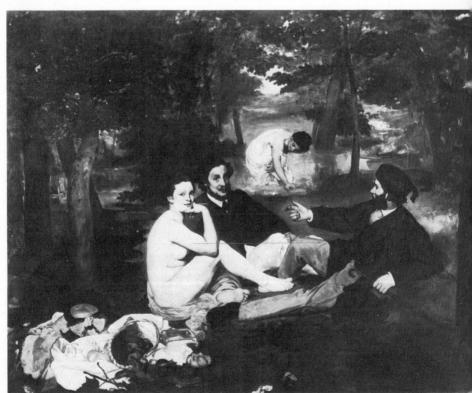

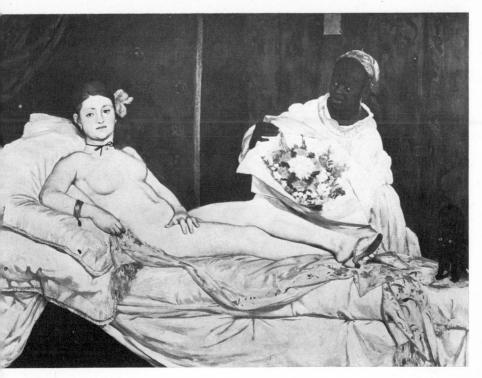

142 ÉDOUARD MANET, Olympia, 1863

And when we look at her face we see that this is anonymous, a beautiful blank. None of these statements applies to the *Olympia*. This woman is alert and self-possessed; she looks out of the canvas in a way which makes it plain that she submits to no man. The irate reviewer who called the picture 'cynical' was, in his own terms, perfectly right. Manet seems to have taken a different view of female sexuality from that which was cherished by most of his contemporaries – we know, in fact, that he not only liked women, but got on well with them as friends.

To all this must be added the fact that the *Olympia* is plainly a portrait, in the sense that Goya's *Naked Maja* is a portrait. Face and body are fully characterized. We are in the presence of an individual, who is naked and rather seems to glory in the fact. In 1865, Manet was capable of a more civilized – and a more complete – conception of eroticism in art than most people have been able to manage since.

143

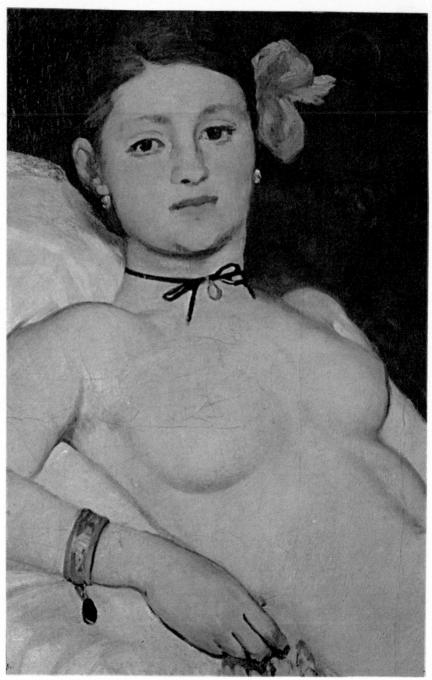

143 ÉDOUARD MANET, Olympia (detail), 1863

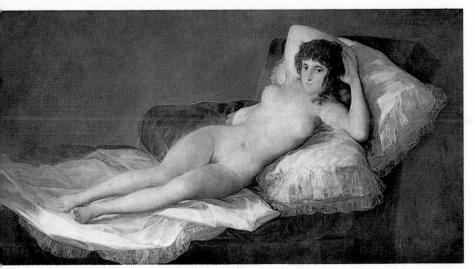

144 FRANCISCO DE GOYA, Naked Maja, c. 1800–5

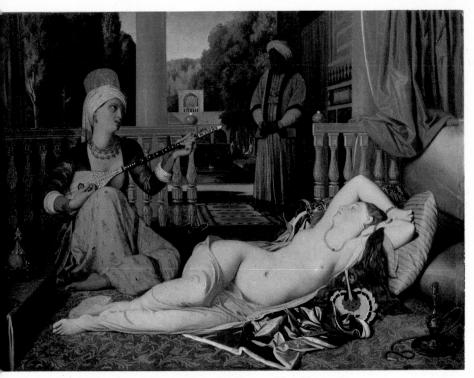

145 JEAN-AUGUSTE-DOMINIQUE INGRES, Odalisque with a Slave, 1842

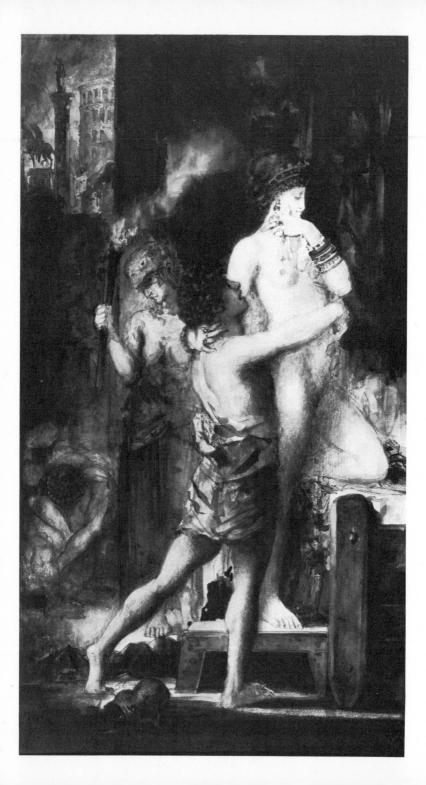

The all-devouring female

The third force in later nineteenth-century art remains to be discussed: the tendency which art historians have now begun to label 'Symbolist', by analogy with the Symbolist movement in literature. The label implies that Symbolist art remained predominantly literary, and this supposition is correct. In this sense it was a true continuation of the Romanticism of the earlier part of the century. Many of the themes most favoured by the Romantics were indeed taken up and used again by their Symbolist successors – the beauty of the Medusa and the vampire, the fascination with evil and with the idea of the fatal woman. It was chiefly the Romantic worship of nature that was abandoned – at least for a while. When it returned, it was much changed.

The most typical of these deliberately 'artificial' artists was Gustave Moreau, who admired in Michelangelo what he took to be the 'ideal somnambulism' of his figures. 'They are unaware', Moreau said, 'of their own movements, absorbed in reveries to the point of being carried away towards other worlds.' But his own figures are far from having the energy, even in dream, of Michelangelo's. They are, in fact, strikingly epicene: his lovers resemble one another to the point of being indeterminate in sex.

Another striking feature of Moreau's art is the emphasis on sensual cruelty and suffering, carried a stage further even than in Delacroix. The Sphinx, Salome, St Sebastian, Helen, the slaughter of Penelope's over-insistent suitors when Odysseus at last returns from Troy – all of these are among his themes. Some favourite subjects he treated in many versions. His work contains curious contradictions. His technique is meticulous – no artist's is more so – yet there is a sense in which any embodiment of his ruling obsessions will do. Messalina will serve in the place of Salome, for both are belles dames sans merci.

Another paradox is the vitality of this apparently devitalized form of art. As well as being the teacher of Matisse and Rouault, Moreau is one of the begetters of the Art Nouveau movement which swept Europe at the end of the nineteenth century, and persisted into the

146

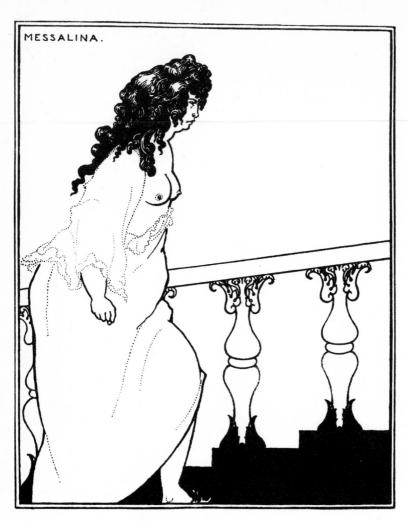

147 AUBREY BEARDSLEY, Messalina, 1897

beginning of the twentieth. If we compare his work with that of the young Englishman Aubrey Beardsley, for example, we immediately recognize how many of their assumptions are the same. It is not merely that Beardsley also depicts Salome and Messalina, but he uses them to say the same things.

Beardsley, however, employed erotic material more boldly than Moreau himself was ever to do. With him, on occasion, the erotic

148 GUSTAV KLIMT, The Kiss, 1907-8

image is an act of aggression against society and against the spectator, who is either forced into a kind of complicity or driven into reacting violently. If the notorious *Lysistrata* illustrations have anything novel about them, as contrasted not only with Moreau's work, but with the frank eroticism of eighteenth-century draughtsmen such as Rowlandson, it lies in the fact that they are not so much coarse as sly; they play tricks with our perceptions. In one design a huge phallus rears

149

149 AUBREY BEARDSLEY, Lysistrata, 1896

150 FÉLICIEN ROPS, The Monsters or Genesis

up in the foreground, so large and so unexpected in its placing that at first we may easily fail to notice it. By contrast, erotic imagery invades even the smallest details of some of the illustrations; they become complicated sexual conundrums, piling pun upon pun.

Here Beardsley has a relationship with another gifted illustrator, the Belgian artist Félicien Rops. Rops is a very various artist. Much of his work consists of versions of galant themes which had already been employed by men such as Baudouin a hundred years earlier. In this mood he belongs to the rather depressing story of Second Empire dix-huitièmerie. He also illustrated the Decadent authors, who deliberately set out to invert the accepted moral values of the day (one text that Rops made designs for was Barbey d'Aurevilly's Les Diaboliques); and it is for this reason that he is usually categorized as a Symbolist.

He stakes a far better claim to this title with his independent works, not designed as illustrations, and most notably with a set of prints entitled *Les Sataniques*, more aggressive even than anything attempted by Beardsley. In these, the Satanism of the Decadents is carried to

gleeful extremes of outrage – *The Calvary* shows an ithyphallic devil upon the cross; *St Mary Magdalen* masturbates while gazing ecstatically at a crucified phallus. One of the most interesting of these prints is also among the rarest. Called *The Monsters*, or *Genesis*, it shows a swarm of phallic creatures being born from the primeval slime. Rops also did a certain amount of work as a caricaturist, and he here adopts the caricaturist's technique of metamorphic transformation, which we have already encountered in the work of Gillray. But he uses it for poetic rather than satiric purposes – an innovation more generally credited to the Surrealists. Nor is this the only occasion on which Rops comes close to being a Surrealist: another set of erotic prints actually has the highly Surrealist title *Transformismes*.

151 EGON SCHIELE, A Cardinal Embracing a Nun, 1912

152 EGON SCHIELE, Reclining Woman, 1917

Also to be compared with Beardsley are two leading members of the Vienna Secession, who continue the development of Art Nouveau into the period immediately preceding the First World War. These are Gustav Klimt and Egon Schiele. In Klimt's work we again encounter Beardsley's emphasis on line, the balance of dense pattern against empty space, the tendency to flatten the forms in the interests of decoration. Like Beardsley, Klimt was fascinated by the more perverse aspects of human sexuality, and even when he is content to show us just a pair of lovers embracing, the cramped attitude of the figures somehow suggests that there is something unwholesome or even demoniacal about their feeling for each other.

Schiele's work is harsher than Klimt's. Some traits – the occasional liking for blasphemy, for example – he inherited from predecessors such as Beardsley and Rops. Others, such as the fact that lassitude is now being replaced by violence, tend to align him with the German Expressionists. There is a balance of all these qualities in *A Cardinal Embracing a Nun*. It is as if the artist wanted to force himself beyond the bounds of everything he or his contemporaries knew – not merely in terms of the mockery of conventional ideas and standards, but also in terms of the charge of energy which could be imparted to

148

the figures. They seem less like lovers than like a pair of praying mantises, each seeking to devour the other.

In France, its place of origin, Symbolist art usually pursued a somewhat gentler course. Moreau was the ancestor not only of Beardsley and Rops, Klimt and Schiele, but also of Paul Gauguin. Gauguin, in his own eyes, was the leader of a Symbolist reaction against the superficiality of Impressionism, and his late works, in particular, are permeated with languid erotic feeling. But Gauguin was not content to take hints from Moreau alone; he looked back to the whole Romantic tradition. When he interpreted the South Seas as a voluptuous paradise, he imposed upon this setting and society which he had travelled so long and so laboriously to see, ideas which had been current in France for most of the nineteenth century. The beautiful reclining nude Te Arii Vahine, with its mangoes which allude suggestively to the female sexual organs, is sometimes said to be intended as a conscious tribute to Manet's Olympia. In reality it reaches back beyond Manet to the odalisques of Ingres: the slave-girl in the harem here becomes an equally passive and receptive child of

153 PAUL GAUGUIN, Te Arii Vahine, 1896

154 PABLO
PICASSO, Figures
in Pink, 1905

nature. Nor is this painting the final statement of the theme in French art. Picasso, who was to make so much use of Ingres in the so-called Classical Period of the early 1920s, and indeed subsequently, was influenced by him much earlier, at a time when he himself was still a Symbolist rather than a Modernist. A Rose Period harem scene is a fascinating variation on the older master. And even the *Demoiselles d'Avignon*, the work which marks Picasso's official break with the past, takes as its subject a group of prostitutes such as Degas or Lautrec might have painted.

155 GEORGES
ROUAULT, Two
Prostitutes,
1906

The passive or captive female was, however, in the process of being displaced in European art by her rival archetype – the dominating woman. Fear of her is expressed in the frenzied athleticism of Rodin's sculpture *The All-Devouring Female*, resignation to her power in the same artist's *The Eternal Idol*. The great Norwegian Expressionist Edvard Munch rather edgily satirizes her in his lithograph *Under the Yoke*; and the young Rouault seems terrified of her in a

Under the Yoke; and the young Rouault seems terrified of her in a
 characteristic study of Two Prostitutes. The sadism of the early Romantic here comes full circle, and becomes masochism.

157

156 AUGUSTE RODIN, The Eternal Idol, 1889

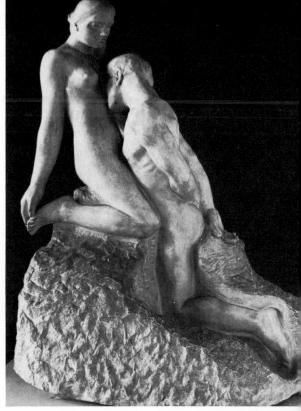

157 AUGUSTE RODIN, The All-Devouring Female, 1888

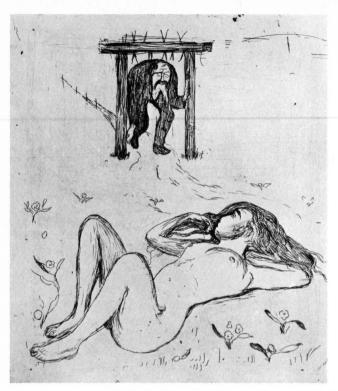

158 EDVARD MUNCH, Under the Yoke, 1896

Rodin's sculptures and Munch's print (and how many other works by the same artists) offer us an example of the increasing tendency, as the twentieth century dawned, to use works of art as vehicles for direct personal statement. Rouault's whores are very different from Lautrec's. Lautrec is still an observer, interested in what his subjects look like and what they are thinking and feeling, Rouault uses them to embody a state of feeling within himself. We find much the same kind of thing being done a little later by Pascin, where women are treated, not so much with half-realized fear as with unconscious dislike. Pascin's girls do not threaten – very much the opposite. They look easily available; and they also look cheap.

Gradually artists were able to become more candid about their own attitudes to sexuality, and candour brought self-knowledge in its wake. This increased degree of self-consciousness cannot be associated purely and simply with Symbolism, though Symbolist introversion had undoubtedly had much to do with it. Expressionism, too, played its part. An artist who opted for primitive directness, for escape from

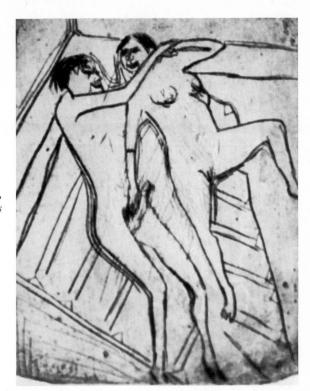

159 ERNST LUDWIG KIRCHNER,

Lovers

the labyrinthine corridors of aesthetic theory, had to come to a decision about the things which it was essential to express.

The theme of the couple is often used by Expressionist artists: sex was seen by them as something closely analogous to art, a primitive outpouring of energy. Yet it often seems that there is little joy in these representations. The gleeful, rather frivolous celebration of the pleasures of the sexual act, such as we find in a picture like Fragonard's *The Happy Lovers*, gives place to the embodiment of feelings of doubt and anguish in the prints of leading Expressionists such as Kirchner and Heckel.

100

Kirchner's *Lovers* have a memorable awkwardness. They lie on their bed, which is tilted towards us, like two shipwrecked sailors on a raft, and grope for one another's bodies as if blind. We seem to find here the expression of feelings of sexual responsibility, the acceptance of the partners as equals in what they do, of woman as a person rather than an object. It is this, rather than its technical qualities, that makes the print moving.

160 GEORGE GROSZ, Yet Another Bottle, 1925

After the First World War, George Grosz carried the notion of sexual responsibility one stage further. In some of his satirical drawings, the corruption of society is reflected in the corrupt nature of sexual relationships.

More moving than any of these, in fact one of the profoundest statements about the complexities of an erotic relationship that we have so far encountered, is the beautiful Picasso, *The Embrace*. This turns our attention to the responsibilities of sex, rather than its pleasures. The couple are naked; they stand firmly planted upon the ground, and bend towards one another, as if overcome by melancholy. The climax of passion is already long past, as we can see, for the woman is visibly and heavily pregnant.

Erotic metamorphosis

From one point of view – which is very much the point of view of this book – Cubism can be regarded as a puritan reaction against the excesses and complications of Symbolism, just as Neoclassicism was a revolt against the laxity and restlessness of the Rococo. Synthetic Cubism is still sometimes labelled 'abstract art'; in reality, the opposite was the case. Its practitioners were interested in rendering the object with absolute completeness, in its totality, and with all literary allusions shorn away.

It is of course true that Picasso's Les Demoiselles d'Avignon, which represents the first and fateful step towards the new style, has an erotic component. The subject-matter of the picture, or the subject-matter which the poet André Salmon imposed upon it by suggesting that it be christened 'The Girls of the Calle Avinyo' (whores practising their trade in Barcelona), was an additional bit of mischief which was meant to reinforce the aggression of its forms. But the content was wholly subordinate to the stylistic intentions which the painting embodied.

The fully developed Synthetic and Analytic Cubism of Braque, Picasso and their followers confined itself to a narrow range of far from erotic subject-matter: still-lifes, often with musical instruments; portraits and other single-figure compositions, and (leading towards Cubism rather than strictly speaking part of it) landscapes with simplified and geometricized forms.

Parallel with Cubism, developed the art of Matisse. Matisse is a hedonistic rather than an erotic artist. *The Joy of Life*, painted in 1906, a year earlier than the *Demoiselles d'Avignon*, treats its subject-matter in a very general way; but it is clear that Matisse owed a good deal to Gauguin, and indeed was trying to convey his own version of the kind of feeling which Gauguin conjured up in his paintings done in the South Seas. Indeed, it is important to realize that Matisse, even more than Picasso, continues the line of Ingres – the long series of odalisques painted by Matisse in the 1920s and 1930s demonstrate this

163 HENRI MATISSE, L'Après-midi d'un faune, 1933

164 PABLO PICASSO, Four ceramics, 1962

point very clearly, just as they demonstrate the artist's continuing interest in the Moroccan paintings of Delacroix.

When he depicted a specifically erotic subject – for example in his illustrations to Mallarmé's poem L'Après-midi d'un faune - Matisse 163 resorts quite deliberately to Neoclassical convention. He wants to remind us of the 'pagan' simplicity and vitality of the designs on 18

Greek vases and the erotic murals at Pompeii and Herculaneum.

Picasso, too, makes use of a modernized version of the Neoclassical 164 style, not merely during the brief Classical Period of the early 1920s but throughout his career. And with him, too, we find it used as a vehicle for erotic subject-matter.

Picasso was also attracted by the ideas put forward by the Surrealists, though in many ways what the Surrealist movement preached was a contradiction of everything which Cubism had stood for. Surrealism represents a revival of the literary and the symbolic in a new guise. Content was again important, but the content of a pictorial representation should now be an image of the workings of the artist's unconscious mind. This meant that special emphasis was put on the idea of transformation, and also upon that of association. The Surrealist artist sought to remake reality, so that it became the perfect expression of his own fantasies. One consequence was that this was an art movement entirely without a shared style.

165 PABLO PICASSO, Drawing, 1927

166 RENÉ MAGRITTE, The Ocean, 1943

A simple example of what might be expected to happen is supplied by a well-known picture by René Magritte. Called *The Rape*, it presents a weird female head, whose component parts turn out to be the specifically sexual portions of a woman's body. Thus, her eyes are also breasts; and her mouth is a vulva. Other works by Magritte are equally specific in their sexual symbolism. In *The Titanic Days* a naked female struggles with a clothed male who is also, by some alchemy, a part of her own body. *The Ocean* shows a naked bearded figure, whose erect penis has become a tiny female nude.

Magritte's paintings supply us with very literal instances of Surrealist transformation. The same process occurs, but in a more complex way, in works by Picasso, Max Ernst, and Salvador Dalí. In a series of drawings executed in 1927, Picasso takes a favourite subject of the Classical Period of a few years earlier, and subjects it to a process of radical transformation: a figure, or pair of figures, on the seashore

are turned into a collection of tumescent forms. The figures are female, but the forms themselves suggest phalluses in a state of erection. Similarly, the large sculpture of a female head executed by Picasso in the 1930s, apparently under the stimulus of his love-affair with Marie-Therèse Walter, simplifies the forms until they suggest the male genitals, thus providing a parallel to the palaeolithic figurines where a female figure can also be read as a representation of the phallus. The atmosphere of Surrealist paintings is often menacing, never more so than when sexual ideas are directly evoked. Max Ernst's *The Robing of the Bride* harks back, with its meticulous technique, to the work of Gustave Moreau. Reminiscent of Moreau, too, is the undercurrent of cruelty. The deformed and weeping sphinx who crouches in the bottom right-hand corner has one wing and one arm, four breasts, and male genitalia. The central figure has an owl's head which may also be thought of as a mask, as a human eye

167 MAX ERNST, The Robing of the Bride, 1939

168 SALVADOR DALÍ, Young Virgin Autosodomized by her own Chastity, 1954

appears among the feathers lower down, while a sneering devil's head emerges from the feathers immediately above the breasts. On the left is another bird-headed being, menacing the bride's sex with an outsize broken arrow; with a languid hand she shields her private parts from this assault.

More specifically sado-masochistic is Salvador Dalí's gleeful anatomical conundrum, the Young Virgin Autosodomized by her own Chastity. The buttocks of the naked female figure which leans through a window are developed into phallus-like forms. Similar transformations also occur in the work of Hans Bellmer, both in the Dolls, which are capricious assemblages of various parts of the human anatomy, and in the artist's prints. A typical example of the latter combines a crouching female figure and an enormous phallus in such a way that testicles may be read as breasts, and the glans as part of a pair of buttocks. Invariably, Bellmer gives one the feeling that the female has been violated in the course of these transformations; that the loss of physical integrity is to be equated with a loss of virginity.

Erotic imagery thus became an important weapon in the battle for modernism. It is not merely that artists seem to be expressing a fear of normal sexuality, and a feeling of aggression towards the woman who threatens the male with her otherness; it is also that the audience itself is to be assaulted. By creating images which outrage conventional ideas of decency and sexual reticence, the artist marks the distance between himself and ordinary members of society – in this the modernist appears as the direct heir of his Romantic predecessors. Contemporary painters and sculptors also use erotic imagery as a means of involving the spectator with the work; it is difficult to confront such imagery with complete neutrality. It is no accident that the history of modernism has been marked by a long series of legal battles on the subject of obscenity.

Since the Second World War, eroticism has come to play an increasingly important role in contemporary art. The continuing emphasis on individuality, and on the free expression of the artist's personality, remains as a heritage from the Romantic movement. On the other hand, our definition of human individuality has been much modified by the discoveries of Freud, and it is perhaps not too much to say that we now feel that the individual is most easily defined as such through an examination of his erotic fantasies and

168

171 RICHARD LINDNER, Leopard Lily, 1966

172 ALAN DAVIE, Bird Noises Number 3, 1963

and historically; one of the main inducements which lead some artists to regret it is the desire to make specific and unambiguous statements about erotic subject-matter.

Some artists have been content to marry abstraction to a kind of symbolic shorthand. That is, an apparently abstract work will turn out to be composed of hieroglyphs which have a sexual connotation. Though these signs, and their positioning, have been arrived at through a process of free association, their forms are traditional enough. Particularly common are two which occur in the painting by Alan Davie illustrated here: a phallic form, and the *vagina dentata* which expresses the male fear of the hostile, biting and devouring sexuality of the female.

With other artists, we seem to find a certain stylistic indecisiveness, a tendency to compromise in order to reinforce erotic statement.

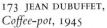

174 WILLEM DE KOONING, Woman and Bicycle, 1952–53

Thus, the most explicitly figurative paintings created by the American Abstract Expressionist painter De Kooning are those which belong to his series of *Women*, and these are interesting not merely because of their surrender to figuration but for the way in which they harp on the notion of threatening, primitive femaleness, as a force that the male must nerve himself to confront. De Kooning's images can be matched in the deliberate crudity of Jean Dubuffet's *Ladies' Bodies (Corps de dames)*. These, too, seem to express a terror of female sexuality.

Nevertheless, it has been those artists most thoroughly committed to figuration, and in particular the practitioners of Pop Art, who have been most prolific in their production of erotic images. This is not surprising when we consider that the source-material for Pop Art is generated by contemporary urban culture – that it is to be

174

175 TOM WESSELMANN, Great American Nude No. 91, 1967

found in comic strips, girlie magazines, advertisements and posters. The pin-up and the pin-up-as-advertisement have provided a starting point for artists such as Peter Blake and Anthony Donaldson in England, and Wayne Thiebaud and Tom Wesselmann in America.

Not surprisingly, there has been an almost obsessional interest in what one might describe as the night-side or underworld of popular culture – in the books and comic strips which emphasize various aspects of sexual deviation, in the catalogues put out by shops which sell fetishistic garments made of rubber or leather, and in pornographic photographs. Richard Lindner, an artist with affiliations to both Pop and Surrealism, makes use of this material in many of his paintings, and it also fascinates the Englishman Allen Jones, whose recently exhibited three-dimensional pieces have been among the most candid statements of their kind to appear on exhibition in London.

175

171

PART TWO Symbols

176 PABLO PICASSO, Man and Woman, 1969

Venus observed

There is one thing which any work of art with an erotic content does to us. If we are stirred by it in the slightest degree, we find ourselves playing the role of the voyeur. The essence of the voyeur's position is his removal from action. He watches, and participates in fantasy. His satisfactions come to him, not through doing, but through seeing what is done (or what is to be done). From the standpoint of psychoanalysis, it would seem that the enjoyment of erotic art is to be regarded as a deviation.

The simplest and most obvious subject of the male voyeur's enthusiasm is the naked female, and, as I have noted, the female nude is one of the standard subjects of European art. But she appears in a very wide variety of guises. One might almost say that the female nude, alone and unconscious of any watchers, is much rarer than one might suppose in this category of subject-matter – something which already puts Kenneth Clark's distinction between nudity and nakedness into jeopardy. Even Giorgione's *Sleeping Venus*, often cited as one of the chastest and most dignified presentations of the theme, was once accompanied by a Cupid who has now vanished as a result of restoration, but who still makes a ghostly appearance in X-ray photographs. Nevertheless, we are conscious in this work of an aloofness which is not precisely the negation of sexuality, but which abashes any directly erotic response.

We already enter a more sensual world with some of the Venuses of Titian. A whole group of paintings takes for its subject the reclining female nude. The most often cited is the *Venus of Urbino*, but there are other works of this type in Madrid, New York and Edinburgh. The *Venus of Urbino* has two characteristics which require comment. First of all, the naked beauty, though not ashamed of being naked, is aware of the spectator's presence. She looks out at him, and it is clear that her eyes are meant to seem to focus on whoever is gazing at her. Secondly, the lady is not alone. In the background, we see the clothed figures of two women who are going about the business of the household.

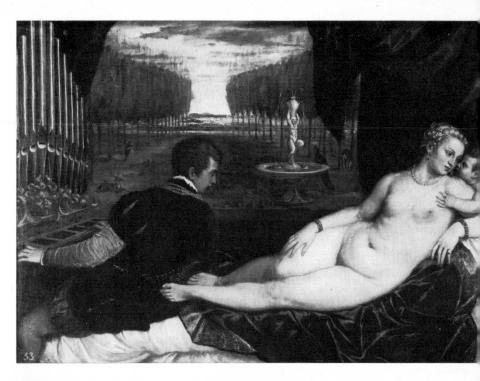

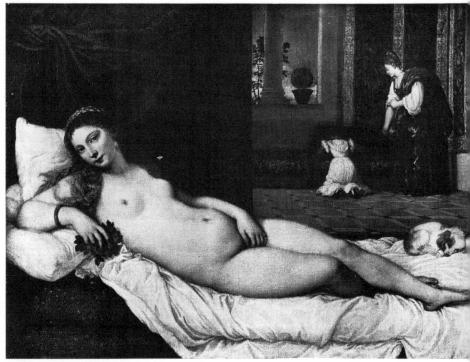

In other, later Venuses, Titian concentrates the message of the *Venus of Urbino*. One of the versions of *Venus with the Organ-player* in the Prado will serve to show his change of attitude. Venus reclines, and turns her head to talk to Cupid. The organ-player sits with his instrument at the foot of her bed, and turns his head back to gaze at her. The direction of his glance, towards the division of her legs, leaves us in no doubt as to the nature of his interest in her. He serves, in fact, as a kind of mediator between the spectator and the erotic object; the voyeur placed within the composition is a surrogate for

I can perhaps reinforce this thesis with a comparison. It is well known that the English artist Stanley Spencer painted a number of markedly erotic compositions, nearly all of them autobiographical in content. The example illustrated here is typical. It shows the artist himself gazing down with fierce concentration at the nude body of his second wife, as she reclines before him. It seems clear, from the whole atmosphere of the work, that we are not being invited, in this case, to witness the preliminaries of love-making. Instead, it is almost as if the Spencer who watches his wife in the picture is to be regarded as a permanent substitute, a magical intermediary, for the Spencer who painted it.

179

177 TITIAN, Venus with the Organ-player, c. 1548

the voyeur who cannot enter it.

178 TITIAN, Venus of Urbino, c. 1538

179 STANLEY
SPENCER, The Leg
of Mutton Nude
(Stanley and
Patricia Spencer),
1937

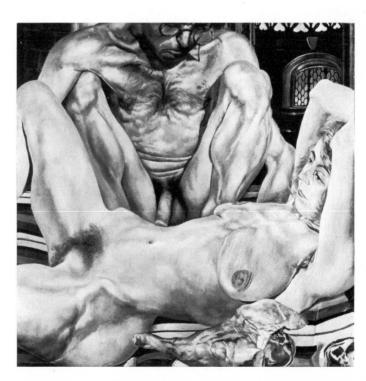

The Old Testament contains a number of stories which hinge upon voyeurism, of which *David and Bathsheba* and *Susannah and the Elders* are the best known. It is therefore not surprising to discover that these are subjects frequently chosen for illustration by Renaissance and later artists. The celebrated *Susannah* by Tintoretto in Vienna gives an idea of the reasons. The artist provided himself with the opportunity to paint a beautiful nude, who is made the more exciting by the fact that she is being watched.

The story of Susannah can be treated in a number of ways. For example, the girl can be as yet unaware that she is observed, though this fact is obvious to us who look at the composition. Alternatively, she can be frightened, and her shame at being seen naked can be used to heighten our sense of sexual arousal. The treatment of the Elders can also be given a variety of inflections. They are sometimes shown as impotent dotards, as powerless to move from lust to action as the spectator himself. More often, as in one of the versions of this

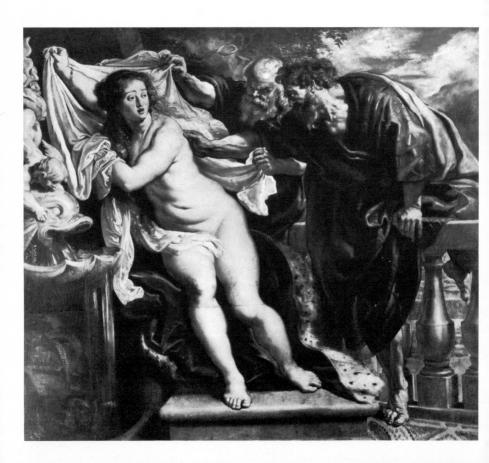

180

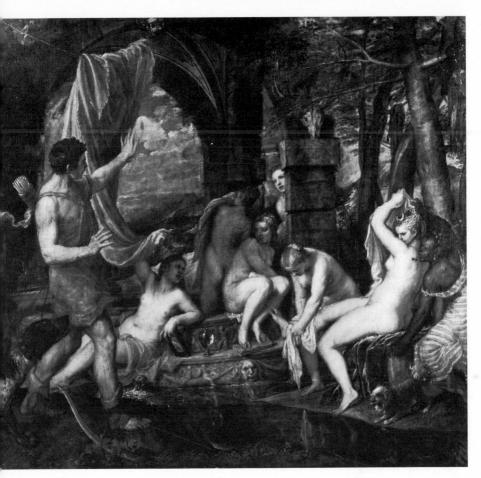

181 TITIAN, Diana and Actaeon, 1556-59

subject by Rubens, they crowd around the female figure in a manner not provided for in the original story.

Pagan mythology also provided artists with a wide range of subject-matter for paintings which appeal to the voyeuristic impulse. Sometimes it is feelings of guilt which are uppermost, as we can see from Titian's version of the *Diana and Actaeon* story. The goddess holds up a veil, and frowns angrily; her nymphs start back in horror, as does Actaeon himself, terrified by his own presumption, and already becoming aware of the fate which lies in store for him.

But guilt does not always triumph. There are, for example, the occasions on which Diana and her nymphs, sleeping after the hunt, are shown being spied upon by satyrs. The satyrs, part men, part animals, make a telling embodiment of men's animal desires. Picasso, with his marvellous instinct for discovering still-valid elements in the work of the Old Masters, uses a simplified version of this idea in one of the most beautiful prints in the Vollard Suite, *Minotaur Watching a Sleeping Girl*. Here what we are made to experience is not merely emotions which are straightforwardly voyeuristic, but the tragic gulf which yawns between the watcher and the watched.

Certain pagan themes actually enable the artist to justify his own voyeurism and that of his audience. One which enjoyed a long popularity is the story of Alexander, Apelles and Campaspe. Campaspe was Alexander's mistress; Alexander commanded Apelles to paint her, and when he discovered that the artist was in love with the girl, magnanimously surrendered his own rights. Usually Campaspe poses alone, but Niccolò dell' Abbate, in a composition recorded by the engraver L.D., characteristically intensifies the eroticism of the scene by showing the king and his mistress posing together, while the artist who longs for Campaspe must show her in the embraces of her royal lover.

183

183 L.D. after NICCOLÒ DELL' ABBATE, Alexander, Apelles and Campaspe, between 1542 and 1548

The most commonly chosen of these 'licit' scenes is, however, *The Judgment of Paris*, which appears many times over in European art. The sexual implications are extremely interesting, for, in addition to the fact that Paris acts the necessary role of intermediary as we examine the three beautiful female nudes whom he, too, has been commanded to look at (most commonly all three goddesses appear nude, though not invariably), we are also aware that the composition serves as an assertion of male superiority: though Paris is a mere mortal, he has become, thanks to his rights as a male, the judge of three immortals.

One artist who treated the subject a number of times was Lucas Cranach, and the version of it illustrated here is one of the most fascinating and revealing that I know. The group of the three goddesses derives ultimately from the Hellenistic group of the Three Graces which haunted the imagination of artists from the Renaissance onwards (among them, as we have seen, both Raphael and Correggio). Rubens was also to play variations on the theme.

Since three female nudes are needed for a *Judgment of Paris*, Cranach naturally turns to a source of inspiration which is very familiar to him. What is significant is the way in which he has altered the originally tranquil poses of the three figures, so that they express not only restlessness but a kind of sexual irritability. One goddess holds her foot; another strains her arms backward, and thus pushes her bosom forward, after the fashion of a twentieth-century sweater-girl.

It is something perhaps too obvious to need stating to say that erotic content can be a matter, not only of the context, but of the pose. Some of Klimt's drawings of the female nude are excellent examples of this. Another factor which influences our reaction is the matter of adornment. The wholly undraped and unadorned female figure often has feebler powers of erotic excitation than one which is not wholly nude. Cranach is a master of this kind of effect. His three goddesses wear rich necklaces, and wispy veils around their loins which serve to attract attention to the primary sexual area. One of them sports a wide-brimmed hat. All this, combined with the provocative poses they have taken up, gives a slightly outrageous air of coquetry to the group whom Paris so phlegmatically regards.

But mere drapery will do the job just as efficiently as rich jewels and fashionable hats. The antique type of the Aphrodite Kallipygeia, who coquettishly exposes her buttocks, is the example which most

184

52

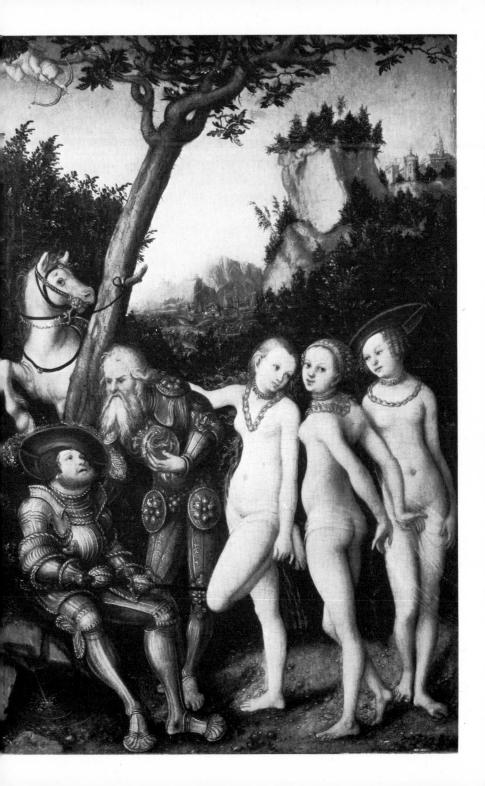

readily springs to mind, but Egon Schiele can also contrive to make something very erotic out of an apparently conventional nude by arranging that the cloth which at first glance seems intended to conceal the more obvious sexual characteristics of the model should in fact reveal and emphasize them.

When, as in Rubens's Hélène Fourment in a Fur Robe, the material used for this partial concealment of the body has strongly fetishistic connotations (fur can be read as an allusion to pubic hair), the effect is perhaps more erotic still, especially as the artist differentiates with marvellous skill between the rough sheen of the fur and the smooth sheen of the body. Rubens's portrait of his young second wife is also an example of erotic intensification of another sort. Part of its spell – like the spell exercised by Goya's Naked Maja, Boucher's Mademoiselle O'Murphy and Vestier's Mademoiselle Rosalie Duthé - springs from our consciousness that this is not merely a nude, but a portrait. It is an individual who appears thus unclothed before us, as innumerable tinv details serve to substantiate. One of the most telling is the deformation, slight but perfectly apparent, of the feet - no doubt the result of wearing fashionably tight shoes. The fact that this painting was the one thing which Rubens specifically left to Hélène in his will seems to confirm the supposition that he intended it as a private monument of his feelings towards her.

Besides this kind of particularity – the particularity of the portrait – erotic tension can be heightened in other ways. One is through actual anatomical deformation - the impossible elongation of Ingres's Grande Odalisque, for instance. Another, already glimpsed in the Cranach Judgment of Paris, is through the multiplication of nude figures. Here again, Ingres supplies an obvious example with Le Bain turc. This picture is a hymn to the glory of the female body - there are nudes everywhere we look; they fill the whole picture-space as if the artist suffered from horror vacui. The eroticism of the painting is of a particularly complex kind, as it is possible to discover a number of contributory elements. In the first place, there is the fact that this is a variant of the 'harem' or 'slave-market' theme. These women are animals, herded together and preparing themselves for the pleasure of the male (whom in any case they cannot refuse to satisfy). Secondly, the implications are strongly voyeuristic: we are looking in at a scene normally forbidden to the male gaze. Thirdly, there is more than a hint of homosexual affection in some of the poses - note, in

83

144, 106

105

184

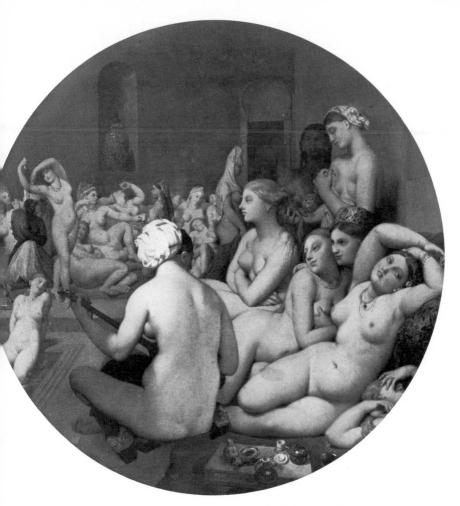

185 Jean-Auguste-Dominique ingres, Le Bain turc, 1862

the principal group, the way in which the second figure from the right is clasping her companion's breast. And lastly, we can also read the composition as something kinetic. Instead of being a crowd of women, this is one woman displaying herself before us in every conceivable variety of pose.

Yet another way in which artists heighten the erotic content of the female nude is by deliberately straying from the accepted ideal of their time – not merely through physical distortion, which may

186 BALTHUS, Study for a Composition, 1963–66

even serve to emphasize the 'ideal' nature of what is being shown, but by particularizing the physical type. One of the ways of sharpening erotic reaction to the female body is to show that body as immature, not yet fully ready for sexual experience. This is an overtone which is often to be discovered in the paintings of Balthus.

186 His Study for a Composition combines this means of excitation with the use of an intermediary voyeur-figure – the yet younger girl crawling on the floor, whose gaze is as explicit in its direction as that of the organist in Titian's Venus and the Organ-player.

Lust in action

Even more than the nude, the sexual act tickles the curiosity of artists and, of course, that of spectators too. Picasso summarizes the situation rather neatly in some of the etchings from the immense series done at Mougins in 1968: a wrinkled old man (perhaps a self-portrait), crowned with a fool's cap, looks on wistfully at the activities of a pair of vigorous young lovers. Commentators have chosen to interpret these prints as a statement about the impotence of age; they could equally well be taken as one about the essential impotence of art.

10/

A distinction is sometimes attempted between those representations of erotic activity which are merely erotic, and those which qualify for the loaded adjective 'pornographic'. The distinction is based, for example, on the question of whether or not the penis can actually be seen entering the vulva, or if some 'deviant' sexual practice such as

187 PABLO PICASSO, Etching, 1968

188 REMBRANDT,
The Monk in the Cornfield,
1645

fellatio is represented. Thus, the etching by Rembrandt which is rather coyly known as *The Bedstead* escapes total condemnation not only because of the genius of the artist, but because he has the tact not to display certain anatomical details.

The most interesting point about *The Bedstead*, however, is probably its realism in a more general sense. Satire plays no part, as it does in another erotic print by Rembrandt, *The Monk in the Cornfield*; nor does mythology, which supplies the excuse for Bernard van Orley's tempestuous *Neptune and a Sea Nymph*. These are ordinary people, engaged in an everyday activity, in perfectly ordinary circumstances. Realism is ennobled by Rembrandt's compassion – he is not afraid to show the act as being somewhat ridiculous, but he also recognizes its urgency to the participants. One sign of this urgency is to be detected in a strange detail: the woman has more than the usual complement of hands and arms; she clutches her lover firmly round the waist, and yet her hand is also to be seen lying relaxed upon the bed, beside his own hand with which he supports himself as he thrusts. It is like a double exposure on film, which records successive stages of the same action.

On the whole, despite Rembrandt's example, it was not until the advent of the Romantic movement that artists were able to nerve themselves to representing this subject without an excuse – without a mythological or satirical gloss. Fragonard's *sujets galants*, such as *The Happy Lovers*, as well as being the tail-end of Baroque art, can also be thought of as the beginning of a breakthrough continued by men such as Géricault, whose erotic scenes have the storminess appropriate to a true Romantic.

184

188

189

100

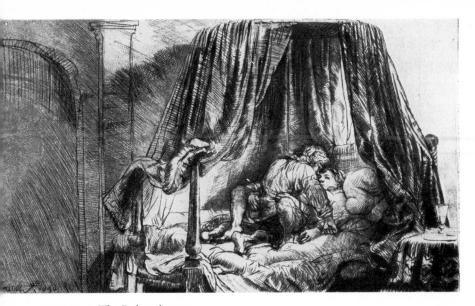

189 REMBRANDT, The Bedstead, 1646

190 THÉODORE GÉRICAULT, The Lovers (detail), 1815–16

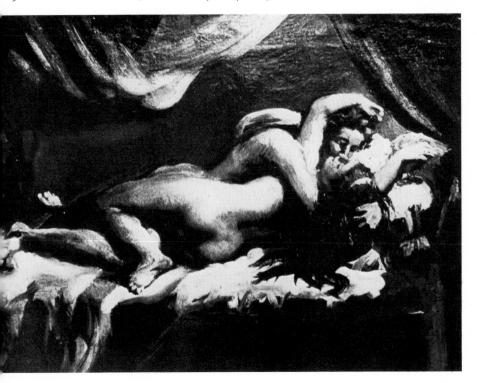

191 PAOLO VERONESE, Mars and Venus Embracing

But, even after the advent of the new attitude towards man's purpose in life and purpose in art which Romanticism represented, artists still found it hard to contemplate the 'deed of kind' with perfect steadiness and objectivity. Erotic scenes where the lovers, though naked, content themselves with kisses and caresses, were easier to handle. Thus it is that we have touchingly beautiful erotic representations from Fuseli, in a series of drawings of intertwined lovers; from Rodin, with his celebrated group *The Kiss;* and from Munch in some of his prints.

These continue a tradition of 'normal' sexuality which earlier had usually manifested itself in various compositions which show Mars and Venus embracing. In the version by Veronese in the Galleria Sabauda, Turin, for example, though the lovers are contemplated both by Cupid and by an amiable horse, we are given the feeling – as we are in the works by Fuseli, Rodin and Munch – that we are witnessing what is essentially a union of natural forces – that the lovers meet upon equal terms, with his strength well matched by her beauty.

192

192 EDVARD MUNCH, The Kiss, 1895

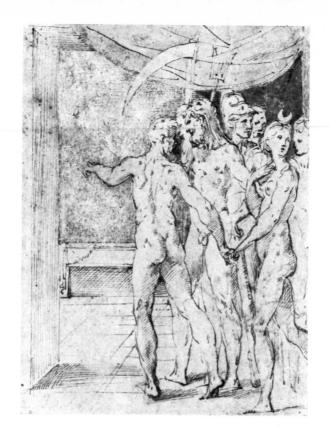

193 FRANCESCO
PARMIGIANINO,
Vulcan showing Mars
and Venus Caught in
the Net to the
Assembled Gods,
c. 1534–40

But, throughout the epoch when artists, thanks both to the pressures put upon them by society and to their own inner anxieties, were able to illustrate erotic themes only upon the pretext of illustrating some story from mythology or the Bible, the pattern of representation betrays feelings of guilt and impotence.

For example, there is the presence of a third party – Vulcan, the cuckolded husband – in many of the scenes which illustrate the story of the God of War and the Goddess of Love. In a drawing by Parmigianino he points to the adulterous lovers entangled in the net he has made to trap them, while his fellow Olympians react to the spectacle according to their own natures – Hercules guffaws, while Diana turns away in angry shame. Significantly, Mars and Venus have subsequently been obliterated by a later hand. In a painting by Tintoretto, Vulcan approaches Venus' bed, wherein she lies reluctant but yet compelled to receive his advances; Mars has hastily hidden

193

himself under a piece of furniture, but looks out to see what is going on. One of the most significant details in the painting is the large circular mirror in which we see Venus and Vulcan reflected; no detail of the coupling is to be lost to us, the spectators, or to the actors themselves. A preliminary drawing has survived which proves that this mirror was established very early in the artist's mind as an important feature of the composition. It is perhaps not too fanciful to liken it to the pupil of an enormous eye.

Even more specific, in their expression of feelings of guilt, are the works which illustrate the story of Samson and Delilah; a good example, perhaps less familiar than some others, is the drawing by Rembrandt in the Groningen museum. The hero lies asleep on his mistress's bosom, and two Philistines watch the couple from behind a curtain. Altogether, the Samson legend must have had a deep emotional significance for our ancestors: Samson's physical strength is brought to nothing through the operation of the sexual urge (a man is least capable of copulation at the very moment when he has just satisfied himself); and the cutting of his hair is itself a symbolic castration, the shears with which it is done a metaphor for the *vagina dentata*.

194 REMBRANDT, Samson and Delilah

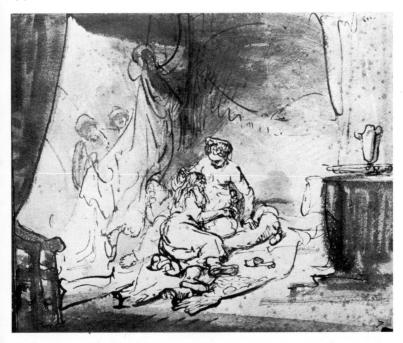

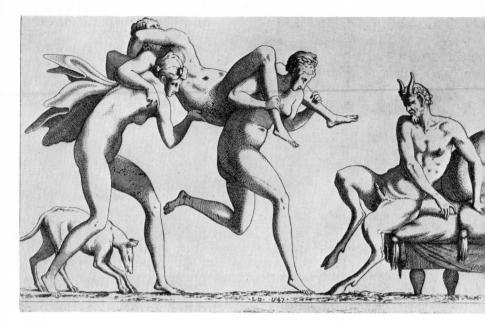

195 L.D. after PRIMATICCIO, Woman Being Carried to a Libidinous Satyr, 1547

The most striking thing, however, about most representations of sexual congress in European art is their violence – the violence offered by the male to the female. Satyrs and other half-human creatures were almost as popular with the artists of the Mannerist period as they had been with the Greeks of the late sixth century BC, and it is fascinating to observe the kind of context that was provided for them. Thus, among the Fontainebleau prints, we find a composition, engraved by Fantuzzi after an unknown artist, in which a satyr is 196 attempting to violate a nymph whom he clasps across his shaggy thighs (his enormous penis, already erect and ready for the deed, peeps from under her buttocks). He is being half-heartedly restrained by three Cupids, but it is clear that his triumph cannot be delayed. In another print, by L.D. after Primaticcio, a violently struggling 195 girl is being carried by two companions towards a couch, where an excited satyr is waiting to receive her.

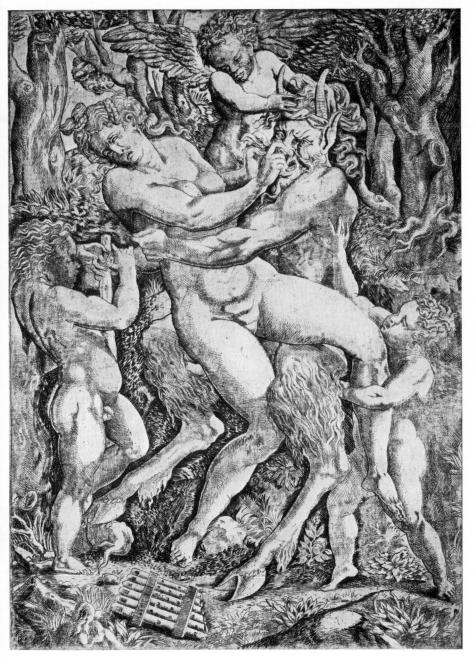

196 FANTUZZI after an unknown artist, A Satyr Assaulting a Woman Defended by Three Cupids, 1542–45

Rape scenes of all kinds are common in European art of the sixteenth and seventeenth centuries, and also later; Pluto and Proserpine, the Daughters of Leucippus, the Rape of the Sabine Women are among the subjects represented. (Picasso reverts to the idea in some of the prints of the Vollard Suite.) Most popular of all these rape scenes are probably the representations of Tarquin and Lucretia. The painting by Titian in Cambridge offers a particularly complete working out of its implications. Tarquin thrusts his knee between the thighs of his naked victim, and threatens her with a dagger which may be read as a symbolic penis. A figure at the left-hand margin of the composition looks in on the scene – the expected intermediary or substitute voyeur.

Perhaps it is in order to suggest a reason for this insistence upon violence (so universal that we even find it expressed in a modern drawing by the Soviet sculptor Ernst Neizvestny). In the first place, it might be argued that the artist has to bridge the gap between appearance and sensation – the act of love produces violent but subjective feelings in the participants, which the observer can only experience dimly, whatever his degree of sexual excitability. This argument can be taken further. Voyeurism and impotence are notoriously linked; so, too, are impotence and sado-masochism. The

197 ERNST NEIZVESTNY, Lovers in a Whirlwind, 1965–67

198

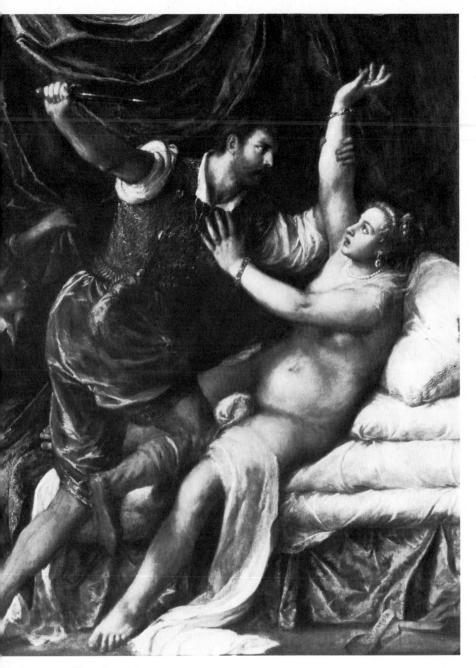

198 TITIAN, Tarquin and Lucretia, c. 1571

artist is placed in the role of an impotent voyeur; and there is much evidence to show that European erotic art is not only voyeuristic, but inherently sado-masochistic as well.

One traditional subject that comes to mind as an illustration of this point is the allegory of *Death and the Maiden*. No one who looks at the version by Hans Baldung Grien in Basle could doubt that it expresses not only the fear of death, but fear of the female, who must be punished because of the threat she represents.

Male fantasy encompasses not only the rape of the female by the male but, subsuming this, the rape of the male by the female. Since this is so present and urgent a terror in the mind of the man who unconsciously fears for his own potency, it is not surprising to discover that compositions alluding to it are usually rather oblique in their message. Rarely does one find anything so candid as the companion sheet to the print after Primaticcio already described. This shows a struggling satyr being borne towards a woman who

199 L.D. after PRIMATICCIO, Satyr Being Carried to a Woman, 1547

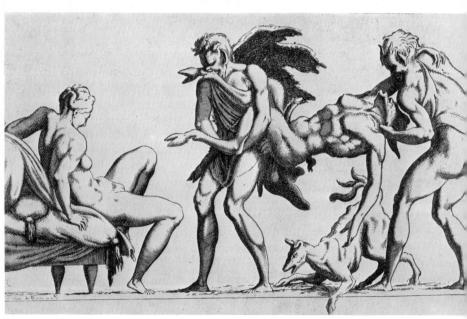

195

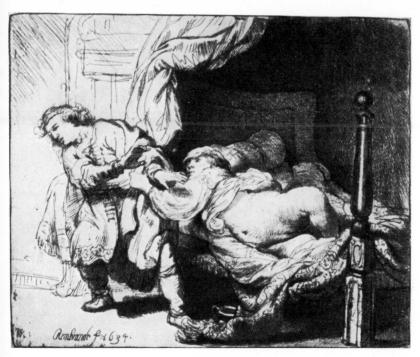

200 REMBRANDT, Joseph and Potiphar's Wife, 1634

opens her legs to receive him. There is a significant detail: one of the bearers bites the foot of the victim, in order to maintain his enthusiasm for the allotted task. Perhaps we may read this not merely as a mildly sadistic detail, but as an actual representation of the dread of the vagina dentata.

The more usual vehicle for the fantasy of the male raped by the female is an illustration of the crucial scene in the story of Joseph and Potiphar's wife. Generally, as in the painting by Tintoretto in the Prado and the etching by Rembrandt dated 1634, the virtuous Israelite is shown desperately wrenching himself away from the clutches of the lubricious and devouring Egyptian. Rembrandt emphasizes the woman's coarse sexuality not only through the physical type he has chosen, but through the way in which she is presented to the spectator – the lines of the composition point towards her enormous vagina, while the knobbed post at the foot of the bed metaphorically suggests the kind of penis that would be needed to fill it.

This print offers a good example of the way in which all elements – both of subject-matter and composition - tend to reinforce one another in the service of erotic impulse. It might be expected, for instance, that artists, in illustrating classical myths and Biblical stories, had intentions which were primarily narrative, and only secondarily erotic. But two interesting points emerge from a study of this kind of material. First, that in dealing with this material European art gradually developed a symbolic language; and second, that the incidents most frequently chosen for illustration are precisely those which involve the direct expression of the feelings I have been discussing. That is, the chosen incident - such as Tarquin's rape of Lucretia – offers a convention, a socially acceptable framework, for the expression of feelings which it might otherwise be impossible to externalize. The spectator and the artist enter into a kind of tacit conspiracy; the story - which is usually a story-with-a-moral makes the content acceptable. Guilt is kept at a distance thanks to the assumption that what is being shown, which might be offensive in isolation, is not being shown for its own sake. Thus the Fontainebleau prints, which lack a narrative theme, would traditionally be considered far more 'libertine' than the story of Joseph.

201 SCHOOL OF SQUARCIONE, Studies of classical themes (detail), c. 1455

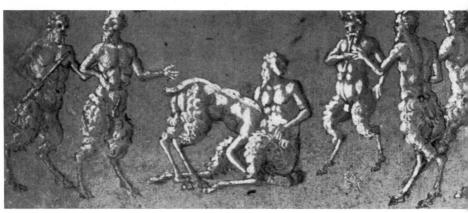

Deviations

Because aberrant sexual practices attract the condemnation of moralists even more certainly than normal ones, it is not surprising that they are even less frequently represented in their own right in the art of medieval and modern Europe. Our definition of what is aberrant, like all our ideas of sexual morality, is governed by the fact that we are inheritors of the Judaeo-Christian tradition.

In Greek and Roman art, themes of this kind are relatively common. Wall-paintings from Pompeii and Herculaneum, now in the Naples museum, treat a wide variety, some of them far-fetched by any definition, such as a scene where a male and a female acrobat engage in anal intercourse while balancing on a tightrope. When such scenes appear in Renaissance art, we can be reasonably sure that they are based on some antique prototype. A sheet of sketches from the workshop of the fifteenth-century Paduan artist Squarcione, for example, shows a meeting and a battle of centaurs, and then, in the lowest of the frieze-like compositions that fill the sheet, an act of homosexual fellatio between two satyrs while other satyrs look on. The disposition of the figures makes it clear that the prototype is likely to have been a Roman relief.

It was not until the nineteenth century that works of art illustrating deviant practices again began to multiply, though a few are known from the more libertine painters and sculptors of the eighteenth century, such as Clodion. These, like the finely illustrated libertine books of the period – favourite texts were Voltaire's *La Pucelle* and Restif de la Bretonne's *Le Paysan perverti* – were carefully stored away from the public gaze.

An exception must be made for scatological representations – where, in any case, the action itself is not deviant, but only the pleasure taken in looking at it. The art of the Middle Ages is exceptionally rich in scatology – examples include some of the gargoyles of the Hôtel de Cluny in Paris – and a taste for it long persisted in Northern Europe. The *Manikin Pis* in Brussels is perhaps the most public surviving reminder of this fact, but there are plenty of others.

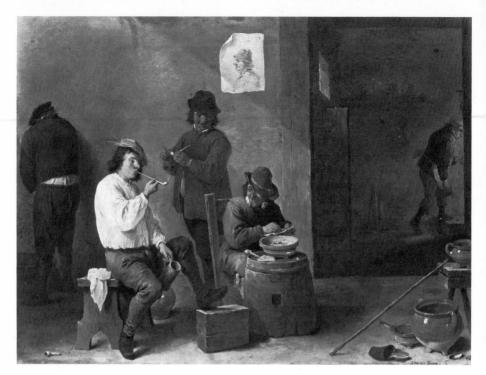

202 DAVID TENIERS THE YOUNGER, Boors Carousing, 1644

In a society in which it was difficult to achieve even the smallest measure of privacy, the sight of both men and women answering the calls of nature must have been commonplace indeed. The tavern scenes produced by Dutch and Flemish genre painters often include incidents of this kind – they seem to occur with especial frequency in the work of David Teniers the Younger. Rembrandt, too, did not shrink from such sights, as is proved by his etchings of a man and a woman urinating.

Scatological representations are nearly always treated in terms of genre. A work such as Hans Baldung Grien's print which shows a little faun perched on top of a wine-barrel, and pissing on the drunken Bacchus who lies helplessly below him, is exceptional even in the context of its time. Unlike other deviations, an interest in scatology did not require either the disguise or the excuse of mythological illustration.

198

202

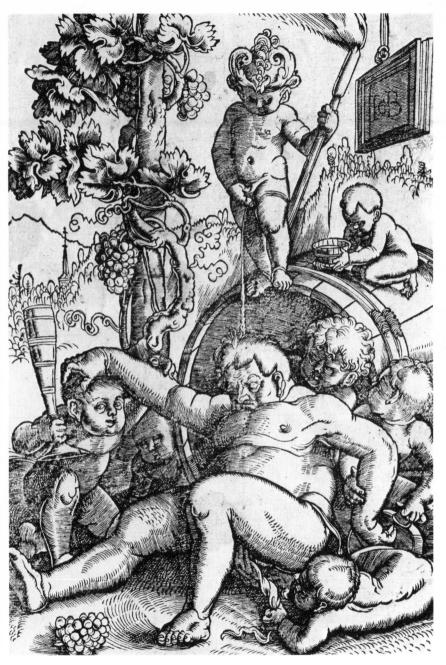

203 HANS BALDUNG GRIEN, Drunken Silenus, 1513–14

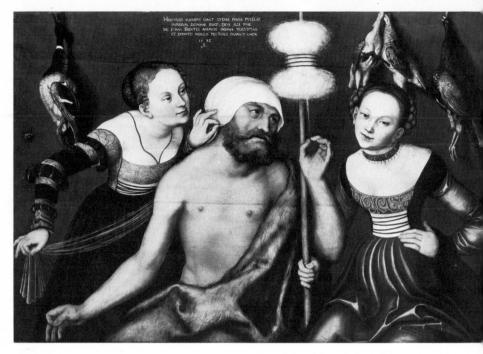

204 LUCAS CRANACH THE ELDER, Hercules and Omphale, 1532

Other situations had to be alluded to more obliquely. Yet here we must be careful. Are we, for example, to assume that a painting showing Hercules dressed in the clothing of Omphale is primarily an example of a given artist's interest in transvestism? Almost certainly not. On the other hand, it is impossible to deny the erotic feeling which Lucas Cranach brought to his *Hercules and Omphale* now in Berlin.

204

The rather rare theme of Aristotle and Phyllis, ostensibly an allegory of the subjection of the intellect to the passions, also invites a treatment which stresses the sexual undertones. The print by Hans Baldung Grien, though it closely follows a pattern established in late medieval art, submerges moral allegory in erotic fantasy: the naked Phyllis, whipping her victim forward, is very recognizably an ancestress of today's professional ladies, who offer 'strict discipline' to their clients in discreetly worded advertisements.

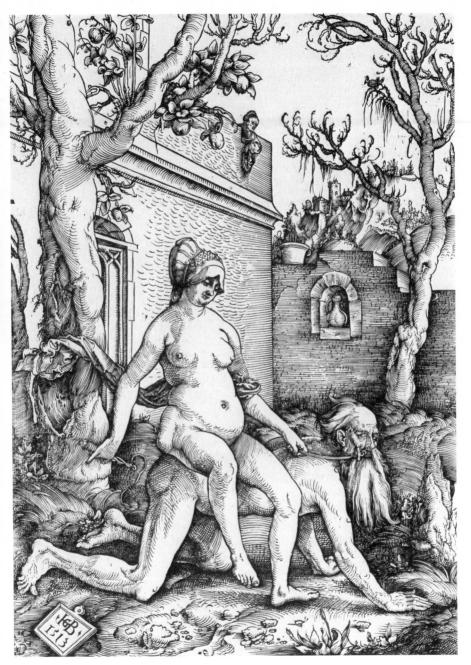

205 HANS BALDUNG GRIEN, Aristotle and Phyllis, 1513

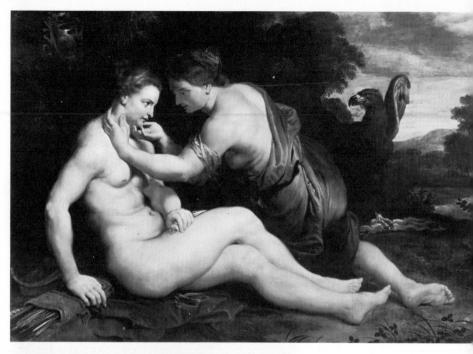

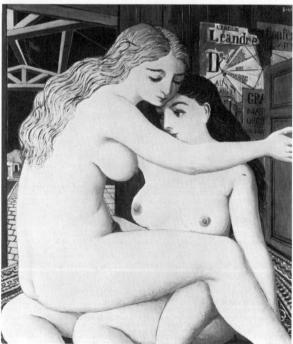

206 PETER PAUL RUBENS, Jupiter and Callisto, 1613

207 PAUL DELVAUX, Two Girls, 1946

207

Where the European visual arts are concerned, the most richly represented of all sexual deviations is undoubtedly lesbianism, and it seems to me that there are several interconnected explanations for this preponderance. First, since erotic art for the most part addresses itself to males, there is the attempt to satisfy male curiosity about what females do when they are alone together. Secondly, Freudian theory inclines to the hypothesis that a voyeuristic interest in lesbianism is directly linked to the voyeur's own castration fear. A woman who acts as if she already possessed a penis is, for the watcher, a reassuring spectacle, in that she is less likely to try and rob him of his own.

Many paintings showing Diana and her nymphs have lesbian overtones, which indeed are implied in the body of myths concerning

208 LOVIS CORINTH, Friends, 1904

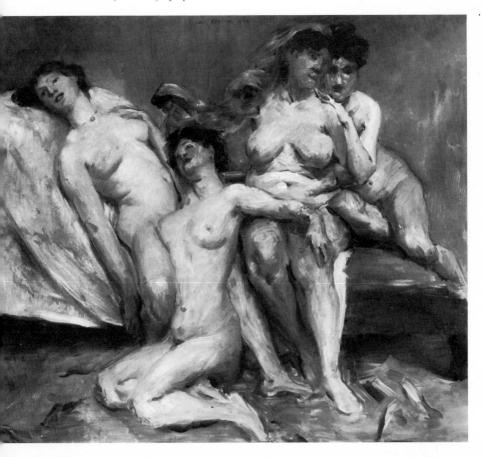

this goddess, but few are so specific as the painting by Rubens representing the courtship of Jupiter and Callisto. In order to win this especially obdurate nymph, the god has been forced to turn himself into the semblance of Diana, whose follower and devotee Callisto is. Only the eagle in the background serves as a warning that the situation is not as it seems. What is represented – one woman making sexual advances to another – must necessarily work upon the spectator more powerfully than any knowledge he may happen to have of the legend which supplies the work with its pretext. It seems to me that this would have been true even in the seventeenth century, when the classical myths were more immediately and certainly a part of any educated person's mental furniture.

In the nineteenth century, such mythological pretexts were laid aside. Courbet's *Sleep* is only one – if the most celebrated – among many lesbian representations to be discovered in the art of the nineteenth and twentieth centuries – we find similar couples in the drawings or paintings of Rodin, Klimt and Pascin, among others. The German Impressionist Lovis Corinth even contrives to present us with what seem to be the preliminaries of a lesbian orgy, in a painting which, for all its evident merits, ought to stand as a warning of how quickly the erotic can transform itself into the ridiculous.

The tabu against male homosexuality being so much stronger than the tabu against lesbianism, homosexual feelings between men have mostly been forced to express themselves in much more devious ways. One way is through an interest in the androgyne. Examples of this are to be found in the work of both Leonardo da Vinci and Michelangelo. Leonardo's St John the Baptist has always disturbed commentators because of its sexual ambiguity – indeed, the painting is an example of a work of art with an extremely high level of erotic content where nothing overtly erotic is represented. The same is true of the Bacchuses of Michelangelo and of Caravaggio. Michelangelo's Bacchus has always tended to shock commentators, who object to what they term its 'coarseness of expression'. Vasari, on the other hand, admired what he termed 'a marvellous blending of both sexes – combining the slenderness of a youth with the round fullness of a woman'.

Homoeroticism can be a matter of pose as well as form. Parmigianino's drawing *Ganymede* makes the point not merely through the legend of Ganymede's abduction by Jove's eagle but through the

140

208

88

81

210

provocative attitude of the principal figure. Caravaggio's *St John the Baptist* relies not only on the provocative pose and expression of the figure (the pose is a parody of Michelangelo's *ignudi* in the Sistine Chapel), but on an ingenious distortion of traditional iconography. Instead of being accompanied by a lamb, St John nestles against a full-grown ram – easily read as a symbol, not of innocence, but of the male lust the boy exists to satisfy.

Certain commentators have long held that Michelangelo's Victory, in the Palazzo Vecchio in Florence, is to be construed as an expression of another aspect of homosexual feeling – the desire of the lover to subject himself to his younger partner. For this reason, attempts have been made to prove that the crouching figure is intended as a self-portrait, and that the triumphant youth is to be identified as Tommaso Cavalieri, or, more probably, as one of Cavalieri's predecessors in the sculptor's affections. Known portraits of Michelangelo have, however, only a general resemblance to the lower figure in the Victory group. Although the intended symbolism of the sculpture remains obscure, one must respect, I think, the fact that so many spectators have discovered homoerotic emotion in it. Whatever his conscious intention, subconsciously at least Michelangelo seems to have been expressing feelings and attitudes towards his own homosexuality.

209 FRANCESCO PARMIGIANINO, Ganymede

Narcissism is more difficult to situate firmly in art than homosexuality. The most famous case is probably that of Dürer, author of a series of intensely revealing self-portraits, including that in the Prado, in which he presents himself as a handsome young gallant with elaborately curled hair, and that in Munich, where he seems to equate his own image with the traditional iconography of the Salvator Mundi. It seems legitimate to connect these with the drawing of a nude, also apparently a self-portrait, reproduced here. In an age notably prudish about representations of the male genitalia, Dürer seems to have scrutinized his own with the same degree of attention

210 MICHELANGELO, Victory, 1527-28

211

211 ALBRECHT DÜRER, Self-portrait, c. 1506-7

212 GIOVANNI LANFRANCO, Young Boy on a Bed

that he brought to studying his features. The way in which the sexual organs are drawn is quite different, for example, from the conventional way in which Dürer draws them in the sheet showing Adam and Eve which is now in the Pierpont Morgan Library.

Equally narcissistic in feeling is the painting of a Young Boy on a Bed, by Lanfranco, which recently made an appearance in a London auction-room. The painting is not a traditional academy; instead, it seems intended as a parody of the reclining Venuses favoured by sixteenth-century artists such as Titian. Lanfranco has even provided the boy with a cat – the equivalent of the little dog which often accompanies Venus, and an equally delicate allusion to latent animality. But there is a further point to be made – the boy himself appears to be a self-portrait of the artist, not only because the face resembles other known portraits, but because the picture was fairly obviously painted with the help of a mirror, something which gives a rather different complexion to what at first might seem an unusually candid example of a homosexual representation.

A third tabu revealingly treated in a number of works dating from the sixteenth and seventeenth centuries is the tabu against incest. There are, for example, a number of representations of Lot engaged in dalliance with his own daughters (after the destruction of Sodom, Lot, who had no son, was made drunk by his own daughters, who then lay with him in order that he should beget one). The painting of this subject now in Vienna shows Lot lying in a close embrace with one daughter, while the other sits naked in the middle distance, apparently awaiting her turn. Far away behind her, Sodom still burns.

The thing which is striking about the painting is the domestic air which the artist has given the scene. There is no feeling of guilt or shame – the patriarch clasps his beautiful daughter confidently, enthusiastically and – dare one say it? – rather cosily. It seems like the fulfilment of a dream which many fathers have had about their daughters, and many daughters about their fathers. The myth itself seems to excuse what is represented.

213 ALBRECHT ALTDORFER, Lot and his Daughters, 1537 (?)

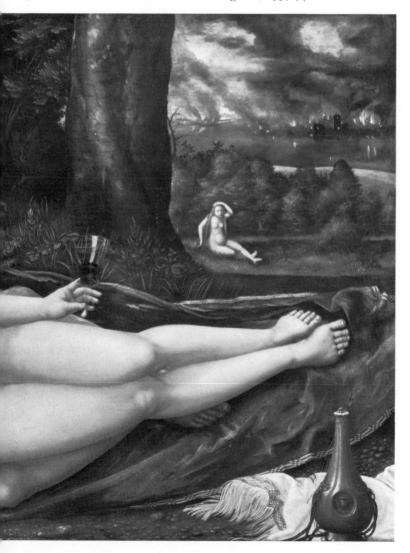

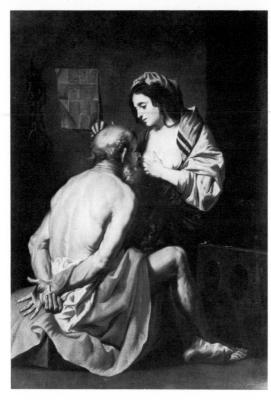

214 MATTHÄUS STOMER, Roman Charity

Precisely the same thing can be said about a less common subject, the so-called *Roman Charity*, which illustrates a story about a dutiful daughter who kept her father alive, after he had been condemned to starve to death in prison, by feeding him with her own milk. The old man's mouth, closing upon the breast of the beautiful girl, inevitably seems to be bestowing a caress.

It must be said that in these cases the blood relationships between the persons represented, which is something that must be assumed from the spectator's prior knowledge of what is being shown, is probably of much less importance than the very visible difference in age between the parties concerned. The lesson implied, in the *Roman Charity* as much as in *Lot and his Daughters*, is a reassuring one: that erotic prowess need not fail with the years.

Altogether, it would be difficult to find two better examples of the complex relationship between the myth which is supposedly being illustrated, and the representation itself.

Pleasurable pains

One deviant sexual fantasy is so frequently and urgently expressed in European art that it calls for more detailed treatment here. This fantasy concerns the plight of the bound and helpless victim.

The greatest blot on the long history of European civilization is its addiction to cruelty – a cruelty often sanctified and made respectable by the machinery of Church and State. For many centuries, public executions remained popular and well-attended spectacles all over Europe. Callot's prints of the *Miseries of War*, based upon what he had seen of the progress of the Thirty Years War in Lorraine, give some idea of the ingenuity with which human beings were put to death in the name of justice.

From the point of view of our present investigation, however, it is mythological and religious works that better illustrate both sadistic fantasies and the probable psychological explanations for them. The paintings which show *Perseus and Andromeda*, or, alternatively,

215 JACQUES CALLOT, The Wheel, from Miseries of War, 1633

Ruggiero and Angelica, are interesting from several angles. There is, for example, the fact that the fantasy of bondage is combined with a fantasy of rescue which apparently contradicts it, but which is perhaps even better thought of as excusing it. There is, too, the implied symbolism of the dragon which threatens to devour the maiden; its gaping jaws, as in Titian's Perseus, may be thought of as another version of the vagina dentata – the composition hints that we are to think of the beast's aggression as directed less at the woman than at the man. In Ingres's Ruggiero, the hero is actually shown thrusting his immense lance straight into the monster's mouth. Jungian and Freudian theory are on this occasion more or less in step with one

216 TITIAN, Perseus and Andromeda, c. 1554

216

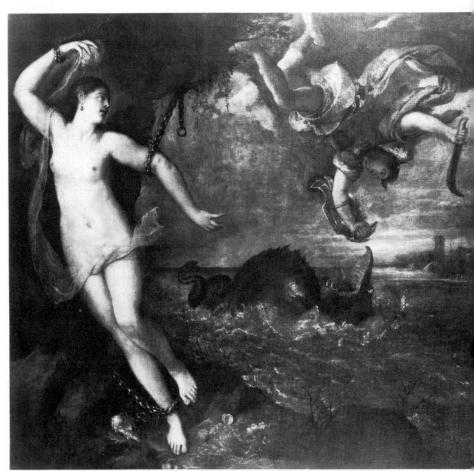

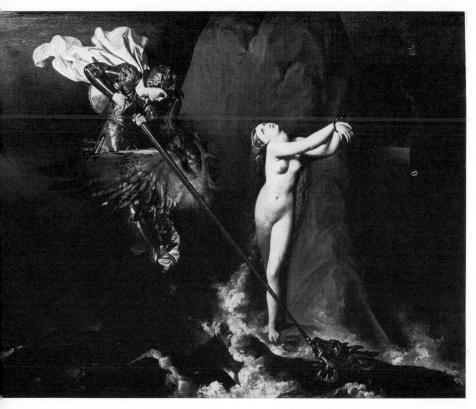

217 JEAN-AUGUSTE-DOMINIQUE INGRES, Ruggiero and Angelica, 1819

another: Jung says that the hero's action, in rescuing the maiden from the peril that faces her, can symbolize the freeing of the anima (or essential self) from the 'devouring' aspect of the mother.

If we examine a number of scenes of this type, one thing is evident beyond contradiction – the tendency for the female figure, despite her bonds, to be presented in the most inviting manner possible. This tendency can also be discovered in religious paintings showing the martyrdom of female saints, though here the sadism loses any element of playfulness, and is savagely in earnest. Sebastiano del Piombo's disquieting *Martyrdom of St Agatha* is a case in point. Not only is the particular form of torture to which the saint is being subjected an overtly sexual one, but she herself seems to welcome it with far from holy ecstasy.

218 SEBASTIANO DEL PIOMBO, Martyrdom of St Agatha, 1520

Often these martyrdoms strike the modern spectator as being a little comic – but perhaps we laugh in order to protect ourselves from their sadistic implications. Lelio Orsi's St Catherine is shown being tormented on a machine whose fantastic ingenuity and elaboration would do credit to Heath Robinson. All the same, we must recognize the kinship between what is shown in this painting and the images which make their appearance in the 'specialized' films and photographs of the present day. Sometimes, indeed, we seem to catch a glimpse of consciously excitatory intention, as in the extraordinary painting The Young Martyr, by the Bolognese artist Cagnacci. Here the figure, shown without any conventional attributes which might enable us to identify her, but surrounded nevertheless with instruments of torture, seems devoid of any devotional purpose, and intended merely to excite a sexual appetite of a particular kind.

214

219

Curiously enough, however, it is representations of male saints which offer more abundant material for the study of sadistic imagery in painting than representations of female ones. St Sebastian, for example, is one of the most frequently represented personages in Christian art, and the scene chosen is most usually that in which we see him bound and pierced with arrows (the role played by the arrow as one of the most candid of phallic symbols will be remembered from my first chapter).

Occasionally the saint is shown as an androgynous being – a Christianized version of the Hermaphrodite. We see him thus in a painting by Biliverti, a seventeenth-century Florentine, who has actually endowed him with a pair of female breasts. More usually, however, he is shown as a beautiful youth of unambiguous sex. Artists are often at some trouble to stress the agonies to which he is being subjected – there is a *St Sebastian* by Mantegna in which one of the arrows passes clean through the victim's head, entering under the

220 GUIDO CAGNACCI, The Young Martyr

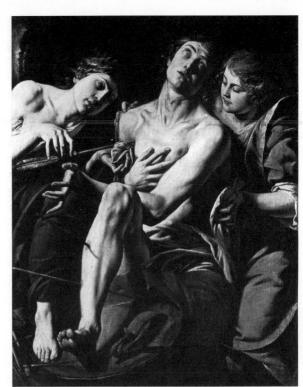

221 TANZIO DA VARALLO, St Sebastian Tended by Angels, c. 1620–30

jaw to emerge in the centre of the forehead; a similar detail can be found in a drawing by Urs Graf. A common elaboration is to show the saint being tended by angels or holy women – a scene which links the kind of rescue fantasy I have already mentioned in connection with the legend of Perseus to the masochistic rapture which one so often finds in martyrdoms. How ambiguous the expressions and gestures are, for example, in Tanzio da Varallo's St Sebastian Tended by Angels! The saint himself is in a trance of emotion and pain; the angel on the left grasps one of the arrows with an affected gesture which makes it seem uncertain whether he is trying to draw it out, or is in fact determined to press it further in; and another arrow, piercing Sebastian's calf-muscle, points – thanks to the position of his leg – directly towards his groin.

We also get a full measure of both eroticism and sadism not only in scenes representing the martyrdoms of other popular saints – St Lawrence writhing on his gridiron, St Andrew being crucified, St Bartholemew being flayed like Marsyas – but in Passion subjects.

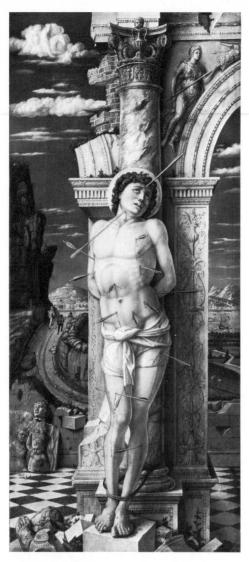

222 ANDREA MANTEGNA, St Sebastian, c. 1457–58

The Mocking of Christ and the Crucifixion itself were treated by artists with an intensity which was often more savage than compassionate. If the Good Thief and the Bad Thief are represented in a Crucifixion group, these are often used to bring home to the spectator, in contrast to the idealized figure of Christ, the full pain and humiliation of punishment.

Even this does not come near to exhausting the repertoire of sadistic subject-matter in European art. Among the more commonly represented mythological scenes, for example, we find Prometheus. chained to the rock; and the Old Testament supplies the story of Samson, who is shown blind and in prison, as well as in Delilah's bed. Yet here one must pause, to point out that many erotic representations fit into not one but several of the categories I have been using. Samson, for example, is a story about loss of potency. When Delilah seduces the hero, and then cuts his hair, she plays the classic role of the castrating woman - the cropping of the hair symbolizes quite plainly the cropping of the penis. The loss of eyes which follows can not only be read as a loss of testicles, but tells us that this is also a version of the Oedipus story. Annibale Carracci's Samson in Prison, now in the Villa Borghese, can be used to support all of these interlocking interpretations. We do not have here the erotic contortions of a St Sebastian. The massive figure (the physical type and pose clearly derive from Michelangelo's Captives for the tomb of Pope Julius II) seems resigned, like the protagonist of some Greek tragedy, to what fate has brought.

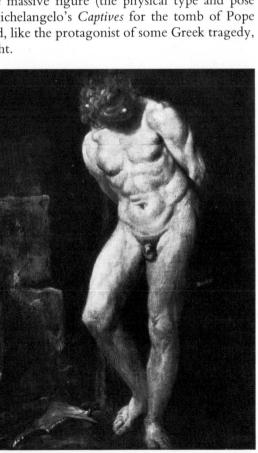

223 ANNIBALE CARRACCI, Samson in Prison, c. 1695–1700

224

Prometheus, too, is the hero of a story which can be made to yield Oedipal as well as sado-masochistic connotations. Prometheus' punishment – to be chained to a rock, and to have his liver perpetually eaten by an eagle, and perpetually renewed – is imposed upon him for stealing fire from the gods. That is, he has rebelled against the father, and in particular has tried to take over the father's creative (or procreative) function. The early Rubens of *Prometheus Bound* is particularly fascinating for two closely interconnected reasons. One is the position of the eagle in the picture itself: it seems to threaten Prometheus' eyes with its claws as much as it threatens his liver with its beak. The second is the fact that the painter has used the same drawing for Prometheus as he used (reversed) for the body of Argus in a contemporary painting, *The Death of Argus*. Argus, it will be remembered, was the hundred-eyed watcher appointed by Juno to

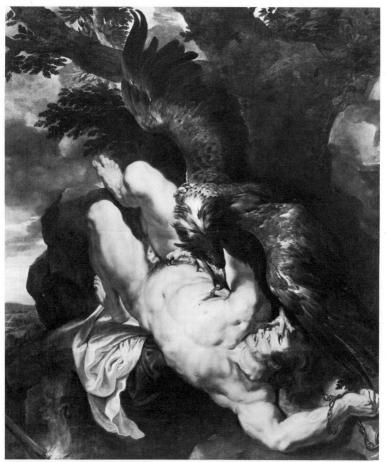

224 PETER PAU RUBENS, Prometheus Bou 1611–12

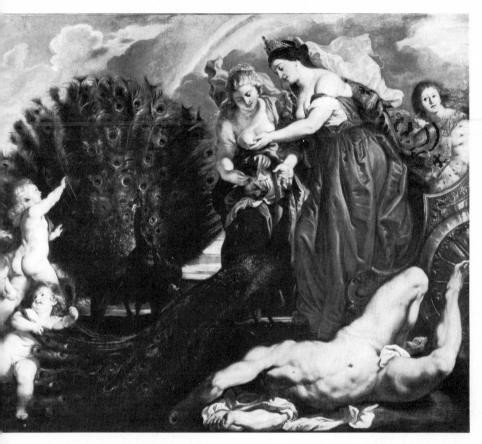

225 PETER PAUL RUBENS, The Death of Argus, 1611

spy upon Io, the beloved of Zeus. Mercury lulled Argus to sleep, and then cut off his head (a very common castration symbol, as I hope to illustrate in the next chapter), whereupon Juno placed his hundred eyes in the tail of her favourite bird, the peacock.

Yet another dimension can be given to the interpretation of these two paintings by Rubens: the Prometheus-Argus link also suggests that Rubens may have felt that part of Prometheus' crime was voyeurism: the untoward visual curiosity which impels the artist towards creativity. If this hypothesis is correct, the picture is masochistic indeed, hinting as it does at several facets of the desire for self-punishment.

More candid expressions of masochistic feelings are not lacking in European art, as we shall see from the next chapter. One example worth mentioning here, because it has an interesting connection with Michelangelo's *Victory*, the obvious source of the compositional idea, is Balthasar Permoser's group, *The Apotheosis of Prince Eugene*, where the sculptor has represented himself in the guise of a crouching Turkish prisoner, upon whom the triumphant general rests his foot.

Genre scenes, though less amenable as a vehicle for sado-maso-chistic feeling than religious and mythological compositions, are occasionally used for this purpose. As I have noted, life was harsh enough until comparatively recent times to supply the artist with a wide choice of subject-matter. Primitive medical, and particularly surgical, techniques, were a commonplace. There exists, for example, a series of compositions by Dutch genre painters of the seventeenth century, which show itinerant dentists at work. A certain brutal humour is to be found in these paintings. I remember seeing one, by an anonymous artist, in which the patient, in order to counteract the agony of having his teeth drawn, has opened his breeches, and is vigorously masturbating.

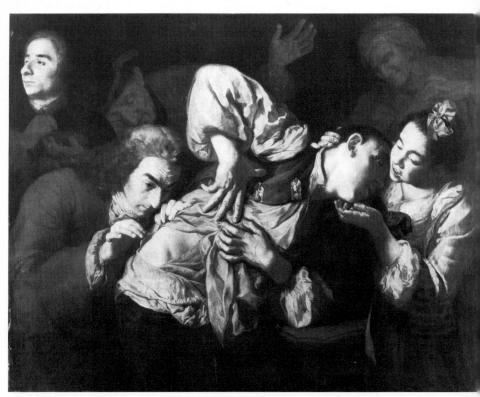

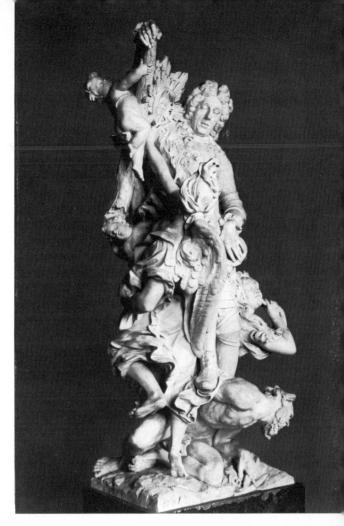

226 GASPARE TRAVERSI, The Wounded Man

227 BALTHASAR PERMOSER, The Apotheosis of Prince Eugene, 1718–21

Far more powerful and remarkable as a work of art is the genre painting by the eighteenth-century Neapolitan painter Gaspare Traversi illustrated here. Traversi's *The Wounded Man* is a secular variant of *St Sebastian Tended by Angels* and *St Sebastian Tended by Holy Women*. The expressionism of the style, and, in particular, the packed and spatially illogical arrangement of figures, bring the victim's sufferings into sharp focus – and it is these sufferings which become the spectator's point of identification. The painting is therefore less ambiguous about pain and the infliction of pain than the religious works from which it derives.

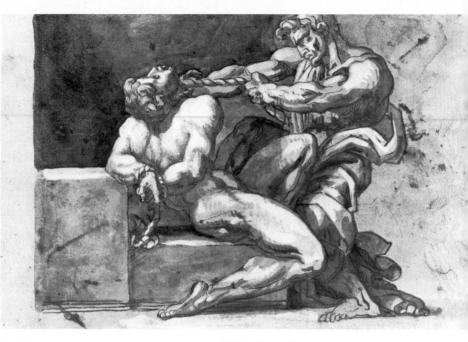

228 THÉODORE GÉRICAULT, A Nude Being Tortured, c. 1817

forward to the artists of the Romantic movement. As I have noted, sadistic subjects were very much in vogue with nineteenth-century artists. However, there is an important change in orientation: sadistic aggression is henceforth more and more directed towards women, and subjects where it is men who suffer become less common. Delacroix's Mazeppa, Géricault's powerful drawing in the Musée Bonnat, Bayonne, A Nude Being Tortured, and a handful of paintings by Gustave Moreau, such as his Prometheus or his Death of the Suitors, are conspicuous exceptions to this rule, but exceptions nevertheless.

The element of the excessive in *The Wounded Man* points the way

In our own century, the expression of sadistic aggression towards the female remains very common in art: we find it, for example, in the deformations and dismemberments imposed upon the female figure by artists such as Bellmer and Dali. Aggression towards the male, on the other hand, is now largely confined to caricature. The savage distortions of Gillray are matched, and more than matched, by those of contemporary satirists such as Gerald Scarfe.

168–69

125

228

111, 114 229

229 GERALD SCARFE, Caricature of Lord Snowdon, c. 1965

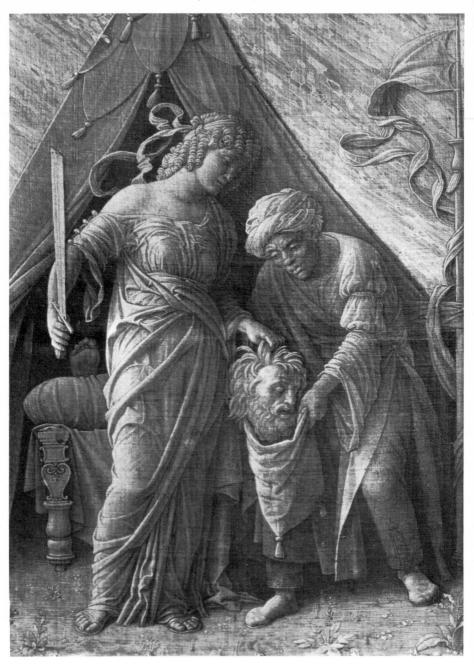

230 ANDREA MANTEGNA, Judith with the Head of Holofernes

Here comes a chopper

The basic fear of the male, from the sexual point of view, is that of castration, and, more specifically, that of the castrating female. This terror can in fact act so powerfully as to render the subject impotent (this, too, is implicit in the story of Samson, who 'loses his strength'). So deeply rooted is it, that direct expression of it must necessarily be rare. The School of Fontainebleau print, by L.D. after Primaticcio, is almost the only candid example known to me – though perhaps the medieval illustration showing William III of Sicily being blinded and castrated might be counted as another.

232

33

The print has a certain gruesome fascination. For example, it is just as much a 'bondage' picture as an *Andromeda*, or a *St Sebastian*, or a *Flaying of Marsyas*. Indeed, by comparison, it emphasizes the masochistic element in the two latter. Many versions of the *Flaying of Marsyas* suggest that it is the punishment of castration, rather than the canonical one, which is about to be inflicted on the helplessly waiting victim.

Mostly, however, the fear of castration is expressed through symbolic displacement. The sexual organs are not threatened; instead the head is cut off. The large number of surviving paintings depicting Salome, Judith, and the boy David confirms the importance of the theme. So does the curious persistence of interest in the legend of Salome, which lasted into the nineteenth century and beyond, and obsessed not only Oscar Wilde and Richard Strauss but the whole Symbolist movement.

The story of Judith and Holofernes is, however, the one which symbolizes the castration fear in perhaps its simplest form, because the woman is directly the aggressor. It comes as no surprise to find that the hero of Sacher-Masoch's story *Venus in Furs*, the classic fictional expression of male masochism, has a fantasy in which he imagines himself as Holofernes, victim of a beautiful and implacable Judith. In art, Judith's deed is often endowed with tremendous, almost surrealistic violence. Caravaggio painted a particularly gruesome version which influenced many artists during the seventeenth century;

it seems, for instance, to have been the inspiration of the painting by his French follower, Valentin, which is illustrated.

Holofernes comes to grief thanks to the power of sexuality.

Cranach made this very plain in his full-length *Judith* formerly in Dresden, where the heroine was shown nude, but for a transparent veil, and carried Holofernes' severed head in one hand and his sword in the other: through female sexuality (so the picture tells us) Judith has succeeded in cutting off and stealing her lover's virile powers. The outsize weapon is as significant as the head itself in this pantomime of penis envy. We get a variation of this kind of symbolism in the grisaille by Mantegna in Dublin, where Judith is thrusting Holofernes' head into a bag – i.e. is making it vanish – before she takes it away with her.

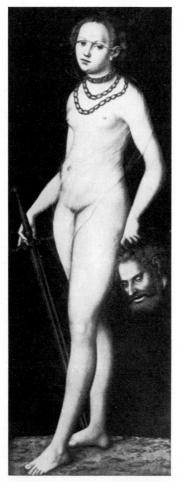

233

232 L.D. after PRIMATICCIO, Nymph Mutilating a Satyr, c. 1543–44

233 VALENTIN, Judith and Holofernes

231 LUCAS CRANACH THE ELDER, Judith, 1537

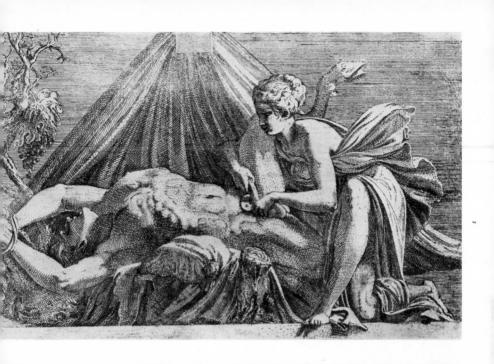

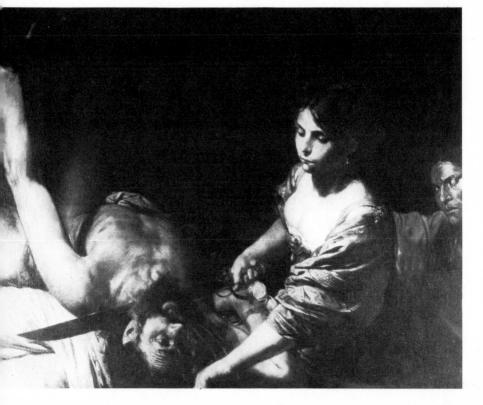

In many respects closely comparable to the story of Judith – but less often illustrated – is that of Jael and Sisera, in which the heroine disposes of her sleeping enemy by driving a tent-peg through his head. This spike, comparable to the arrows which occasionally pierce the head of St Sebastian, is a stolen penis being used to attack its rightful owner.

Salome differs from Judith because she demands the head of the Baptist, but does not herself cut it off. The Baptist himself is a major

235 REMBRANDT, Jael and Sisera, 1648-50

saint in the Christian calendar, and it is therefore not surprising to find his martyrdom frequently represented in Christian art. More unexpected, perhaps, is the degree of prominence which is often given to the executioner in versions of the subject. Often, we are almost encouraged to see him as John's triumphant rival, able to dominate the castrating woman rather than fall victim to her. Sometimes the executioner is coarse and brutal in type, but not always. On occasion, indeed, he is almost coquettishly posed, his back towards the spectator, with a strong erotic emphasis on his buttocks and his muscular legs in their tight-fitting hose. One of the most extreme examples I know is the painting by Bachiacca now in Berlin. We can perhaps read into this a hint of the homosexual attraction which may link the masochist to the man who supplants and triumphs over him; this, again, is a situation alluded to in *Venus in Furs*.

Salome's reaction to her gruesome prize is shown by artists in a variety of moods. In Caravaggio's *Decollation of St John* in Valletta Cathedral, she holds out the dish in readiness, but looks squeamishly away. Guido Reni, in the wonderfully grand *Salome Receiving the Head of the Baptist*, now in Chicago, depicts her as coolly self-possessed. In a painting by Francesco del Cairo, on the other hand, she faints with horror as the head is put before her. Interestingly enough, this painting is sometimes labelled *Herodias* rather than *Salome*, because of the apparent maturity of the female figure; it is perhaps not too risky to interpret the difference between the Reni and the del Cairo as reflecting the difference between the awakened and the unawakened woman – at least as the male would like to see it.

Salome's immaturity and her frigidity were, of course, important elements in the fantasies which nineteenth-century artists wove about her. We find this in the famous Beardsley illustrations to Oscar Wilde's play, where Salome combines depravity and innocence in a manner characteristic of author and artist alike. But Beardsley's

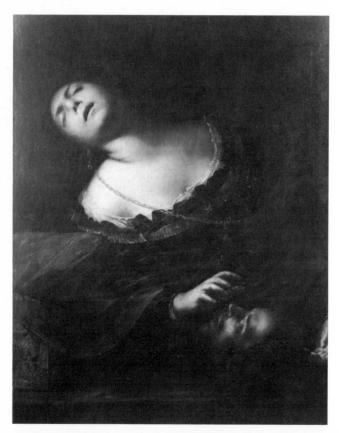

247

236 FRANCESCO DEL CAIRO, Herodias

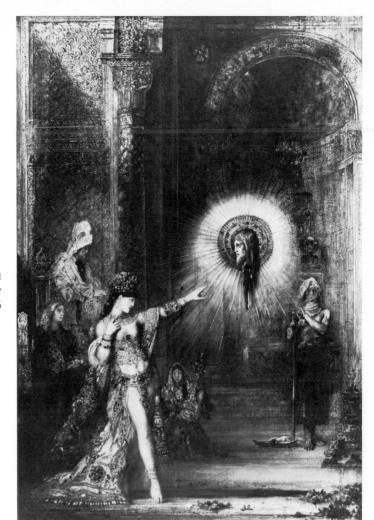

237 GUSTAVE MOREAU, The Apparition, 1876

Salome is preceded by Moreau's. Moreau was fascinated by the legend, and treated it over and over again. In *The Apparition*, for example, Salome is haunted by a vision of the severed head of the prophet. Perhaps we may interpret this scene as a metaphor (invented by the male unconscious) for the plight of the frigid woman. The satisfaction she so ardently desires hovers just out of reach, while at the same time she both covets and threatens the instrument through which it must be achieved.

Paintings which show the boy David holding the head of Goliath, whom he has just slain, must primarily be read as statements of Oedipal feelings. But it is also possible, I believe, to read some of them, at least, as homosexual variations on the themes of Judith and Salome. The aggression felt towards the homosexual partner in paintings of St Sebastian is now transformed into masochistic submission. The clearest case is provided by Caravaggio's well-known David with the Head of Goliath, where the gruesome relic of triumph which the boy grasps is, according to well-established tradition, a self-portrait, while the boy himself, according to a contemporary source, represents the artist's current Caravaggio.

Nor is this the only time that we find a confessional metaphor of this kind in Caravaggio's work. The *Head of Medusa* in the Uffizi was painted early in Caravaggio's career, at a time when we know

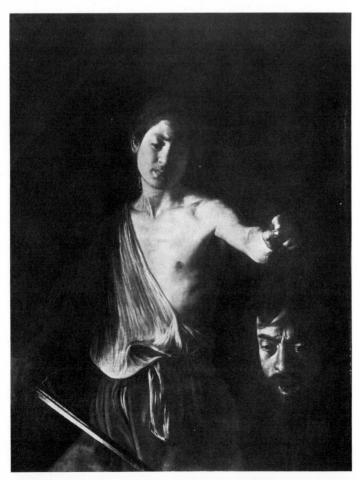

238 CARAVAGGIO, David with the Head of Goliath, 1605–6

that he was accustomed to use himself as a model – a number of early fancy pictures of young boys are fairly evidently self-portraits only lightly disguised, and contemporary sources record that at this period he was producing small works 'painted in a mirror'. If we compare the *Medusa* with other paintings of the same period, it is clear that this, too, represents the artist.

Though the *Medusa* is earlier than the *David*, the unconscious symbolism goes a stage further: not only is there a decapitation/castration which the painter refers directly to himself, but, at the same time, a change from male to female. The snakes – usually to be read as phallic emblems – seem to attack the head which they surround, and one strikes towards the screaming mouth, in which the teeth are prominently visible. Roger Hinks, one of the principal authorities on Caravaggio's work, notes that the screaming grimace seen here evidently had a special significance for the artist, as it is to be seen in other pictures, including one of the disguised self-portraits already referred to, in which we see a beautiful, rather effeminate young boy being bitten in the finger by a lizard. The same grimace can also be found in works by artists other than Caravaggio; it always seems to convey a feeling of erotic excitement.

240 THÉODORE GÉRICAULT, Two Severed Heads, 1818

Caravaggio has been so intensively studied that it is easy to find connections between his paintings and the facts that are known about his life: his early biographers make it quite plain that he was a homosexual, and the temptation is to refer the type of symbolism to be discovered in his paintings to this established fact. Yet the confessional aspect of Caravaggio's work is not unique. Cristofano Allori, a Florentine contemporary, widely different in style, is the author of an impressive *Judith*, in which, again, the head of the victim is by tradition a self-portrait. The heroine's own coolly triumphant air would probably have satisfied Sacher-Masoch himself.

The castration fear also seems to make its appearance, though in more disguised form, in the studies of guillotined heads which Géricault made in preparation for his vast painting *The Raft of the Medusa*. This, with its heaps of dead and dying bodies, certainly required the painter to form some acquaintanceship with the lineaments of death. But the studies have an obsessional intensity which transcends their apparent purpose – a painting such as the one in Stockholm (the best known of the series) may reasonably be regarded as a vehicle for personal statement.

240

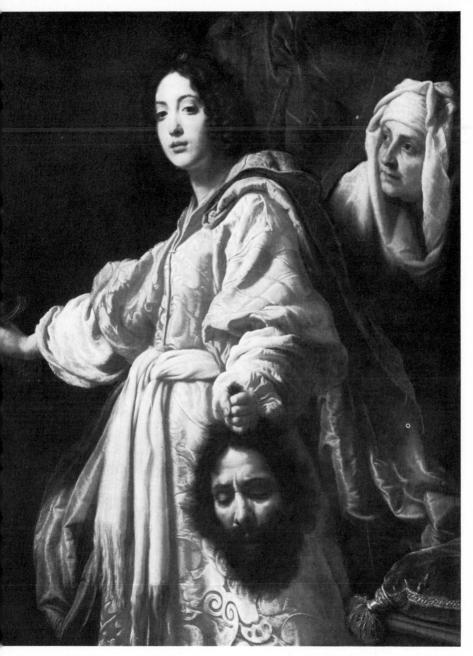

241 CRISTOFANO ALLORI, Judith

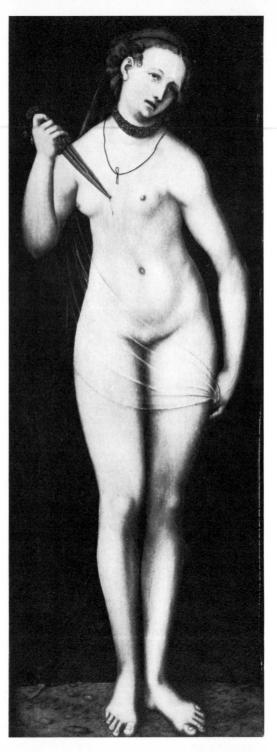

242 LUCAS CRANACH THE ELDER, Lucretia, 1537

Symbols and disguises

The male fear of female aggression is matched, and even overmatched, as we have already seen, by sadistic impulses towards women. It is therefore not unexpected to find that these impulses, in addition to being expressed directly – as, for example, in the slave-market scenes beloved of the nineteenth century – are also presented in symbolic form. I have already noted the popularity of the Tarquin and Lucretia story as an image of sexual violence. In fact, however, representations of Tarquin's assault upon Lucretia are probably more than matched in number (and therefore, presumably, in popularity) by representations of Lucretia's suicide.

The superficial reason for this is the allegorical content of the legend. Lucretia was accepted as the very type of the virtuous heroine; her act of self-destruction was seen as a choice of death before dishonour. Sometimes Lucretia and Judith are put together, as a heroic pair; thus, the Cranach *Judith* already illustrated has a *Lucretia* for its pendant, and this latter painting is quite as erotic. Lucretia, like Judith, is naked except for a diaphanous veil and some jewellery – most notably, an ornate collar. She plunges the dagger into her own breast with a slightly languishing look, which suggests that she is taking a masochistic pleasure in the act. It does not take much imagination to read the painting in a symbolic sense. The dagger symbolizes not only aggression, but, more literally, a phallus; the inadequate veil suggests a lost innocence; the collar, perhaps, is an emblem of servitude.

Nor is this the most erotic version of the subject known to me. A Lucretia by Joos van Cleve in Vienna presents the heroine at half-length, in an elaborate costume which exposes her ample breasts, between which the dagger enters. Her expression leads us to suppose that she is in the throes of orgasm, and the costume could scarcely stress erotic attraction more emphatically. Indeed, the painting has a strange resemblance to a work of art very remote from it both in time and in cultural context: the gold and ivory Minoan goddess discovered at Knossos. Here, too, the physical type is regal, and the breasts are provocatively exposed. But, instead of plunging a dagger

231 242

244

244 JOOS VAN CL Lucretia, 1520

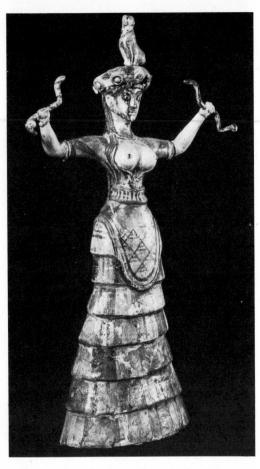

243 Minoan Snake Goddess, c. 1600 BC

into her own breast, the Minoan goddess has snakes twined around her arms, which she extends in a commanding gesture. From the symbolic point of view, the difference is not enormous – the snake is as common a phallic symbol as the dagger – though we must grant that the goddess is quite evidently in charge of the situation in which she finds herself, instead of being, like Lucretia, destroyed by it. In this she recalls the Douanier Rousseau's mysterious *Snake Charmer*, which can also be read as an image of the sexual power of woman.

It will probably be asked how it is that the snake can be so emphatically phallic, when the sea-monster in Titian's *Perseus and Andromeda* and Ingres's *Ruggiero and Angelica* has been interpreted as an emblem of the *vagina dentata*? The answer is that symbols of this

245

216

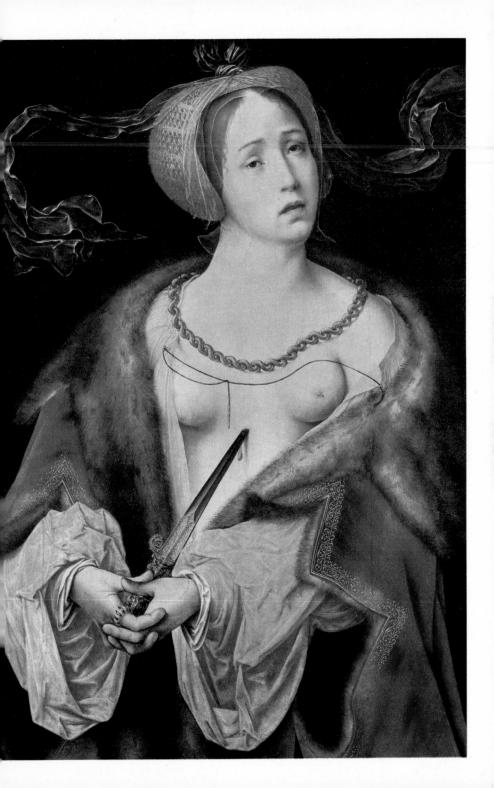

245 LE DOUANIER ROUSSEAU, Snake Charmer, 1907

kind do not have the one-for-one equivalence of rationally elaborated allegory. The serpent is phallic, if we see it in relation to the bound and waiting female victim; but its open jaws, gaping to engulf the hero and his weapon, is in both cases given such emphasis by the artist that we are entitled to opt for another explanation as well – though this explanation is not an alternative, but has a parallel existence and a parallel validity to the first one.

Nevertheless, the snake is usually phallic – and aggressive and destructive – in the European art of the Christian era. This is the role the creature plays in representations of the Fall, where sexuality and evil are identical, and the serpent embodies both. In Renaissance and post–Renaissance painting, Lucretia has another counterpart, in addition to Judith: she is often paired with Cleopatra, who destroys

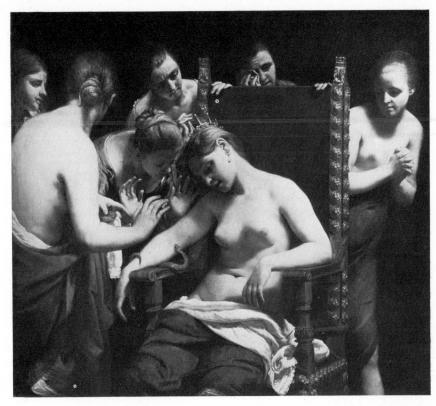

246 GUIDO CAGNACCI, Cleopatra, c. 1659

herself with an asp for love of Antony – thus representing another aspect of the vulnerability-through-sex which the male imagination imposes upon the female. The beautiful version of this subject by the Florentine Baroque painter Sebastiano Mazzoni has already been illustrated, and there is an equally fascinating, though very different, treatment of the theme by Mazzoni's Bolognese contemporary Guido Cagnacci, in which we see Cleopatra seated in a far from classical high-backed armchair, with the asp or snake wound round her forearm. She is stripped to the waist, and her women are also en déshabille. Technique as much as symbolism helps to make the painting erotic. The voluptuous physical types which the painter has chosen, and the melting quality of the paint, combine to excite the spectator's sensibility.

85

247 GUIDO RENI, Salome Receiving the Head of the Baptist, c. 1638–39

248 HANS BALDUNG GRIEN, Death and the Maiden, 1517 Even more forthright in its use of the sexual symbolism of the snake is a once-celebrated sculpture by Auguste Clésinger. This was first shown in the Paris Salon of 1847, and the model was the demimondaine Mme Sabatier, nicknamed La Présidente, who numbered both Baudelaire and Théophile Gautier among her admirers. A version of this sculpture was included in the Council of Europe exhibition devoted to the Romantic movement, at the Tate Gallery in 1959, and the cataloguer was then moved to remark that 'the snake is little more than a pretext for the model's voluptuous pose'. Yet in one important sense the pretext could scarcely have been more aptly chosen: the attitude of the nude figure recalls that 'death' is one of the more frequently employed poetic metaphors for orgasm.

249

184

251

If the more commonly encountered erotic symbols often suggest that the role of the female is to be destroyed by sex, there is also imagery which seems to preach the gospel of male invulnerability. In Cranach's Judgment of Paris, the hero wears armour, while the three goddesses are naked; and the contrast between soft flesh and shining armour continued to tickle the taste of European painters from the sixteenth century onwards. We find this contrast strikingly employed in many paintings by Rubens – for instance, in The Hero Crowned by Victory in Dresden, and The Triumph of the Victor in Kassel. Perhaps one reason for the interest taken by painters in the image of the armoured man, juxtaposed with the female nude, was that armour is characteristically both rigid and form-fitting, so that it is a kind of substitution (taking the whole body for part of the body) for a permanently erect penis.

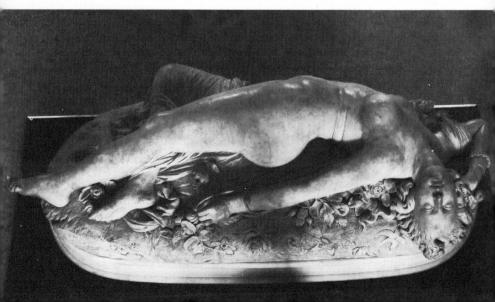

250 MAX SLEVOGT, The Knight and the Women, 1903

Rubens's *The Triumph of the Victor* is an especially fascinating case; it demonstrates how a work of art which does not have an overtly erotic subject can be endowed, unconsciously, with a pervasively erotic tone. The victor is a warrior clad in Roman armour, who is seated in the centre of the composition, with a corpse under his feet, a bound prisoner kneeling to kiss his knee. Victory, an opulent female equipped with a pair of property wings, is naked to the waist. She reaches up to place a wreath on the victor's head, while his dagger rests in her lap and points directly towards the vulva which a fold in the drapery contrives to suggest.

In Max Slevogt's *The Knight and the Women*, we find an unintentionally comic version of the same kind of symbolism. The knight,

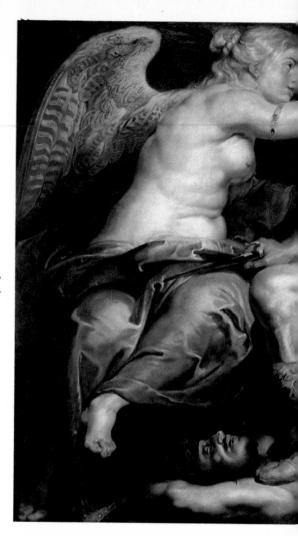

251 PETER PAUL RUBENS, The Triumph of the Victor, c. 1614

clad from head to toe in medieval plate armour, is preparing to leave his quarters, presumably for battle. A pack of naked women cling to him, some rolling on the floor and clutching at his feet and thighs, one wrenching at his arm. It comes as a surprise to discover that the painting dates from as recently as 1903, so naïvely revelatory is it about the artist's own psychology.

It must always be remembered, in fact, that the symbolism of the works discussed in this chapter is for the most part unconscious – the

artist speaks a language not fully known to himself. Pursuing the 'armour' theme a little further, we can gain a better understanding of this by looking at the Victorian painter William Etty's *Britomart Redeems Fair Amoret*. This is a 'bondage' picture, rather like the Andromedas and St Sebastians already discussed. Only here the rescuer is an armoured female, and the two women are threatened by a male opponent with a dagger. What we seem to have here is in fact a confession of male impotence and sexual confusion – the armoured

heroine can be seen as the woman-with-a-penis whom the male is powerless to overcome. The facts which are known about Etty's blameless and rather passive life would tend to support this thesis.

Another aspect of Rubens's *The Triumph of the Victor* which invites comment is the fact that it can be read without too much difficulty as a celebration of sexual triumph rather than victory in warfare. The armoured or potent male reduces the other males who surround him to impotence, and wins the exclusive attention of the female. We can discover a more open statement of a similar fantasy in a drawing by the early sixteenth-century Swiss artist Urs Graf, which shows a satyr with a single large horn growing from his head, who with one hand grasps a naked woman, while throwing some coins towards a

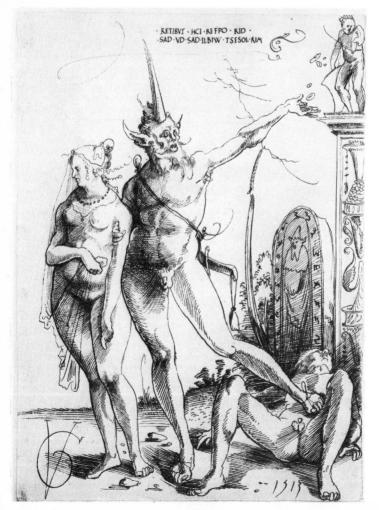

252 URS GRAF, Satyr with Naked Woman and Dead Man, 1513

253 WILLIAM ETTY, Britomart Redeems Fair Amoret, 1833

stele with a small statue on top of it. His left foot is planted upon the corpse of a nude male. An inscription in mirror-writing reads:

IUPITER·ICH·OPFER·DIR·DAS·DU·DAS·WIBLI·LOSEST·MIR

- 'Jupiter, I sacrifice to thee that thou dost leave the wench to me.'

The phallic aspect of the principal figure can scarcely be denied, and indeed we can discover symbolism of this sort throughout Graf's æuvre, much of it, however, concerned with the notion of the female-with-a-penis rather than with the potent male. One drawing, for example, shows Fortuna with a phial which resembles the male genitals; while in another, a horned satyress is blowing an immense horn which sends a blast of air between her legs.

254 RENÉ MAGRITTE, The Collective Invention, 1935

The satyr with his single horn also summons to mind the image of the unicorn, long recognized by psychoanalysts as a virility symbol. Less commonly cited in this context is yet another legendary creature, the mermaid, whose large fishtail can be thought of as a gigantic penis, stolen by the woman who forms the creature's upper half.

The mermaid has a most interesting history in European postclassical art. Very early in the Christian era, she became identified with the siren, the seductress of men's souls. During the Middle Ages she was therefore widely popular as an emblem of libidinous passion. Often, she is shown with a fish gripped in her hand – the soul gripped by lust. As Tertullian, one of the greatest of early Christian writers, put it, in a striking phrase, at baptism men are spiritually 'born in water like the fish'.

This is a case in which the psychoanalytic explanation coincides very closely with the theological one. The mermaid with the (phallic) fish in her grip is indeed a powerful image of the thieving seductress who haunts the male imagination, and it is amusing to find her brandishing her trophy on one of the misericords in Exeter Cathedral.

255 Mermaid with a fish, on a misericord in Exeter Cathedral, c. 1230-70

But the image of the mermaid by no means lost its force with the close of the Middle Ages. She makes a seductive enough impression, for example, in Arnold Böcklin's painting *Calm Sea*. The gulls who perch beside her on her rock, under a sky that presages a storm, are hunters of fish, so even this detail of the symbolism remains persistently alive. And the mermaid's confident bearing contrasts with the flaccid passivity of the triton in the water below her.

In our own century, the image of the mermaid has continued to fascinate artists. René Magritte, in his painting *The Collective Invention*, reverses the usual conjunction, and shows a creature with the head and body of a fish and the legs and sexual organs of a woman. The meaning is even plainer than in traditional representations – at least, so far as the unconscious mind is concerned: here is a woman who is 'all cock', like the strutting phalluses which form the subjectmatter of some of Félicien Rops's caricatures.

From mythical creatures, it is convenient and indeed logical to pass to representations which show encounters between human beings and animals of various species. It is, I think, naïve to interpret 256

254

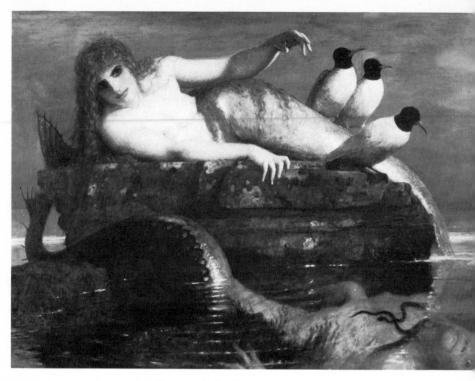

256 ARNOLD BÖCKLIN, Calm Sea, 1887

most of these encounters as straightforward bestiality. These are symbolic conjunctions, not to be imagined as 'real'. Sometimes the symbolism is coarsely satirical in its intention. If we turn to Rops again, for instance, we find a print called *Experimental Medicine*, which shows a seedily dilapidated doctor having intercourse with a sow, which is held in a kind of sling. Coarse humour of a similar kind occurs in various Japanese representations, created to amuse a very similar kind of bourgeois public – for example, there are numerous *netsuke* (the toggles which held in place the little medicine-cases which formed a part of traditional Japanese costume) showing an octopus making love to a fisher-girl. There is also a masterly print by Hokusai, which shows the same subject. But this has an interest beyond the satiric, as it is one of the rare attempts, in either Asiatic or European art, to symbolize sexual sensations as they are experienced by the female.

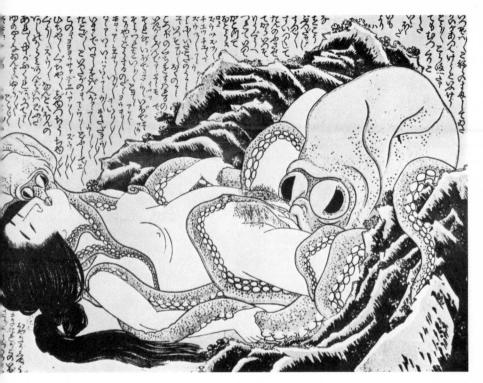

257 HOKUSAI, The Dream of the Fisherman's Wife, c. 1820

In support of my contention that the symbolic element is to be regarded as dominant in most representations of bestiality, it is worth recalling that, so far as European art is concerned, the most famous conjunction of human being and animal is supplied by the story of Leda and the Swan. We have already noted that both Michelangelo and Leonardo da Vinci interested themselves in this theme. So did Correggio, in an exceedingly explicit picture. What we notice in this, perhaps more than in any other illustration to the same myth, is the way in which the swan's body and long neck become a scarcely veiled allusion to the penis and testicles.

Nineteenth- and twentieth-century artists have sometimes invented their own erotic myths, and in these animals sometimes play an important part. Picasso uses the half-animal Minotaur in some of the prints of the Vollard suite, and in the same series there is the extraordinarily violent *Bull*, *Horse and Sleeping Girl*, in which the straining

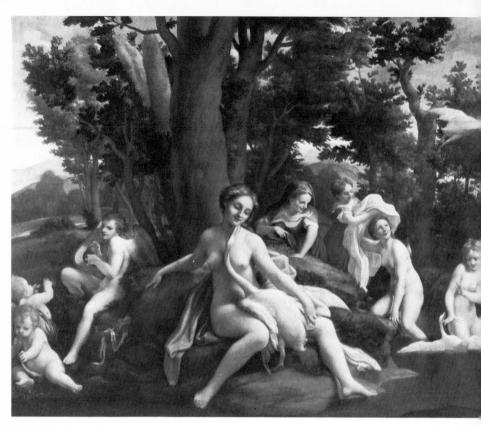

258 ANTONIO CORREGGIO, Leda and the Swan

neck and head of the horse form a kind of phallus rearing up to threaten the girl, who is sprawled helplessly across the bull's back. Edvard Munch made some delightful prints to illustrate a prosepoem written by himself, *The Story of Alpha and Omega*: 'Omega quivered when she felt the bear's soft fur against her body. When she placed her arms around its neck, they sank into the soft fur.'

Nearly always, it is the female who couples with the beast – yet another example of sadistic impulses being expressed towards her. At the same time, animals are used, quite literally, to express what is felt to be the animality of sex.

260 EDVARD MUNCH, Omega and the Bear, 1909

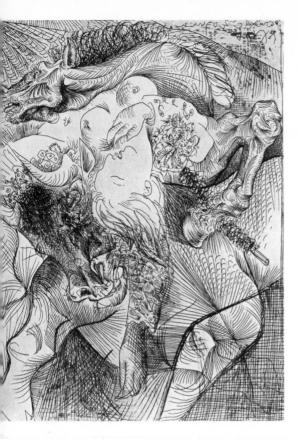

259 PABLO PICASSO, Bull, Horse and Sleeping Girl, 1934

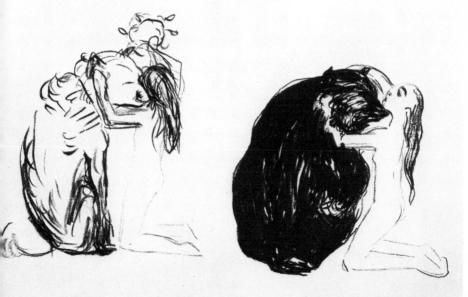

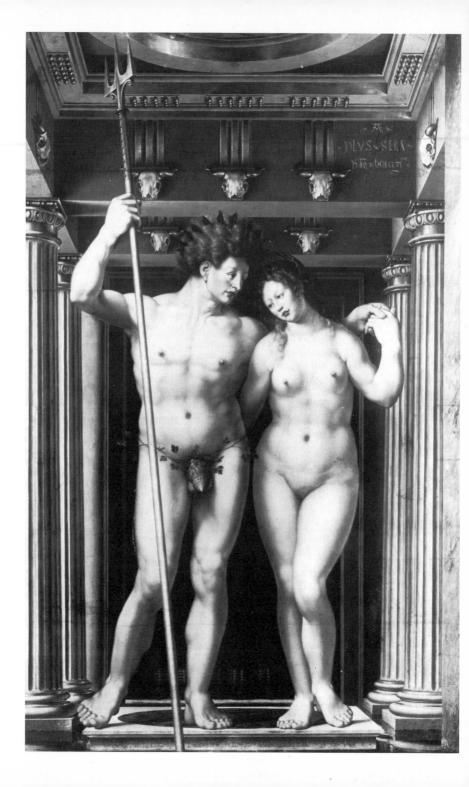

The range of erotic symbolism is so very wide that it would be possible to give many more examples than are contained in this chapter. Two more must suffice, singled out for their ingenuity. One occurs in a painting by Mabuse representing Neptune and Amphitrite: it is the earliest known example of large-scale painting of the nude in the art of Northern Europe. Neptune has been supplied, to preserve his, or rather the spectator's, modesty, not with the conventional fig-leaf, but with a large sea-shell which, in concealing his genitals, draws our attention inexorably towards them, and suggests their form with its own. This is a good instance of the way in which eroticism can be intensified through symbolic presentation.

So too, though in more light-hearted fashion, is a drawing from a series made by Picasso in the mid-1950s, and published in the magazine Verve. Here a putto playfully threatens a kneeling nude girl with a mask which he holds in front of him. The mask is that of an old man - perhaps it is meant to be a portrait of the artist himself - and the nose has been given an unmistakably phallic shape. Picasso fittingly closes this chapter, not only because his art has been involved, throughout his career, with erotic feeling, but also because he is one of the few artists of our own epoch who have been able to command

261 MABUSE, Neptune and Amphitrite, 1516

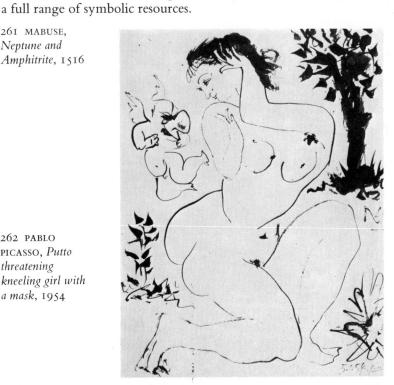

262 PABLO PICASSO, Putto threatening kneeling girl with a mask. 1954

261

Eroticism and modernism

The modern movement in the arts has often been identified, both by its partisans and its opponents, with eroticism. The sexual revolution has seemed to go hand in hand with the artistic one. While it is probably true that in literature, and also in the theatre, a much greater degree of outspokenness now prevails upon the subject of sexuality and sexual activity, it is by no means certain that painting and sculpture have benefited – or profited – from the situation to the extent that both partisans and opponents suppose.

It may seem surprising to say this, in view of my earlier assertion that contemporary art has tackled, and continues to tackle, a wide variety of sexual themes; and that the erotic impulse has played an important part in modernism's battle of styles. Nor can one say that modern artists, with their appetite for scandal, have neglected the possibility of sexual scandal. At the same time, painting and sculpture have not, among the arts, been the real pioneers. Not only did they enjoy more freedom already than other arts, but in recent years, they have merely responded to the changed attitudes towards sex pioneered by scientists and writers, but have seldom or never led the way.

I have already spoken of the part played by erotic impulses in the struggle between figurative and abstract art. It might be argued, quite plausibly, that it is a continuing interest in erotic subject-matter which has kept figurative art alive in the second half of the twentieth century. One can go further still, and make the claim that critics and public alike are willing to classify certain kinds of entirely traditional figurative art as 'modernist' merely because of powerful erotic content. This thesis can be applied, for example, to the meticulously naturalistic drawings of the Californian artist Gerald Gooch. Gooch has also made drawings of the violinist Isaac Stern playing Mendelssohn, and even a drawing (which appeared on the cover of *Time*) of the baseball pitcher Juan Marichal; but it is clearly his muchdiscussed and reproduced erotic works that gain him space in avantgarde art magazines.

One interesting thing about these drawings is the close relationship they have to photography – the one untraditional thing about them apart from their frankness. But, on reflection, this dependency is not really surprising. Since erotic art obeys the necessity to be specific, photography from its beginnings offered powerful competition to more traditional kinds of image-making in this field. It is in large part through their success in handling erotic subject-matter that the still camera and the movie camera have become the primary image-makers of our society, and that 'fine art', so called, has been forced to abandon a large part of this function. New printing techniques, allied to what the camera can do, have also enormously increased the availability of all images, including erotic ones.

When we look at the images in our magazines and newspapers, the posters on our hoardings, the pictures which adorn the directmail advertising which arrives through the post, we cannot claim

264 GERALD GOOCH, Lovers, 1969

267 Model and motor car, 1965

humbler but more accessible equivalent of Europa being borne away on the back of her bull, we now see a pretty girl sprawled on the bonnet of a high-powered sports car - phallic symbol of a technological age.

Occasionally, the symbolism developed by the old order of art survives, unaltered, its translation into a new medium. Thus, the Japanese novelist Yukio Mishima not only described, in his semiautobiographical book Confessions of a Mask, a youth's obsession with the sado-masochistic fantasies suggested to him by Guido Reni's St Sebastian, but actually went so far as to have himself photographed playing the saint's role, two months before his spectacular suicide in

266

1970. And in the portfolio issued by the successful fashion-photographer David Bailey, *David Bailey's Box of Pin-Ups*, we find the rock-singer P.J. Proby posed to resemble the crucified Christ.

These are striking images, but it would be hard to pretend that they count for much as works of art – even in the case of the Bailey photograph, which seems to have some aspirations to be so. What is jarring about them can be attributed not only to the frantic exhibitionism of the subjects of these two portraits, but to the fact that such images are now totally out of context, wrenched away from the surroundings which might have given them meaning, which were those of the old Christian culture of Europe. Conversely, the peculiar blankness of many Pop Art images seems to derive from the translation of the language of photography into that of fine art; and, more important, from the transmutation of the language of salesmanship into that of art-for-art's-sake. European Pop, with its unresolved ambiguity of attitude towards the sources from which its images derive, and the purposes to which they are subsequently put, is especially subject to these feelings of uneasiness, as can be seen from the painting by D. Smerck which is illustrated. I have chosen it, too, for the candour of its erotic symbolism. It provides another example of the way in which erotic impulses contrive to adapt themselves to new social and technological situations.

A useful study could probably be made of the imagery of the lipstick, a minor object absolutely characteristic of our century, and characteristic, moreover, of contemporary erotic obsessions. In the painting by Smerck, the lipstick the girl holds more than hints at oral intercourse; while in a poster which appeared some three or four years ago on sites in the London underground, its function was openly aggressive – an attractive and scantily clad girl was shown wearing a cartridge-belt, with lipsticks of various shades instead of bullets, with the caption 'A Woman's Armoury'. Many a man doubtful of his own virility must have seen this and shuddered.

The erotic ingenuity shown by many contemporary advertisements and posters is certainly considerable. An instance which springs to mind is the poster for the first English showing of Andy Warhol's film *Chelsea Girls*, designed by Alan Aldridge. A woman's body becomes a multi-storey building, with an entrance through the vagina. It might be argued, however, that here is a proof that the fine arts still had something to give to advertising, as the idea would

263

268

268 DAVID BAILEY, P.J. Proby from David Bailey's Box of Pin-Ups, 1964

almost certainly have been differently executed without the influence of Magritte.

But the fine arts, though plundered from time to time, are not a necessary crutch to the makers of popular images. The female nude, in particular, is presented in advertising with a great deal of independently impudent wit, as for example in the advertisement for a new range of make up, which showed a naked, crouching girl whose body was spangled with stylized daisies (the trademark of the advertiser), with the headline 'Mary Quant Gives You the Bare Essentials'. It is worth making the point that – despite assertions to the contrary – these fashion and beauty advertisements are often (though not always) created by women, and that they are certainly directed *towards* women. In this sense, they represent a radical departure from the traditional stance of the creator of erotic images, who assumes that his audience is male

MARY QUANT GIVES YOU THE BARE ESSENTIALS

270 D. SMERCK, I Love Gemey Too Much, 1964

Advertising, as a source of voyeuristic gratification, has played its part in displacing the visual arts from the niche in society which they once occupied. And it is not merely the change which is significant, but the shift in orientation which it implies. The striking thing about most advertisements – whether they address themselves to women or to men – is the way in which they play upon narcissistic fantasies. They present the spectator with an ideal image of himself or herself. Other people are present simply in order to confirm, through their reactions, that the ideal has indeed been achieved. For a woman, the phrase 'A Woman's Armoury', and the picture which accompanies it, is suggestive of invulnerability – which equals perfection. It is Rubens's *The Triumph of the Victor*, translated into female terms.

If advertisements and photographs – so often, they may be said to amount to the same thing – play an important part in giving visible form to the erotic fantasies of our own age, they do not have the field entirely to themselves. Anyone interested in studying contemporary attitudes to sexual imagery must turn first of all to the cinema. This, with its moving images, and its capacity to direct our attention inexorably first to this detail and then to that, in pre-planned sequence, must necessarily be more powerful in its capacity to arouse erotic feeling than any competing medium.

As Raymond Durgnat has shown, in *Eros in the Cinema*, film-makers have not been slow to exploit the film's advantages in this sphere. But Durgnat is also careful to point out the paradoxical—which might also be labelled narcissistic—nature of much cinematic eroticism. 'An aura of almost palpable frigidity', he notes, 'hovers around many a famous sex symbol.' On the other hand, he cannot deny the sado-masochism of many films, though he attempts to defend it:

'The moral and ideological changes of our time lead people to be less inclined to spontaneous moral indignation, while traditional outlets for sado-masochism are rapidly diminishing (one thinks of the declining popularity of fisticuffs or of corporal punishment, or the blanket use of anaesthetic). Left with less righteous satisfaction for their cruel streak, people become more conscious of, and more guilty about, cruelty; and turn with pleasure and relief to the fantasy outlet provided by the ever-indulgent cinema.'

This justification is a little shuffling, but it is worth examining some of the points that Durgnat makes. For example, it is in the

271 FRANCIS BACON, Two Men on a Bed, 1953

highest degree unlikely that any pre-Freudian spectator would have been able to analyse his reactions to some of the material in this book (though, as Freud himself pointed out, we get the first hint of the concept of the Oedipus complex from Diderot). He or she would certainly not have been conscious of its implications as the contemporary film-maker and film-watcher have to be, thanks both to the context and to the information supplied to them by the network of relationships which is contemporary society. But it is equally true that the fantasy outlets which Durgnat sees as modern have always been necessary to Western European culture, at least as it has developed from the late Middle Ages onwards. It is simply that the film now for the most part provides the outlet which was formerly offered by paintings and sculptures. In effect, the social function of the works of art discussed in earlier chapters has been close to, if not at all points identical with, that of much contemporary imagery which makes no claim to the status of art at all.

Nevertheless, it remains commonplace to condemn even those products of our time which qualify as art in the narrow traditional sense, for their lack of reticence about sex, and indeed for their fascination with sexual perversion. One must agree that the candour of a painting such as Francis Bacon's Two Men on a Bed reflects an increased degree of tolerance in our society for male homosexuality. Yet this is a special case. A careful study of the great art galleries of the world, and of the contents of their print and drawing collections, will soon reveal the degree to which the alleged reticence of the artists of former epochs is a convenient myth. It was invented largely by the puritans of the nineteenth century, who contrived to suppress the most blatant of the works created in preceding centuries, and to ignore the erotic meaning of the rest. The eroticism of the art of the past is important, especially when it is a matter of achieving a balanced understanding of that past, because, lacking competition, art formerly occupied a more central position in the awareness of its audience. It is important to examine the art of the past in order to achieve an understanding of the present, too.

My contention is that in our own day, despite a greater permissiveness about what may be directly represented, rather than hinted at or symbolized, the painting and sculpture which are produced are actually weaker in their effect on the psyche than those produced by our ancestors. One reason for this, in addition to the loss of centrality

272 YVES KLEIN, Painting ceremony

I have mentioned, is that painting and sculpture show an ever-feebler grip upon intimately experienced reality. In order to convince us that what is shown is 'real' – to convince us of its actual presence in the work of art – an artist can no longer rely on mere skill as a draughtsman, modeller or colourist. Like the French neo-Dadaist Yves Klein, he must perhaps persuade a model to cover herself in paint, and then impress her naked body on the canvas. To convince us of the reality of an erotic encounter, he must, like the American

273 GEORGE SEGAL, Legend of Lot, 1966

sculptor George Segal, make direct castings from the bodies of the participants. Failing devices such as these, he will, in any case, have recourse to photographs.

Erotic art in the European tradition – now apparently coming to an end – actualizes and externalizes what is very intimately part of ourselves. The true purpose of this inquiry has been to discover something, not only about the erotic impulse in art, but about the nature of the culture in which I find myself living.

Acknowledgments
Further Reading
List of Illustrations
Index

Acknowledgments

Dr Werner Muensterberger was kind enough to read the manuscript of this book, with particular reference to its use of certain psycho-analytic concepts. His comments undoubtedly saved me from many errors, and I should like to express my gratitude to him. Such faults as may remain are, of course,

entirely my own responsibility. I am also most grateful to his wife Helene Muensterberger, for reading the manuscript and making helpful comments and suggestions, and to my editor David Britt, who contributed a great deal of very necessary criticism.

Further Reading

While there are numerous books with erotic illustrations, it is surprisingly difficult to discover works which make any sensible attempt to tackle the theme of eroticism in Western art. Books on eroticism in Indian, Japanese and primitive art, etc., are far more numerous, perhaps because the fact that the material is drawn from an alien culture makes it seem less 'shocking', and less dangerous to the publisher.

Though a number of books on the subject are, at the moment of writing, reported to be in the press, the standard work is still Eduard Fuchs, Illustrierte Sittengeschichte (6 volumes, Munich, 1909). This is both rare and out of date, and the illustrations, though numerous, are not of good quality. Where recent publications are concerned, the most interesting is probably Studies in Erotic Art, edited by Theodore Bowie and Cornelia V. Christenson (New York/London, 1970), issued under the auspices of the Kinsey Institute. Also useful, though many of the modern European paintings and sculptures illustrated are unimpressive, considered simply as works of art, is the catalogue of the exhibition 'Erotic Art' organized at the Lund Konsthalle in Sweden by Drs Phyllis and Eberhard Kronhausen.

The works of Sigmund Freud (The Complete Introductory Lectures on Psychoanalysis, latest edition, London/New York, 1971) and Havelock Ellis (The Psychology of Sex, London, 1909) cannot be too earnestly recommended to any student of the subject. Useful, too, is the handsomely illustrated Man and his Symbols (London, 1964), edited by Carl Gustav Jung.

The one area of research in which the student finds himself reasonably well provided is the field of archaeology. S. Giedion's *The Beginnings of Art* (London, 1962) is a brilliantly original treatment of its theme; and one could compile a long list of books which touch upon the theme of eroticism in Greek and Roman art. Among the most interesting are Margaretha Bieber, *The Sculpture of the Hellenistic Age* and *The History of the Greek and Roman Theatre* (both Princeton, 1961).

For information about erotic works by Renaissance and post-Renaissance masters, the researcher must address himself to the increasing number of catalogues raisonnés, where the scholarly desire for completeness is more and more tending to overcome any remaining prudish scruples.

List of Illustrations

Measurements are given in inches and centimetres, height before width.

ABBATE, NICCOLO DELL' (1512-71)

183 Alexander, Apelles and Campaspe, 1542–8. Etching by L.D. Oval $13\frac{3}{8} \times 9\frac{3}{8}$ (34·1×24). Bibliothèque Nationale. Paris.

AESTAEAS OF PAESTUM

19 Dwarf staring at a female tumbler, c. 350 BC. Vase-painting. Museo Archeologico, Lipari.

ALBANI, FRANCESCO (1578-1660)

89 Salmacis and Hermaphroditus, c. 1628. Copper, $5\frac{1}{2} \times 12\frac{1}{4}$ (14 × 31). Louvre, Paris.

ALDRIDGE, ALAN (b. 1939)

263 Film poster for Andy Warhol's film *Chelsea Girls*, 1968. $29\frac{1}{8} \times 20\frac{1}{8} (76 \times 51)$. Published by Motif Editions. London.

ALLORI, CRISTOFANO (1577-1621)

241 *Judith.* Oil on canvas, $54\frac{3}{4} \times 45\frac{5}{8}$ (139×116). Galleria Pitti, Florence.

ALMA-TADEMA, SIR LAWRENCE (1836–1912)

129 A Favourite Custom, 1909. Oil on wood, 12×9 (30.5 × 23). Tate Gallery, London.

ALTDORFER, ALBRECHT (c. 1480–1538)

76 Imperial Bath (detail). Couple Embracing. Fresco

fragment from Kaiserbad, Regensburg. Museum der Stadt Regensburg.

213 Lot and his Daughters, 1537(?). Oil on panel, $42\frac{1}{8}\times74\frac{3}{8}$ (107×189). Kunsthistorisches Museum, Vienna.

ANONYMOUS

See also antwerp; fontainebleau; Aesteas; Epilykos: Kangra: Peithinos

- 2 Phallic altar of Dionysus, Hellenistic. Delos.
- 3 'Venus' of Willendorf, late Aurignacian. Limestone, h. 4\frac{1}{8} (10.5). Naturhistorisches Museum, Vienna
- 4 La Polichinelle, late Aurignacian. Figurine, h. $1\frac{7}{8}$ (4·7). Musée des Antiquités Nationales, Saint-Germain-en-Laye.
- 5 'Venus' of Laussel, Aurignacian. Limestone, h. 17 (43.5). Private collection, Bordeaux.
- 6 'The Sorcerer', Magdalenian. Figure partly painted, partly engraved, 29½ (75). Cave of Les Trois Frères, Ariège.
- 7 The Egyptian god Min, fourth millennium BC. Statue. Ashmolean Museum, Oxford.
- 8 The Cerne Abbas Giant, Turf figure. Cerne Abbas, Dorset.
- 9 Tomb of the Bull, early Etruscan. Wall-painting. Tarquinia.
- 10 Greek herm, c. 500–475 BC. Bronze, $3\frac{1}{2} \times 2\frac{1}{6}$ (9 × 5·5). Norbert Schimmel Collection, New York.
- 11 Priapus pouring oil on to his phallus, Graeco-Roman. Bronze, h. $2\frac{3}{4}$ (7). Museum of Fine Arts, Boston. Gift of E.P. Warren.
- 12 Cock treading a hen, fifth century BC. Greek scaraboid gem. By courtesy of the Trustees of the British Museum, London.
- 13 Satyr carrying off a nymph, c. 550 BC. Silver stater. By courtesy of the Trustees of the British Museum, London.
- 14 Satyr with a drinking-bowl, c. 460 BC. Reverse of a silver tetradrachm of Naxos, Sicily. By courtesy of the Trustees of the British Museum, London.
- 15 Satyr, 575–550 BC. National Museum, Athens. Karopanus Collection.
- 16 Courtesan and client, fifth century B.C. Tondo of a red-figure kylix. By courtesy of the Trustees of the British Museum, London.
- 18 Comic actors with strapped-on phalluses in satyr dance, c. 490 BC. Attic red-figured kalpis. Museum of Fine Arts, Boston. Francis Bartlett Foundation.
- 21 Satyr uncovering a sleeping hermaphrodite, Roman. Cameo. By courtesy of the Trustees of the British Museum, London.
- 22 Sleeping satyr bestraddled by a winged female figure, Hellenistic. Marble. Museum of Fine Arts, Boston. Gift of E.P. Warren.
- 23 A hermaphrodite struggling with a satyr, Roman copy after a late Hellenistic work. Marble, h. 35⁵/₈ (90·6). Skulpturensammlung, Dresden.

- 24 Aphrodite threatening Pan with her slipper, Hellenistic. National Museum, Athens.
- 25 Attis, Graeco-Roman. Bronze figure. By courtesy of the Trustees of the British Museum, London.
- 26 Hermaphrodite, Graeco-Roman. Bronze figure. Louvre, Paris.
- 27 Girl initiate unveiling a symbolic phallus before a winged figure, before AD 79. Wall-painting. Villa of the Mysteries, Pompeii.
- 28 Yakshi torso, first century BC. Stone sculpture, h. 28 (71). Museum of Fine Arts, Boston. Ross Collection
- 29 Façade of Kandarya-Mahadeva Temple, Khajuraho, tenth to eleventh century A.D. Height of figures about 32 (81.5).
- 30 Shelah-na-Gig, Irish fertility figure, eleventh to fourteenth century AD. Stone, h. 24 (61). National Museum of Ireland, Dublin.
- 31 The game of pet-en-gueule, ϵ . 1340. Carved on a misericord, Ely Cathedral.
- 33 Torture of King William III of Sicily, from De casibus virorum illustrium of Boccaccio, fifteenth century. Bibliothèque de l'Arsenal, Paris.
- 35 The Golden Age, from manuscript MS Douce 195F, fifteenth century. Bodleian Library, Oxford.
- 36 The Garden of Nature, from Les Echecs amoureux, fifteenth century. Bibliothèque Nationale, Paris.
- 37 The Land of the Hermaphrodites, $16\frac{1}{2} \times 19\frac{5}{8}$ (42 × 49·8). From a Livre des merveilles, early fifteenth
- 49·8). From a Livre des merveilles, early fifteenth century. Bibliothèque Nationale, Paris.
 38 Bathsheba Bathing, from the Hours of Marguerite de
- Coëtivy, fifteenth century. Musée Condé, Chantilly. 69 Lovers, from a series illustrating the Kama Shastra, late eighteenth century. Tempera on paper, 6\frac{1}{2} \times \frac{2}{3} \((17.4 \times 17.4)\). Victoria and Albert Museum, London.
- 70 Indian Prince Receiving a Lady at Night, c. 1650. Miniature, tempera on paper. Victoria and Albert Museum, London.
- 101 Woman dressing, third century BC. Greek gemstone. By courtesy of the Trustees of the British Museum, London.
- 196 A Satyr Assaulting a Woman Defended by Three Cupids, c. 1542–45. Etching by Fantuzzi, 12 \times 8 (31 \times 20·5). Albertina, Vienna.
- 243 Minoan Snake Goddess, c. 1600 B C. Ceramic 11½ (29·5). Heraklion Museum, Knossos.
- 255 Mermaid with a fish, c. 1230–70. Wood. Misericord, Exeter Cathedral.
- 265 Marilyn Monroe calendar picture, 1953.
- 266 Yukio Mishima as St Sebastian, 1970.
- 267 Model and motor car, 1965. By courtesy The Condé Nast Publications.
- 269 Mary Quant advertisement, 1966.

ANTWERP, SCHOOL OF

54 Bathsheba Being Spied on by David, ϵ . 1520. Pen and brown ink and brown wash, diameter $8\frac{1}{16}$ (20·5). The National Gallery of Canada, Ottawa.

BACHIACCA (FRANCESCO UBERTINI, 1494-1557)

234 The Beheading of John the Baptist, 1539(?). $66\frac{1}{2} \times 57\frac{1}{2}$ (169×146). Gemäldegalerie, Staatliche Museen, Berlin.

BACON, FRANCIS (b. 1909)

271 *Two Men on a Bed*, 1953. $59\frac{1}{8} \times 45\frac{5}{8}$ (152.5 × 116.5). Private collection, England.

BAILEY, DAVID (b. 1938)

268 P.J. Proby, from David Bailey's Book of Pin-ups, 1964.

BALDUNG GRIEN, HANS (1484/5-1545)

56 Allegory, 1514–15. Pen and wash, highlighted with white, on brown paper, 106×76 (270 × 195). Albertina, Vienna.

78 Old Man and Young Woman, 1507. Copper engraving, $68\frac{1}{8} \times 54\frac{3}{8}$ (173 × 139). Albertina, Vienna. 203 Drunken Silenus, 1513–14. Woodcut, $8\frac{7}{8} \times 6$ (22:4 × 15·3). Öffentliche Kunstsammlungen, Basle. 205 Aristotle and Phyllis, 1513. Woodcut, $13\frac{1}{8} \times 12\frac{7}{8}$ (33·3 × 32·8). Staatliche Museen, Berlin.

248 Death and the Maiden, 1517. Panel, $11\frac{3}{4} \times 5\frac{1}{2}$ (30×14·5). Öffentliche Kunstsammlungen, Basle.

BALTHUS (BALTHAZAR KLOSSOWSKI DE ROLA, b. 1908) 186 Study for a Composition, 1963–66. Oil on canvas, $59\times66\frac{7}{8}$ (150×170). Collection Henriette Gomès, Paris.

BAUDOUIN, PIERRE ANTOINE (1725-69)

104 Morning. Gouache, $9\frac{1}{2} \times 7\frac{1}{2}$ (24 × 19).

BEARDSLEY, AUBREY (1872-98)

147 Messalina, 1897. Pen and ink, $6\frac{7}{8} \times 5\frac{1}{2}$ (17.5 × 14). Published in Second Book of Fifty Drawings, 1899, then in a folder, 1906.

149 Lysistrata, 1896. Pen and ink, $8\frac{5}{8} \times 5\frac{3}{4}$ (22 × 15). Illustration to the Lysistrata of Aristophanes.

BELLMER, HANS (b. 1902)

169 Cephalopode, 1968. Pencil drawing, $8\frac{3}{4} \times 9$ (22 × 23.5). Brook St Gallery Ltd, London.

BERNINI, GIANLORENZO (1598-1680)

84 The Ecstasy of St Teresa, 1645–52. Coloured marble and gilt metal, life-size. Cornaro Chapel, Sta Maria della Vittoria, Rome.

BLOT, MAURICE (1753–1818) See FRAGONARD.

BÖCKLIN, ARNOLD (1827–1901)

256 Calm Sea, 1887. Oil on wood, $40\frac{1}{2} \times 41\frac{3}{8}$ (103 × 105). Museum of Fine Arts, Berne.

BOSCH, HIERONYMUS (c. 1450–1516)

39 Adam and Eve from The Garden of Earthly Delights

(left panel of triptych), ϵ . 1500. Oil and tempera on panel, $86\frac{8}{8} \times 38\frac{1}{8}$ (220×97). Prado, Madrid. 40–41 The Garden of Earthly Delights (central panel of triptych), ϵ . 1500. Oil and tempera on panel, $86\frac{8}{9} \times 76\frac{3}{8}$ (220×193). Prado, Madrid.

BOTTICELLI, SANDRO (c. 1444-1510)

42 The Birth of Venus (detail), c. 1478. Oil on canvas, $68\frac{7}{8} \times 109\frac{1}{2}$ (175 × 278). Uffizi, Florence.
43 Calumny (detail), 1494–95. Panel, $24\frac{3}{8} \times 35\frac{7}{8}$

(62×91). Uffizi, Florence.

BOUCHER, FRANÇOIS (1703–70)

106 Mademoiselle O'Murphy, 1751. Oil on canvas, $23\frac{3}{8}\times28\frac{3}{4}$ (59·5 × 73). Wallraf-Richartz Museum, Cologne.

BOUGUEREAU, ADOLPHE (1825-1905)

128 Nymphs and a Satyr, 1873. Oil on canvas, $102\frac{3}{8} \times 70\frac{7}{8}$ (260 \times 180). Sterling and Francine Clark Art Institute, Williamstown, Mass.

BRONZINO, AGNOLO (1503-72)

63 Venus, Cupid, Folly and Time, 1545. Oil on panel, $57\frac{1}{2} \times 45\frac{3}{4}$ (146 × 116). National Gallery, London.

BROUWER, ADRIAEN (1605/6-38)

93 The Smoker, c. 1628. Oil on panel, $16\frac{1}{8}\times12\frac{5}{8}$ (41 \times 32). Louvre, Paris.

CAGNACCI, GUIDO (1601-81)

246 Cleopatra, c. 1659. Oil on canvas, $54\frac{3}{8} \times 62\frac{5}{8}$ (138· 5×159). Kunsthistorisches Museum, Vienna. 220 The Young Martyr, no date. $37\frac{3}{8} \times 54\frac{3}{4}$ (95 × 139). Musée Fabre, Montpellier.

CAIRO, FRANCESCO DEL (1598-1674)

236 Herodias. Oil on canvas. Galleria Sabauda, Turin.

CALLOT, JACQUES (1592-1635)

215 The Wheel, from Miseries of War, 1633. Etching. By courtesy of the Trustees of the British Museum, London.

CANOVA, ANTONIO (1757-1822)

116 Cupid and Psyche Embracing, 1787–93. Marble, 18½ × 22½ × 16½ (46×58×43). Louvre, Paris. 117 Venus Italica, 1812. Marble, life-size. Galleria Pitti. Florence.

CARAGLIO, GIOVANNI JACOPO (c. 1500–70)

CARAVAGGIO (MICHELANGELO MERISI 1573-1610)

81 St John the Baptist, c. 1595. Canvas, $50\frac{3}{4} \times 37\frac{3}{8}$ (129×95). Musei Capitolini, Rome.

88 Bacchus, 1593–94. Oil on canvas, $37\frac{3}{8} \times 33\frac{1}{2}$ (95 × 85). Uffizi, Florence.

90 St Matthew and the Angel, 1597-98. Oil on canvas,

 $91\frac{3}{8} \times 72$ (232 × 183). Formerly Kaiser Friedrich Museum, Berlin, now destroyed.

92 Amore Vincitore, 1598–99. Oil on canvas, $60\frac{5}{8} \times 43\frac{1}{4}$ (154×110). Staatliche Museen, Berlin.

238 David with the Head of Goliath, 1605–6. Oil on canvas, $49\frac{1}{4}\times39\frac{3}{8}$ (125 \times 100). Galleria Borghese, Rome.

239 Head of Medusa, 1596–98(?). Oil on canvas, $23\frac{5}{8} \times 21\frac{5}{8}$ (60 × 55). Uffizi, Florence.

CARRACCI, ANNIBALE (1560-1609)

223 Samson in Prison, c. 1595–1600. Oil on canvas, $70\frac{7}{8} \times 51\frac{1}{8}$ (180 \times 130). Galleria Borghese, Rome.

CLÉSINGER, AUGUSTE (1814-83)

249 Woman Bitten by a Snake, 1847. Sculpture. Louvre, Paris.

COLOMBE, JEAN (1467-1529)

34 Purgatory from Très Riches Heures du Duc de Berry, c. 1485. 9×7 (25·1×19). Musée Conde, Chantilly.

CORINTH, LOVIS (1858-1925)

208 Friends, 1904. Oil on canvas, $38\frac{5}{8} \times 46$ (98 × 119). Gemäldegalerie, Dresden.

CORREGGIO, ANTONIO (ANTONIO ALLEGRI, c. 1494–1534)

53 The Three Graces, c. 1518. Fresco lunette. Camera di San Paolo, Parma.

59 Io, c. 1530. $64\frac{1}{4}\times29\frac{1}{8}$ (163·5×74). Kunsthistorisches Museum, Vienna.

258 Leda and the Swan. Oil on canvas, $60 \times 74\frac{1}{4}$ (154:5 \times 189). Gemäldegalerie, Berlin.

COURBET, GUSTAVE (1819-77)

140 Sleep, 1866. $53\frac{1}{8} \times 78\frac{3}{4}$ (135 \times 200). Petit Palais, Paris.

COUTURE, THOMAS (1815-79)

130 The Romans of the Decadence, 1847. $183\frac{1}{2} \times 305\frac{1}{8}$ (466 × 775). Louvre, Paris.

CRANACH, LUCAS THE ELDER (1472-1553)

80 Ill-Matched Couple, c. 1595. Akademie der Bildenden Künste, Vienna.

184 The Judgment of Paris, 1530. Oil on panel, $13\frac{3}{4} \times 9\frac{1}{2}$ (35 × 24). Staatliche Kunsthalle, Karlsruhe.

204 Hercules and Omphale, 1532. Oil on panel, 31½×46½ (80×118). Formerly Kaiser Friedrich Museum, Berlin.

231 *Judith*, 1537. Oil on panel, $67\frac{3}{4} \times 25\frac{1}{4}$ (172 × 64). Formerly Gemäldegalerie, Dresden, now destroyed. 242 *Lucretia*, 1537. $67\frac{3}{4} \times 25\frac{1}{4}$ (172 × 64). Formerly Gemäldegalerie, Dresden, now destroyed.

dalí, salvador (b. 1904)

168 Young Virgin Autosodomized by her own Chastity, 1954. Collection Carlos Alemany, New York City.

DAVID, JACQUES-LOUIS (1748-1825)

115 Loves of Paris and Helen, 1788. Oil, $57\frac{1}{2} \times 71\frac{1}{4}$ (146 × 181). Louvre, Paris.

DAVIE, ALAN (b. 1920)

172 Bird Noises Number 3, 1963. Gouache, 20×30 ($51 \times 76 \cdot 5$). Collection Calouste Gulbenkian Foundation, Lisbon.

DEGAS, EDGAR (1834-1917)

135 The Madam's Birthday, c. 1879. Monotype, $4\frac{3}{4}\times 6\frac{1}{4}$ (12×16). By permission of the Lefevre Gallery, London.

136 *The Client, c.* 1879. Monotype, $8\frac{1}{4} \times 6\frac{1}{4}$ (21 × 16). By permission of the Lefevre Gallery, London.

DELACROIX, EUGÈNE (1798-1863)

125 Mazeppa, ϵ . 1824. Watercolour, $9 \times 12\frac{1}{2}$ (23 × 31·5). The Art Museum of Ateneum, Helsinki. 126 Death of Sardanapalus (detail), 1827. Canvas, $155\frac{1}{2} \times 194\frac{2}{3}$ (395 × 495). Louvre, Paris.

DELVAUX, PAUL (b. 1897)

207 *Two Girls 1946.* Oil on board, $33 \times 29\frac{3}{8}$ (84 × 75). Brook Street Gallery, London.

DONATELLO (c. 1386-1466)

45 Attis-Amor. Bronze. Bargello, Florence.

46 David, c. 1430. Bronze, h. $62\frac{1}{4}$ (158·2). Bargello, Florence.

DUBREUIL, TOUSSAINT (1561-1602)

74 Lady Rising, second half of sixteenth century. Louvre, Paris.

DUBUFFET, JEAN (b. 1901)

173 Coffee-pot, 1945. Oil, sand and other materials, $45\frac{1}{2} \times 35$ (116 × 89). Collection Mr and Mrs Ralph F. Colin. New York.

DÜRER, ALBRECHT (1471-1528)

77 Women's Bath, 1496. Pen and ink, $9\frac{1}{2} \times 9$ (23·2 × 22·9). Kunsthalle, Bremen.

211 Nude Self-portrait, c. 1506–07. Pen and brush, highlighted with white, 11 $\frac{3}{8}$ × 6 (29·1 × 15·3). Schlossmuseum, Weimar.

EPILYKOS

17 Erotic scenes, fifth century BC. Red-figure cup. Louvre, Paris.

ERNST, MAX (b. 1891)

167 The Robing of the Bride, 1939. Oil on canvas, $47\frac{1}{8} \times 37\frac{3}{4}$ (130 × 96). Peggy Guggenheim Collection, Venice.

ETTY, WILLIAM (1787-1849)

253 Britomart Redeems Fair Amoret, 1833. 35 $\frac{3}{4}$ × 26 (91 × 66). Tate Gallery, London.

FANTUZZI, ANTONIO (1508–after 1550) See ANONYMOUS (196).

FETI, DOMENICO (1589-1623)

82 Hero and Leander. Oil on wood, $16\frac{1}{2} \times 37\frac{3}{4}$ (42 × 96). Kunsthistorisches Museum, Vienna.

FLORIS, FRANS (FRANS DE VRIENDT, c. 1517-70)

66 The Gods of Olympus. Oil on wood, 59 \times 78 (150 \times 198). Musée Royal des Beaux-Arts, Antwerp.

FONTAINEBLEAU, SCHOOL OF

68 Gabrielle d'Estrées and the Duchesse de Villars, c. 1594. Oil on wood, $37\frac{3}{4}\times49\frac{1}{4}$ (96 × 125). Louvre, Paris.

71 Lady at her Toilet, mid-sixteenth century. Panel, $41\frac{2}{8} \times 27\frac{2}{8}$ (105 × 70·5). Musée des Beaux-Arts, Dijon. 79 Woman Between the Two Ages of Man. Oil on canvas, $41\frac{1}{8} \times 66\frac{2}{8}$ (117 × 170). Musée des Beaux-Arts, Rennes.

FRAGONARD, JEAN HONORÉ (1732-1806)

100 The Happy Lovers, c. 1770. Oil on canvas, $19\frac{3}{4} \times 24$ (50×61). Private collection, Paris.

107 The Bolt. Engraving by Maurice Blot, 1784, after lost painting.

108 The Swing, c. 1766. Oil on canvas, $32\frac{5}{8} \times 26$ (83 × 66). Wallace Collection, London.

109 Waterworks, before 1777. Brush and brown ink and brown wash over pencil sketch, $10 \times 15\frac{1}{8}$ (27 × 38). Sterling and Francine Clark Institute, Williamstown, Mass.

110 Fireworks, before 1777. Sepia on cream ground wash, $9\frac{7}{8} \times 14\frac{1}{8}$ (25 × 36). Museum of Fine Arts, Boston. Otis Norcross and Seth K. Sweetser Fund.

FUSELI, JOHN HENRY (1741-1825)

1 *The Kiss*, c. 1816. Chalk on paper. Öffentliche Kunstsammlungen, Basle.

119 A Sleeping Woman and the Furies, 1821. Oil on canvas, $48 \times 61\frac{3}{4}$ (122·5 × 157). Kunsthaus, Zürich. 120 The Fireplace, 1798. Pen and wash, $14\frac{1}{2} \times 9\frac{1}{4}$ (37×23·5). Collection Brinsley Ford, Esq.

121 Wolfram Looking at his Wife, whom he has Imprisoned with the Corpse of her Lover, 1812–20. Oil on canvas, $38\frac{8}{8} \times 27\frac{8}{8}$ (97·5 × 69·8). Collection Georg Schäfer, Schweinfurt.

GAUGUIN, PAUL (1851-1903)

153 Te Arii Vahine (The King's Wife), 1896. Oil on canvas, $38\frac{1}{8} \times 51\frac{1}{8}$ (97×130). Pushkin Museum, Moscow.

GÉRICAULT, THÉODORE (1791–1824)

122 A Nymph Being Raped by a Satyr, c. 1817–29. Terracotta, $6\frac{1}{4} \times 7\frac{1}{2}$ (16 \times 19) at base. Albright-Knox Art Gallery, Buffalo, New York.

190 The Lovers (detail), 1815–16. Canvas, $9\frac{1}{2} \times 12\frac{1}{4}$ (24 × 32·5).

228 A Nude Being Tortured, c. 1817. Drawing. Musée Bonnat, Bayonne.

240 Two Severed Heads, 1818, study for The Raft of the Medusa. Oil on canvas, $19\frac{5}{8} \times 26\frac{3}{8}$ (50×67). Nationalmuseum. Stockholm.

GÉRÔME, JEAN LÉON (1824-1904)

133 The Slave Market, undated. Oil on canvas, 33×25 ($83 \cdot 5 \times 62 \cdot 5$). Sterling and Francine Clark Art Institute, Williamstown, Mass.

GILLRAY, JAMES (1757-1815)

111 Ci-devant Occupations (Mme Talian [sic] and the Empress), 1805. Engraving (coloured impression), $11\frac{1}{8} \times 17$ (58.5 × 44.5). By courtesy of the Trustees of the British Museum, London.

114 Lubber's Hole – Alias the Crack'd Jordan, 1791. Engraving (coloured impression), 10×8 (27×21). By courtesy of the Trustees of the British Museum, London.

GIOTTO (c. 1267-1337)

32 The Last Judgment (detail), Punishment of the Lustful. Fresco. Arena chapel, Padua.

GIULIO ROMANO (1492 or 1499-1546)

75 Jove and Olympia, 1525–35. Palazzo del Tè, Mantua.

GOOCH, GERALD

264 Lovers, 1969. Lithograph. Hansen Fuller Gallery, San Francisco.

GOUJON, JEAN (active 1540-62)

61 Diana of Anet, before 1554. Sculpture. Louvre, Paris.

GOYA Y LUCIENTES, FRANCISCO DE (1746-1828)

123 Woman attacked by Bandits, c. 1808–14. Collection Dr Carvalho.

144 Naked Maja, c. 1800–5. Canvas, $38\frac{1}{8} \times 74\frac{3}{4}$ (97 \times 190). Prado, Madrid.

GRAF, URS (c. 1485-1527/8)

252 Satyr with Naked Woman and Dead Man, 1513. Pen and ink, 11 $\frac{3}{8}$ \times 8 $\frac{1}{4}$ (29 \times 21 · 1). Öffentliche Kunstsammlungen, Basle.

GREUZE, JEAN-BAPTISTE (1725-1805)

103 The Two Sisters. Drawing, pen and wash, $19\frac{5}{8} \times 13\frac{5}{8}$ (50 × 32). Musée des Beaux-Arts, Lyon.

GROSZ, GEORGE (1893-1959)

160 Yet Another Bottle, 1925. Watercolour, 46×60 (117 \times 152 \cdot 5). Brook Street Gallery Ltd, London.

GUYS, CONSTANTIN (1802-92)

137 Girls Dancing in a Cabaret, undated. Pencil, pen

and ink with grey wash, $7\frac{1}{8} \times 11\frac{3}{4}$ (20 \times 29·5). Ex Gerald Paget Collection, New York City.

HOGARTH, WILLIAM (1697-1764)

113 The Rake's Progress (detail), 1732–33. Oil on canvas, $24\frac{1}{2} \times 29\frac{1}{2}$ (61 × 75). The Trustees of Sir John Soane's Museum.

HOKUSAI (1760-1849)

257 The Dream of the Fisherman's Wife, c. 1820. Large coloured print. By courtesy of the Trustees of the British Museum, London.

HOOGH, PIETER DE (1629-after 1684)

96 Interior with Gay Company, signed but not dated. Oil on canvas, $25 \times 31\frac{1}{2}$ (63·5×80). Private collection, England.

INGRES, JEAN-AUGUSTE-DOMINIQUE (1780–1867)

127 Study for *Ruggiero Freeing Angelica*. Oil on canvas, $33\frac{1}{2} \times 16\frac{1}{2}$ (45·7 × 36·8). Louvre, Paris.

145 Odalisque with a Slave, 1842. Oil on canvas, $29\frac{7}{8} \times 41\frac{3}{8}$ (76×105). The Walters Art Gallery, Baltimore.

185 Le Bain turc, 1862. Oil on panel, diameter $42\frac{1}{2}$ (108). Louvre, Paris.

217 Ruggiero and Angelica, 1819. Oil on canvas, $57\frac{7}{8} \times 74\frac{3}{4}$ (147 × 189). Louvre, Paris.

JONES, ALLEN (b. 1937)

170 Girl Table, 1969. Painted glass fibre and resin, tailor-made accessories, life-size. Collection Allen Jones, London.

KANGRA SCHOOL

67 Erotic Scene, c. 1830. Miniature, $7\frac{1}{8} \times 5\frac{5}{8}$ (18 × 14·5). Private collection, Japan.

KIRCHNER, ERNST LUDWIG (1880-1938)

159 Lovers. Etching. Neue Pinakothek, Munich.

KLEIN, YVES (1928-62)

272 Painting Ceremony.

KLIMT, GUSTAV (1862-1918)

148 The Kiss, 1907–8. Oil on canvas, $70\frac{7}{8} \times 74$ (180×188). Österreichische Galerie, Vienna.

KOONING, WILLEM DE (b. 1904)

174 Woman and Bicycle, 1952–53. $76\frac{1}{2}\times49$ (194 \times 124·5). Whitney Museum of American Art, New York.

LANFRANCO, GIOVANNI (1580–1647)

212 Young Boy on a Bed, 44×63 (112×160). By courtesy of Christie's, London.

L.D.

See PRIMATICCIO; ABBATE

LEONARDO DA VINCI (1452-1519)

50 Leda and the Swan (copy attributed to his principal pupil Cesare da Sesto), 38×29 (97×74). Reproduced by permission of the Earl of Pembroke from his collection at Wilton House.

72 Nude Gioconda (after Leonardo). Drawing. Musée Condé, Chantilly.

LINDNER, RICHARD (b. 1901)

171 Leopard Lily, 1966. $70 \times 59_8^7$ (177·8 × 152·4). Wallraf-Richartz Museum, Cologne. Collection Ludwig.

LONG, EDWIN (1829-91)

131 The Babylonian Slave Market, 1875. Oil on canvas, 68×120 (172· 5×304 ·5). Collection Royal Holloway College, University of London.

MABUSE (JAN GOSSAERT, active 1503-c. 1533)

55 Hercules and Deianeira, 1517. Oil on panel, $14\frac{1}{2} \times 10\frac{1}{4} (37 \times 26)$. Barber Institute of Fine Arts, University of Birmingham.

261 Neptune and Amphitrite, 1516. Oil on oak, $75\frac{1}{4} \times 50\frac{1}{2}$ (191 × 128·5). Staatliche Museen, Berlin.

MAES, NICOLAES (1634-93)

94 Lovers with a Woman Listening, signed but not dated. Oil on canvas, $23\frac{1}{8} \times 25\frac{1}{4}$ (59×64). The Wellington Museum, Apsley House, London.

MAGRITTE, RENÉ (1898-1967)

162 The Rape, 1934. Oil on canvas, $28\frac{3}{4} \times 21\frac{1}{4}$ (73 × 54). Collection George Melly, London.

166 The Ocean, 1943. Oil, $19\frac{3}{4} \times 25\frac{5}{8}$ ($50 \times 63 \cdot 5$). Ex Collection Robert Lewin, London.

254 The Collective Invention, 1935. Oil, $28\frac{7}{8} \times 45\frac{5}{8}$ (73×116). E. L. T. Mesens Collection, Brussels.

MANET, ÉDOUARD (1832-83)

141 Le Déjeuner sur l'herbe, 1863. Canvas, $81\frac{7}{8} \times 103\frac{7}{8}$ (208 × 264). Louvre, Paris.

142–43 *Olympia*, 1863. Canvas, $51\frac{1}{8} \times 74\frac{3}{4}$ (130×190). Louvre, Paris.

MANTEGNA, ANDREA (1431–1506)

222 St Sebastian, c. 1457–58. On wood, $28\frac{3}{4}\times11\frac{3}{4}$ (68 × 30). Kunsthistorisches Museum, Vienna.

230 Judith with the Head of Holofernes. Tempera on linen attached to millboard, 18×14 (45×35). National Gallery of Ireland, Dublin.

MASTER OF FLORA (sixteenth century)

60 The Birth of Cupid, c. 1540–60. Oil on wood, $42\frac{1}{2} \times 51\frac{3}{8}$ (108×130·5). The Metropolitan Museum of Art, New York. Rogers Fund.

MATISSE, HENRI (1869-1954)

163 L'Après-midi d'un faune, 1933. Drawing (illustration to Mallarmé's poem).

MAZZONI, SEBASTIANO (c. 1611-78)

85 Death of Cleopatra. Canvas, $39\frac{3}{8} \times 30\frac{3}{4}$ (100 × 78). Alte Pinakothek, Munich.

MICHELANGELO BUONARROTI (1475-1546)

44 Leda and the Swan (after Michelangelo). 41\frac{1}{2} \times 55\frac{1}{2} (105 × 141). National Gallery, London.

49 The Drunkenness of Noah, 1508-10. Fresco (detail), Sistine Chapel, Vatican.

51 Venus and Cupid (school of Michelangelo). Oil on wood, 58 × 78 (147.5 × 198). Hampton Court Palace, reproduced by gracious permission of Her Majesty the Oueen.

210 Victory, 1527-28. $102\frac{3}{4} \times 31\frac{1}{8} \times 33$ (261 × 79 ×

84). Museo Nazionale, Florence.

MOREAU, GUSTAVE (1826-98)

146 Messalina, no date. Watercolour, $95\frac{1}{4} \times 53\frac{7}{8}$ (242 × 137). Musée Gustave Moreau, Paris.

237 The Apparition, 1876. Watercolour, $41\frac{3}{4} \times 28\frac{3}{8}$ (106 × 72). Louvre, Paris.

MUNCH, EDVARD (1863-1944)

158 Under the Yoke, 1896. $13 \times 9\frac{1}{4}$ (33 × 23·5). By courtesy of Oslo Kommunes Kunstsamlinger, Munch-museet, Oslo.

192 The Kiss, 1895. Drypoint and aquatint, 13 × 101 (32.9×26.3). By courtesy of Oslo Kommunes Kunstsamlinger, Munch-museet, Oslo.

260 Omega and the Bear, from The Story of Alpha and Omega, 1909. Lithograph, $7\frac{7}{8} \times 7$ (20 × 19·5). By courtesy of Oslo Kommunes Kunstsamlinger, Munch-museet, Oslo.

MURILLO, BARTOLOMÉ ESTEBAN (1617-82)

87 Christ after the Flagellation, 1650-70, Oil on wood. $16\frac{1}{8} \times 22\frac{7}{8}$ (41 × 58). Formerly Cook Collection, Richmond

NEIZVESTNY, ERNST (b. 1926)

197 Lovers in a Whirlwind, 1965-67. Drawing, $8\frac{1}{4} \times 4\frac{3}{4}$ (21 × 12).

ORSI, LELIO (1511-87)

219 St Catherine, c. 1659(?) Oil on canvas, $34\frac{5}{8} \times 26\frac{3}{8}$ (88 × 67). Galleria Estense, Modena.

PARMIGIANINO, FRANCESCO AVARROLA (1503-40)

193 Vulcan Showing Mars and Venus Caught in the Net to the Assembled Gods. Drawing, pen, bistre and watercolour, $5\frac{1}{2} \times 4\frac{3}{8}$ (14.2 × 11.0). By courtesy of the Trustees of the British Museum, London.

209 Ganymede. Pencil. By courtesy of Christie's, London. Private collection.

PEITHINGS

20 Scenes of homosexual dalliance, fifth century BC. Red-figure cup. Staatliche Museen, Berlin.

PERMOSER, BALTHASAR (1651-1732)

227 The Apotheosis of Prince Eugène, 1718-21. Österreichische Galerie, Vienna,

PICASSO, PABLO (b. 1881)

154 Figures in Pink, 1905. Oil on canvas, $60\frac{3}{4} \times 43$ (154×110). The Cleveland Museum of Art, Ohio. Leonard C. Hanna Ir Collection.

161 The Embrace, 1903. Pastel, $38\frac{5}{8} \times 22\frac{1}{2}$ (98 × 57). Collection Paul Guillaume, Paris.

164 Four ceramics, 1962.

165 Drawing, 1927. Charcoal drawing.

176 Man and Woman, 1969. Red crayon, $19\frac{7}{8} \times 20\frac{5}{8}$ (50 × 52.5). Brook Street Gallery Ltd, London.

182 Minotaur watching a sleeping girl, 1933. Drypoint, $11\frac{5}{9} \times 14\frac{3}{9}$ (30 × 37).

187 Etching, 4 September 1968, Mougins. 6×7 (15.5 × 20).

259 Bull, Horse and Sleeping Girl, 1934. Combined technique, 11×9 (30 × 24.5).

262 Putto threatening kneeling girl with a mask, 1954. Etching, $12\frac{1}{2} \times 9\frac{1}{2}$ (32 × 24).

PIOMBO, SEBASTIANO DEL (c. 1485-1547)

218 Martyrdom of St Agatha, 1520. Oil on panel, $50 \times 70\frac{1}{8}$ (127 × 178). Galleria Pitti, Florence.

POWERS, HIRAM (1805-73)

132 The Greek Slave, 1846. Marble, h. 66 (167.5). Corcoran Gallery of Art, Washington DC.

PRIMATICCIO, FRANCESCO (1504/5-70)

195 Woman Being Carried to a Libidinous Satyr, 1547. Etching by L.D., $9\frac{3}{8} \times 16\frac{1}{4}$ (23.6 × 42.4). Bibliothèque Nationale, Paris.

199 Satyr Being Carried to a Woman, 1547. Etching by L.D., $8\frac{5}{8} \times 15\frac{3}{4}$ (22.6 × 40). Bibliothèque Nationale,

232 Nymph Mutilating a Satyr, c. 1543-44. Etching by L.D., $6\frac{1}{4} \times 6$ (16 × 15·2). Bibliothèque de l'Ecole des Beaux-Arts, Paris.

PRUD'HON, PIERRE-PAUL (1758-1823)

118 Venus and Adonis, 1810. Oil on canvas, $94\frac{1}{2} \times 66$ (240 × 167.5). Wallace Collection, London.

RAPHAEL (RAFFAELLO SANZIO, 1483-1520)

47 Triumph of Galatea, c. 1511. Fresco, $116\frac{1}{8} \times 88\frac{5}{8}$ (295 × 225). Villa Farnesina, Rome.

52 The Three Graces, c. 1500. Panel, $6\frac{3}{4} \times 6\frac{3}{4}$ (17 × 17). Musée Condé, Chantilly.

REMBRANDT VAN RIJN (1606–69)

188 The Monk in the Cornfield, 1645. $1\frac{7}{8} \times 2\frac{5}{8}$ (4.5× 6.5). Rijkmuseum, Amsterdam.

189 The Bedstead, 1646. $4\frac{7}{8} \times 8\frac{7}{8}$ (12·2 × 22·5). Rijksmuseum, Amsterdam.

194 Samson and Delilah. Pen and bistre, bistre wash, white body colour on white paper, $7\frac{1}{2} \times 9$ (19 × 23·3).

Groningen Museum, Groningen, Netherlands. Collection Dr C. Hofstede de Groot.

200 Joseph and Potiphar's Wife, 1634. $3\frac{1}{2} \times 4\frac{3}{8}$ (9 × 11). Rijksmuseum, Amsterdam.

235 Jael and Sisera, 1648–50. Pen and ink, $6\frac{5}{8} \times 10$ (17.4 \times 25.5). Ashmolean Museum, Oxford.

RENI, GUIDO (1575-1642)

247 Salome Receiving the Head of the Baptist, c. 1638–39. Canvas, $97\frac{3}{4}\times 68\frac{1}{2}$ (248×174). The Art Institute of Chicago, Illinois.

RICCHI, PIETRO (1606-65)

86 Tancred Succoured by Erminia. Panel, 48×31 (122 $\times 81$). Collection Count Rudolf Czernin, Vienna.

RODIN, AUGUSTE (1840-1917)

156 The Eternal Idol, 1889. Plaster, $29 \times 16 \times 20\frac{1}{2}$ (74 × 41 × 52). Musée Rodin, Paris.

157 The All-Devouring Female, 1888. Marble, $24\frac{3}{8} \times 11\frac{3}{4} \times 16\frac{1}{8}$ (62 × 30 × 41). Musée Rodin, Paris.

ROPS, FÉLICIEN (1833-98)

150 The Monsters, or Genesis, print from Les Sataniques, no date. Etching, $10\frac{1}{2} \times 7\frac{1}{2}$ (25.6 × 18.9). Bibliothèque Royale de Belgique, Brussels.

ROSSO (GIOVANNI BATTISTA DEI ROSSI, 1494–1540)

57 Danaë. Tapestry after Rosso. Kunsthistorisches Museum, Vienna.

58 Pluto. Engraving, 1526, by Caraglio, $8 \times 4\frac{1}{8}$ (20.5 × 10.5). By courtesy of the Trustees of the British Museum, London.

ROUAULT, GEORGES (1871-1958)

155 *Two Prostitutes*, 1906. Watercolour with pastel on paper, $27\frac{1}{2} \times 21\frac{1}{2}$ (69·5 × 54·5). National Gallery of Canada, Ottawa.

ROUSSEAU, LE DOUANIER (HENRI ROUSSEAU, 1844–1910) 245 Snake Charmer, 1907. Oil on canvas, $66\frac{5}{8} \times 74\frac{3}{4}$ ($169 \times 189 \cdot 5$). Louvre, Paris.

ROWLANDSON, THOMAS (1756-1827)

112 The Old Client. Watercolour, $5\frac{1}{2} \times 9$ (14×23). Collection Brinsley Ford, Esq.

RUBENS, SIR PETER PAUL (1577-1640)

83 Hélène Fourment in a Fur Robe, c. 1631. Oil on wood, $69\frac{1}{4} \times 38$ (176 \times 83). Kunsthistorisches Museum, Vienna.

91 Ganymede, c. 1636. Oil on canvas, $71\frac{1}{4} \times 34\frac{1}{4}$ (181 \times 87). Prado, Madrid.

180 Susannah and the Elders, c. 1610–12. Academia de San Fernando, Madrid.

206 Jupiter and Callisto, 1613. Oil on panel, $49\frac{3}{8} \times 72\frac{1}{2}$ (126 \times 184). Staatliche Kunstsammlungen, Kassel.

224 Prometheus Bound, 1611-12. Oil on canvas,

 $95\frac{7}{8} \times 82\frac{1}{2}$ (243 \times 209). Philadelphia Museum of Art. The W. P. Wilstach Collection.

225 The Death of Argus, 1611. Wallraf-Richartz Museum, Cologne.

251 The Triumph of the Victor, c. 1614. Oil on panel, $68\frac{1}{2} \times 103\frac{1}{2} (174 \times 263)$. Staatliche Kunstsammlungen, Kassel.

SCARFE, GERALD (b. 1934)

229 Caricature of Lord Snowdon, c. 1965, $28\frac{3}{4} \times 20\frac{3}{4}$ (73 × 52·5). Collection Gerald Scarfe.

SCHIELE, EGON (1890-1918)

151 A Cardinal Embracing a Nun, 1912. Oil on canvas, $27\frac{8}{8} \times 31\frac{1}{2}$ (70 × 80). Catalogue Number: Leopold 210. Private collection, Vienna.

152 Reclining Woman, 1917. Oil on canvas, $35\frac{7}{8} \times 67\frac{3}{8}$ (91 × 171). Catalogue Number: Leopold 278. Private collection, Vienna.

SEGAL, GEORGE (b. 1924)

273 Legend of Lot, 1966. Plaster, $108 \times 96 \times 72$ (275 \times 243·5×183). Sidney Janis Gallery, New York.

SERGEL, JOHANN TOBIAS (1740-1814)

124 Venus and Anchises Embracing. Brown-grey wash, $8\frac{1}{4} \times 6$ (21 × 15·2). National museum, Stockholm.

SLEVOGT, MAX (1858-1932)

134 The Victor (Prizes of War), 1912. Oil on canvas, $59\times 39\frac{3}{8}$ (150×100). Kunstmuseum der Stadt, Düsseldorf.

250 The Knight and the Women, 1903. Oil on canvas, $63 \times 98\frac{3}{8}$ (160 × 250). Gemäldegalerie, Dresden.

SMERCK, D.

270 I Love Gemey Too Much, 1964. Oil on canvas, 76×58 (193 \times 147 \cdot 5). Collection M. and Mme J. Y. Noury, Paris.

SODOMA (GIOVANNI ANTONIO BAZZI, 1477–1549)

48 Marriage of Alexander the Great and Roxana, 1512. Fresco. Villa Farnesina, Rome.

SPENCER, STANLEY (1891-1959)

179 The Leg of Mutton Nude (Stanley and Patricia Spencer), 1937. Oil on canvas, 36×36 ($91\cdot5\times91\cdot5$). Collection Peyton Skipwith, Esq., the Fine Art Society, London.

SPRANGER, BARTHOLOMÄUS (1546–1611)

64 Vulcan and Maia. Kunsthistorisches Museum, Vienna.

SQUARCIONE, FRANCESCO (1394-1474)

201 Studies of classical themes (detail) (school of Squarcione), c. 1455. Pen and brown ink heightened with white, on paper washed blue, $10\frac{3}{4} \times 7\frac{1}{4}$ (27·4×18·6).

STEEN, JAN (1626-79)

95 The Trollop, c. 1660–65. Canvas, $15\frac{3}{4} \times 12\frac{1}{4}$ ($40 \times 36 \cdot 2$). Musée des Beaux-Arts, Saint-Omer. 97 Bedroom Scene. Panel, $19\frac{1}{4} \times 15\frac{1}{2}$ ($49 \times 39 \cdot 5$). Collection Museum Bredius, The Hague.

STOMER, MATTHÄUS (1615-50)

214 Roman Charity. Oil on canvas, $50\frac{3}{8} \times 56\frac{3}{4}$ (128 \times 144). Prado, Madrid.

TENIERS, DAVID THE YOUNGER (1638–85)

202 Boors Carousing, 1664. Oil on copper, $14\frac{3}{8} \times 17\frac{5}{8}$ (36.5 × 44.7). The Wallace Collection, London.

TINTORETTO (JACOPO ROBUSTI, 1518-94)

62 Vulcan Surprises Venus and Mars, c. 1551. Oil on canvas, $52\frac{3}{4}\times78$ (134 \times 198). Alte Pinakothek, Munich.

73 Susannah and the Elders, c. 1555. Canvas, $57\frac{5}{8} \times 76\frac{1}{4}$ (146.6 × 193.6). Kunsthistorisches Museum, Vienna.

TITIAN (TIZIANO VECELLIO, c. 1490-1576)

177 Venus with the Organ-player, c. 1548. Canvas, $58\frac{1}{4} \times 85\frac{3}{8}$ (148 × 217). Prado, Madrid.

178 Venus of Urbino, c. 1538. Canvas, 47×65 (119·5 × 165). Uffizi, Florence.

181 Diana and Actaeon, 1556–59. Canvas, $74\frac{3}{4} \times 81\frac{1}{2}$ (190×207). Duke of Sutherland Collection, on loan to the National Gallery of Scotland, Edinburgh.

198 Tarquin and Lucretia, c. 1571. Oil on canvas, $74\frac{3}{4} \times 57\frac{1}{8}$ (190×145). Fitzwilliam Museum, Cambridge. 216 Perseus and Andromeda, c. 1554. Oil on canvas, $72 \times 78\frac{1}{4}$ (183×199). The Wallace Collection, London.

TOULOUSE-LAUTREC, HENRI DE (1864–1901)

138 In the Salon of the rue des Moulins, 1894–95. Oil on canvas, $43\frac{3}{4}\times52$ (111×132). Musée Toulouse-Lautrec, Albi.

139 *The Sofa*, ϵ . 1893. Oil on cardboard, $24\frac{3}{4} \times 31\frac{7}{8}$ (63×81). Metropolitan Museum of Art, New York. Rogers Fund.

TRAVERSI, GASPARE (1749-69)

226 The Wounded Man. Accademia, Venice.

UTAMARO (1753-1806)

98 Two Lesbians, c. 1788. Coloured print.

VALENTIN DE BOULLONGNE (c. 1594–1632)

233 Judith and Holofernes. Malta Museum, Valletta.

VAN CLEVE, JOOS (1507-?)

244 Lucretia, 1520–25. Panel, $29\frac{7}{8} \times 21\frac{1}{4}$ (76 × 54). Kunsthistorisches Museum, Vienna.

VAN COWENBURGH, CHRISTIAEN (1604-67)

99 The Rape of the Negress, 1632. Canvas, 41 \times 50 (104 \times 127). Musée des Beaux-Arts, Strasbourg.

VAN HAARLEM, CORNELIS CORNELISZ (1562-1638)

65 The Corruption of Men Before the Deluge, c. 1596. $9\frac{1}{2}\times 10\frac{7}{8}$ (23·9 × 27·5). Mauritshuis, The Hague.

VARALLO, TANZIO DA (ε. 1575–ε. 1635)

221 Saint Sebastian Tended by Angels, c. 1620–30. Oil on canvas, $46\frac{1}{2} \times 37$ (118 \times 94). National Gallery of Art, Washington D.C. Samuel H. Kress Collection.

VERONESE, PAOLO CALIAN (1528-88)

191 Mars and Venus Embracing. Oil on canvas, $18\frac{1}{2} \times 18\frac{1}{2} (47 \times 47)$. Galleria Sabauda, Turin.

VESTIER, ANTOINE (1740-1824)

105 Mademoiselle Rosalie Duthé. Canvas, 66×44 (167·6×118). Private collection, Paris.

WATTEAU, JEAN-ANTOINE (1684-1721)

102 A Lady at her Toilet, 1717. Oil on canvas, $17\frac{1}{4} \times 14\frac{1}{2}$ (44 × 37). Wallace Collection, London.

WESSELMANN, TOM (b. 1931)

175 Great American Nude No. 91, 1967. Oil on canvas, $59\frac{1}{2}\times103\frac{1}{2}$ (151 \times 263). By courtesy of the Sidney Janis Gallery, New York.

Photo credits

ACL, Brussels: 66. Archives Photographiques: 140, 161. Arts Council of Great Britain: 46, 62. Bayerische Staatsgemäldesammlungen: 85, 159, 162. Brook Street Gallery Ltd, London: 160, 166, 176, 207. Bulloz: 116, 130, 146, 217, 237. A.C. Cooper Ltd, London: 50, 87, 212. Courtauld Institute of Art, London: 100, 104, 107, 112, 255. Department of the Environment: 5. R. B. Fleming 58. Franz Jupp, Strasbourg: 99. John Freeman and Co., London: 215. Giraudon: 17, 52, 61, 68, 74, 79, 95, 115, 123, 126, 127, 139, 141, 142, 185, 228, 245. Hallsborough Gallery, London: 96. Himpsl, Munich: 121. Mansell-

Alinari: 32, 42, 47, 75, 178, 218, 239, 241. Mansell-Anderson: 43, 48, 53, 84, 117, 210, 223, 238. Marlborough Fine Art Gallery, London: 136. Massellarcelona: 39, 41, 91, 144, 177, 214. Meyer, Vienna: 64. Musées Nationaux: 89, 93. Josephine Powell, Rome: 243. Giustino Rampazzi, Turin: 236. Rijksbureau voor Kunsthistorische Documentatie, The Hague: 97. Royal Academy of Arts, London: 120. Schunk-Kender, Paris: 272. Eileen Tweedy: 98, 163, 197, 229. United Press International (U.K.) Ltd: 265. Vatican Museum and Art Galleries, Rome: 49. John Webb, Brompton Studio, London: 69.

Figures in italic are illustration numbers.

abstract art 164, 166 Abstract Expressionism 167 advertising 262-3, 266-70 Albani, Francesco 85; 89 Alcibiades 16 Aldridge, Alan 266; 263 Alexandrian school 25 Allori, Cristofano 236; 241 Alma-Tadema, Sir Lawrence 121: 120 Altdorfer, Albrecht 75, 208-9; 76, 213 Aphrodite (Venus) 11-13, 22-3, 109, 171, 173, 178 apsaras 28 Aristophanes 21 armour, symbolism of 246-50 arrow, phallic symbolism of 44, 82 Art Nouveau 139-40, 145 Artois, Comte d' (Charles X of France) 99, 108

Abbate, Niccolò dell' 58, 176; 183

Attis, Phrygian cult of 27-8; 25

Bacon, Francis 272; 271

106

Braque, Georges 155

Byron, Lord 116

Bachiacca (Francesco Ubertini) 231; 234

Bailey, David 266: 268 Baldung Grien, Hans 58, 75, 194, 198; 56, 78, 205, 248 Balthus (Balthazar Klossowski de Rola) 182; 186 Barbey d'Aurevilly, Jules 143 Baroque art 56, 78-9, 82-7, 89, 93, 121, 184 Baudelaire, Charles 116, 131, 246 Baudouin, P. A. 96, 106, 143; 104 Beardsley, Aubrey 140-1, 143, 145-6, 232; 147, 149 Bellmer, Hans 162, 224; 169 Bernini, Gianlorenzo 82; 84 Berry, Duke of 34, 75 bestiality 253-6 Bible moralisé 38 Biliverti, Giovanni 216 Blake, Peter 168 Boccaccio, Giovanni 34 Böcklin, Arnold 253; 256 Bosch, Hieronymus 40, 42-5, 47, 66; 39-41 Botticelli, Sandro 42, 47-8; 42-3 Boucher, François 56, 96, 98, 100, 107-8, 119, 180;

Bouguereau, Adolphe 121, 133; 128

Bronzino, Agnolo 58, 118; 63

Bruegel, Pieter the Elder 75, 78

Brouwer, Adriaen 90; 93

Cagnacci, Guido 214, 243; 220, 246 Cairo, Francesco del 232; 236 Callot, Jacques 211; 215 Canova, Antonio 109; 116–17 Caraglio, Giovanni Jacopo 58; 58 Caravaggio (Michelangelo Merisi) 78, 84–7, 204–5, 227–8, 234–6; 81, 88, 90, 92, 238–9 caricatures 104, 106, 144 Carracci, Agostino 79 Carracci, Annibale 79, 219; 223 castration 28, 34, 227–36 Cavalieri, Tommaso 205 Cerne Abbas giant (Dorset) 15; 8 Charles V of France 36 cinema 270, 272 Clark, Kenneth 133, 171 Clésinger, Auguste 246; 249 Cleve, Joos van 239; 244 Clodion, Claude Michel 197 Colombe, Jean 34; 34 Corinth, Lovis, 204: 208 Correggio, Antonio 55-6, 79, 110, 178, 255; 53, 59, Courbet, Gustave 133, 204; 140 Couture, Thomas 121; 130 Cowenburgh, Christiaen van 93; 99 Cranach, Lucas 75, 178, 180, 200, 228, 246; 80, 184, 204, 231, 242 Cubism 155, 157

Dalí, Salvador 158, 162, 224; 168
David, Jacques Louis 108–9; 115
Davie, Alan 166; 172
Decadents 119, 143–4
Degas, Edgar 128–9, 131–2, 147; 135–6
Delacroix, Eugène 114, 116, 118, 139, 224; 125, 126
Delvaux, Paul 207
Diderot, Denis 96, 107–8, 272
Dionysus 18, 26–7; 1
Donaldson, Anthony 168
Donatello 48–50; 45–6
Dubreuil, Toussaint 73; 74
Dubuffet, Jean 167; 173
Dürer, Albrecht 75, 206–7; 77, 211
Durgnat, Raymond 270, 272
Duthé, Rosalie 99

Egyptian art 15, 16; 7 Ernst, Max 158-9; 167 Etruscan tomb-painting 16 Etty, William 249-50; 253 Expressionism 145, 150-1

Fantuzzi, Antonio (Antonio da Trento) 191, 196 Feti, Domenico 80; 82 Flaubert, Gustave 128 Floris, Frans 66; 66 Forain, Jean Louis 128, 132 Fontainebleau, School of 58–62, 72–3, 75, 191, 227; 60, 68, 71, 79, 195–6, 199, 232 Fragonard, Jean-Honoré 94, 100–3, 106, 119, 151, 184; 100, 107–10 François I of France 58 Freud, Sigmund 162, 212, 272 Fuseli, John Henry 111–14, 186; 1, 119–21

Gauguin, Paul 146, 155; 153 Gautier, Théophile 246 genre painting 89–94, 96, 129, 198, 222–3 Géricault, Théodore 114, 184, 236; 122, 190, 228, 240 Gérôme, Jean Léon 126; 133 Gillray, James 104, 106, 144, 224; 111, 114 Giorgione 171
Giotto 34; 32
Golden Age 34, 66; 35
Goncourt, Jules and Edmond 128
Gooch, Gerald 261–2; 264
Goujon, Jean 61
Goya, Francisco de 114, 135, 180, 263; 122, 144
Graeco-Roman art 16–29, 79, 94, 112, 191, 197
Graf, Urs 217, 250–1; 252
Great Mother, Phrygian cult of 27
Greuze, Jean-Baptiste 96, 98, 100, 108, 121; 103
Grosz, George 152; 160
Guys, Constantin 128, 132; 137

Haarlem, Cornelis Cornelisz van 66; 65 Heckel, Erich 151 hermaphrodites 25, 216; 21, 23, 26, 37 herms, Graeco-Roman 16; 10 Hinks, Roger 234 Hogarth, William 103; 113 homosexuality 19, 84–6, 131, 180–1, 203–5, 207, 234, 236, 272 Hokusai 254; 257 Hoogh, Pieter de 92; 96 Hours of Marguerite de Coëtivy 36, 56–7; 38

Impressionism 127, 146, 204 incest 208–10 Indian art 28–31, 67, 70–2 Ingres, Jean-Auguste-Dominique 13, 75, 118, 134, 147, 155, 180, 240; 127, 145, 185, 217

Japanese art 92–3, 254 Jones, Allen 168; 170 Jordan, Dorothy 106 Julius II, Pope 219 Jung, Carl Gustav 212–13

Kama Shastra 69 Kangra school 67 Kirchner, Ernst Ludwig 151; 159 Klein, Yves 273; 272 Klimt, Gustav 145–6, 178, 204; 148 Kooning, Willem de 167; 174

Lanfranco, Giovanni 79, 207; 212
L.D. 191, 227; 195, 199, 232
Leningrad Painter 21
Leonardo da Vinci 48, 54–5, 72, 204, 255; 50, 72
lesbianism see homosexuality
Limbourg, Pol, Hennequin and Hermant 34, 75, 78
Lindner, Richard 168; 171
Livres des merveilles 38, 40; 37
Long, Edwin 123; 131
Louis XV of France 99
Louis XVI of France 99

Mabuse (Jan Gossaert) 57–8; 55, 261 Maes, Nicolaes 92; 94 Magritte, René 158, 253, 268; 162, 166, 254 Mallarmé, Stéphane 156 Manet, Edouard 119, 132–5, 146; 141–2 Mannerism 55, 56–67, 73, 75, 78, 79, 98, 113, 118, 191 Mantegna, Andrea 216, 228; 222, 230 Marco Polo 38 Marichal, Juan 261 Marie-Louise, Empress 110 Matisse, Henri 139, 155–6; 163
Maupassant, Guy de 128–9
Mazzoni, Sebastiano 82, 243; 85
medieval art 32–45
mermaid 252–3
Michelangelo Buonarroti 48, 52–5, 58–9, 78–9, 139, 204–5, 219, 222, 255; 44, 49, 210; School of 51
Min (Egyptian god) 15–16; 7
Minoan Snake goddess 239–40
misericords 33, 252
Mishima, Yukio 265; 266
Mondrian, Piet 164
Monroe, Marilyn 263; 265
Moreau, Gustave 139–41, 146, 159, 224, 233; 146, 237
Munch, Edvard 148, 150, 186, 256; 158, 192, 260
Murillo, Bartolomé Esteban 84: 87

martyrdom 84, 119, 213-18, 230-1

Master of Flora 62, 60

Napoleon III 132 narcissism 206-7 Neipperg, Count 110 Neizvestny, Ernst 192; 197 Neoclassicism 107-14, 155-6 Noland, Kenneth 164 nude in art 133, 171

O'Murphy, Louisa 98–9 Orley, Bernard van 184 Orsi, Lelio 214; 219 Ovid 85

Palaeolithic art 11-14

Parmigianino, Francesco 188, 204; 193, 209 Pascin, Jules 150, 204 Permoser, Balthasar 222; 227 pet-en-gueule (arsy-versy) 33 photography 262-6, 270 Picasso, Pablo 14, 147, 152, 155-9, 176, 183, 192, 255-6, 259; 154, 161, 164-5, 176, 182, 187, 259, 262 Piombo, Sebastiano del 213; 218 Pop art 167-8, 266 pornography 25, 183-4 Powers, Hiram 123; 132 Praz, Mario 119 Premierfait, Laurent de 34 Primaticcio, Francesco 58, 73, 191, 194, 227; 195, 100, 232 Proby, P. J. 266; 268 prostitutes 91-2, 128-32, 147-8, 150 Prud'hon, Pierre-Paul 110-11; 118

Quant, Mary 268

Raimondi, Marcantonio 132
rape 93, 96, 114, 192–6
Raphael (Raffaello Sanzio) 48, 50–2, 55, 74, 79, 132, 178; 47, 52
Rembrandt van Rijn 78, 184, 189, 195, 198; 188–9, 194, 200, 235
Renaissance 47–56, 58, 73, 75, 79, 174, 178, 197
Reni, Guido 232, 265; 247
Restif de la Bretonne, Nicolas-Edme 197
Reynolds, Sir Joshua 79–80, 89
Ricchi, Pietro 82; 86
Rococo art 56, 155
Rodin, Auguste 109, 148, 150, 186, 204; 156–7

Romano, Giulio 74; 75 Romanticism 106–7, 111, 114, 116, 118–19, 139, 146, 162, 184, 186, 224, 246 Rops, Félicien 143–6, 253–4; 150 Rosso, Giovanni 58–9, 73; 57 Rouault, Georges 139, 148, 150; 155 Rousseau, Le Douanier (Henri Rousseau) 240; 245 Rowlandson, Thomas 103–4, 141; 112 Rubens, Peter Paul 12, 79–80, 87, 94, 121, 175, 178,

180, 220–1, 246–7, 250, 270; 83, 91, 180, 206, 224–5, 251

Rudolph II 63

Sabatier, Mme (La Présidente) 246
Sacher-Masoch, Leopold von 227, 236
Sade, Marquis de 107
sadism, sado-masochism 34, 84, 113–14, 116, 119, 139, 148, 159, 162, 192, 194, 211–24, 239, 256, 270
Salmon, André 155

Satanism 143–4 satyrs 19, 21, 25, 176, 191, 194–5, 250–2; 13–15, 21–3 22, 23

Scarfe, Gerald 224; 229 scatological representations 197–8 Schiele, Egon 145–6, 180; 151, 152 Schlegel, August Wilhelm 107

Schlegel, Friedrich 107 Segal, George 274; *273* Sergel, Johan Tobias 111, 113–14; *124*

slavery 123, 136–7, 180, 239 Shelah-na-Gig (Irish fertility figure) 32; 30 Slevogt, Max 127, 247–8; 134, 250

Snerck, D. 266; 270 snake, phallic symbolism of 240–3, 246

Sodoma (Giovanni Antonio Bazzi) 51; 48 Spencer, Stanley 173; 179 Spranger, Bartholomäus 63, 66; 64 Squarcione, school of 197; 201

Steen, Jan 91–2, 94; 95, 97 Stern, Isaac 261 Stomer, Matthäus 214 Strauss, Richard 227

Sturm und Drang movement 111 Surrealism 106, 144, 157–62, 168 Symbolists 119, 139-52, 155, 227

Teniers, David the Younger 198; 202
Tertullian 252
Thiebaud, Wayne 168
Tintoretto, Jacopo 63, 74, 174, 188–9, 195; 62, 73
Titian 134, 171, 173, 175, 182, 192, 240; 177, 178, 181, 198, 216
Tolnay, Charles de 42
Toulouse-Lautrec, Henri de 128–9, 131, 132, 147, 150; 138, 139
transvestism 200
Traversi, Gaspore 223; 226
Très Richtes Heures 34, 75, 78

unicorn, symbolism of 252 Utamaro 92-3; 98

Valentin de Boullongne 228; 233 Van Eyck, Jan 14 Varallo, Tanzio da 217; 221 Vasari, Giorgio 204 Velàzquez, Diego Rodríguez de Silva 78, 171 Venus see Aphrodite Veronese, Paolo 186, 188; 191 Vestier, Antoine 99, 180; 105 Vienna Secession 145 Villa of the Mysteries, Pompeii 26; 27 Vollard, Ambroise 129 Voltaire, F. M. Arouet de 197 voyeurism 34, 36, 75, 171–82, 192, 194, 202, 270

Walter, Marie-Therèse 159 Warhol, Andy 266 Watteau, Jean-Antoine 94, 96, 100; 102 Wesselmann, Tom 168; 175 Wilde, Oscar 227, 232 William III of Sicily 34, 227; 33 William IV of Great Britain 106

yakshis, Indian nature spirits 28–30; 28 Yeats, W. B. 54

Zola, Emile 128